ART TREASURES OF THE LOUVRE

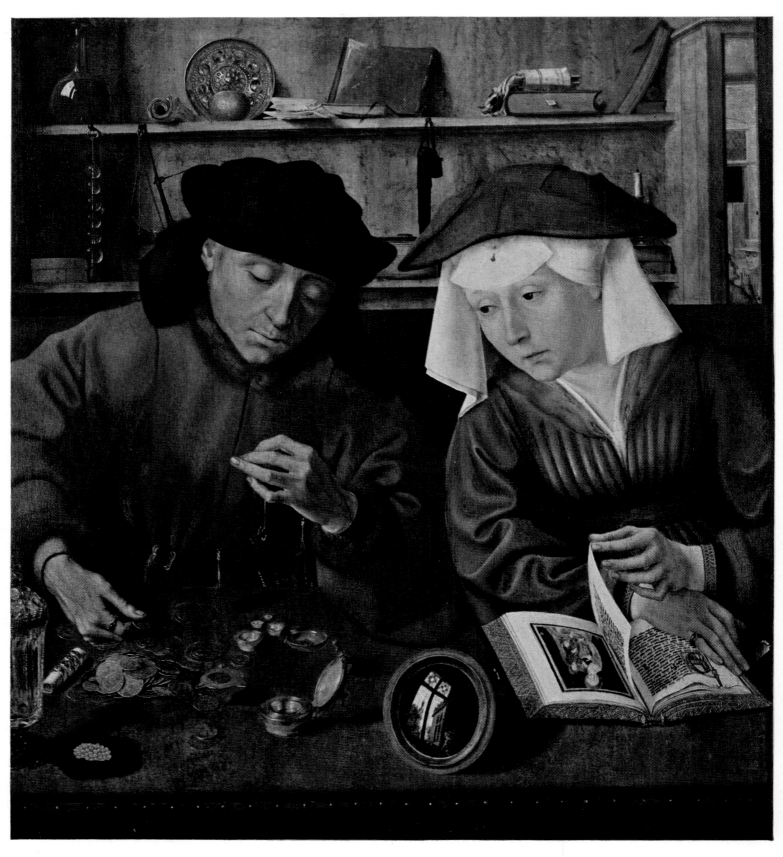

QUENTIN MATSYS [1465?-1530] *The Moneylender and His Wife* · Flemish School

Painted 1514 · Tempera and oil on panel, 28″ x 26¾″ · Commentary on page 154

ART TREASURES
OF THE
LOUVRE

Text translated and adapted from the French of

RENE HUYGHE

CURATOR-IN-CHIEF OF PAINTING AND DRAWING, THE LOUVRE

COMMENTARY BY MME. RENE HUYGHE

WITH A BRIEF HISTORY OF THE LOUVRE BY MILTON S. FOX

HARRY N. ABRAMS *Publishers* NEW YORK

MILTON S. FOX, Editor

Supervision of Color Plates by WALTER NEURATH of Thames & Hudson, Inc. ● Book Design by STEFAN SALTER

Printing of Color Plates by THE CONDE NAST PRESS

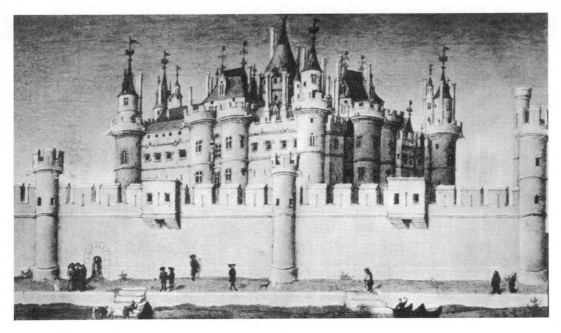

The Louvre of Charles V, about 1400. Detail from the Book of Hours of the Duke of Berry, Condé Museum, Chantilly

CONTENTS

COLOR PLATES

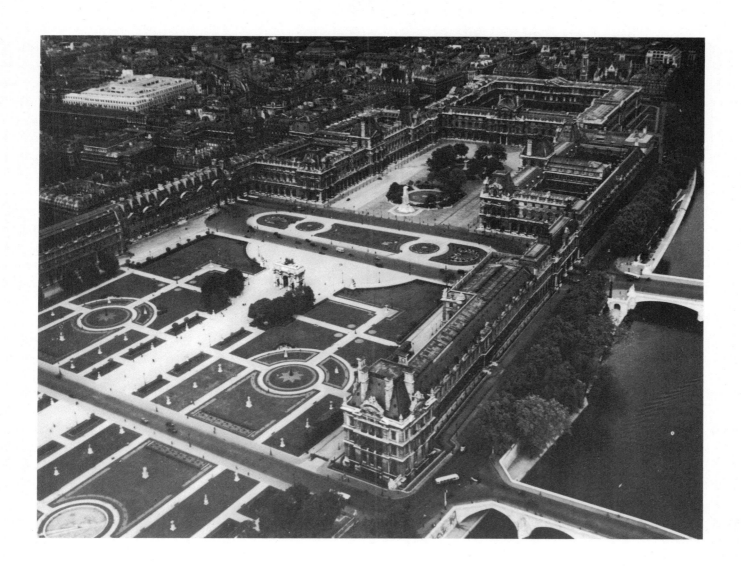

The Louvre

A BRIEF HISTORY

The Louvre is more than a great museum. It is an epitome of a nation's history and culture. For over seven hundred and fifty years it has stood for all that changes and all that remains the same in French life. Each age has helped to shape its character; every important ruler has left his mark upon it. Though it has suffered periods of neglect, desecration, and mean use, the Louvre has had the love of a great people, to whom the pursuit of art is a natural activity of life.

It is not enough to say that the Louvre is the richest of museums, a vast treasury of all arts and all civilizations, magnificently housed. It has a deeper meaning. The Louvre is a living idea. In the succession of monarchs who built, tore down and rebuilt, in the tremendous expenditures of money, in the acquisitions and the gifts of private citizens, we see the forces which shaped its growth. French architects, painters, and sculptors contributed their best efforts, while the rulers of France were gathering their fabulous treasures and extending generous patronage to workers in the arts. The living idea may be seen as an artistic environment where intelligence, talent, and grace are joined; where amidst rich associations, the public may come for enjoyment and artists for nourishment and inspiration.

The Louvre was not the first public museum,

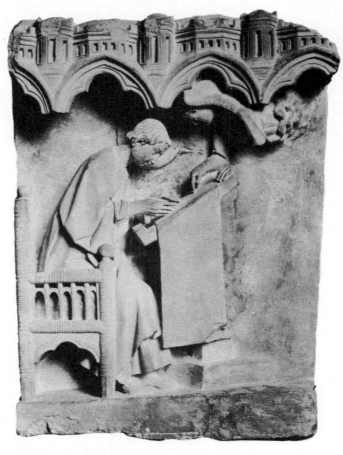

Saint Matthew writing his gospel at the dictation of his symbolic angel. This is a thirteenth-century stone relief from the choir enclosure of the Cathedral of Chartres. The new naturalism of Gothic sculpture is allied here with simplicity, breadth, and architectural form, in a clear harmony. 25½" high.

for it was preceded by the Ashmolean at Oxford, the Vatican Museum, the British Museum, and, in America, by the Charleston Museum, which was organized in 1773, twenty years before the opening of the Louvre as a public institution. But the Louvre's destiny was marked out for it centuries ago, as Paris, of which it is the heart both culturally and geographically, was destined to become the artistic capital of the world.

The earliest known structure on the present site was a fortress, begun about 1190 by Philip Augustus, one of the great Parisian kings. It is likely, however, that during Clovis' siege of Paris at the end of the fifth century, a Frankish tower or fortified camp existed here. If that is so, the name "Louvre" may derive from the Saxon word *lower:* a fortified chateau; but it may also have come from *louveterie* (Low Latin, *lupara*): the headquarters of the wolf-hunt, or, as some believe, from the name of a leper colony.

The Louvre of Philip Augustus, of which traces may still be seen, was huddled in the southwest quarter of the present Court of the Old Louvre, and consisted of a large circular tower guarded by turreted walls and surrounded by deep moats. The battlements to the west, and along the Seine on the south, were backed by buildings; to the north and east stood two thick crenellated facades. Situated outside the walls of the town, the Louvre served the double function of protecting Paris against marauders from the west, and the king from his own Parisian subjects on the east.

With Philip, Paris became at the beginning of the thirteenth century the residence of the crown, but the Louvre itself was used mainly as a fortress and arsenal. It was the symbol of the strength of the king, a "tower of Paris" comparable to the Tower of London. In its dungeons languished the nobles who defied the ascendancy of the crown. Its rooms held the royal treasures — jewels, religious objects of art, illuminated manuscripts, armor. Though it was tiny by comparison with the present Louvre, which, with the Garden of the Tuileries covers forty-five acres — Philip's courtyard measured roughly 160 by 200 feet — it quickly captured popular imagination and was celebrated by story-tellers and balladists. Its legendary career had begun.

Even then, Philip's Louvre was the continuation of a tradition. Since earliest times, France had produced an unbroken line of artists. As a people, the French have been among the first collectors. Their royal houses had preceded even the secular powers of Italy in acquiring works of art and patronizing artists. Long before Philip, Charlemagne decreed that churches should be decorated with pictures, and had engaged artists to paint miniatures for his books. From the twelfth century to the Renaissance, France perfected one of the most astonishing of all arts — that of stained glass.

The kings who succeeded Philip made only minor structural changes in the Louvre. But from Flanders and Italy, the court and nobility drew artists and craftsmen to enrich French cultural life. Art and learning flourished. (The Etude — then the name of the University of Paris — had received a franchise, the first of its kind in the world, from Philip in 1200, and became a model to other nations. In 1461, ambassadors from Florence reported 18,000 "scholars" in Paris, not counting those studying civil law.) The Louvre

now served as a royal retreat and became the scene of sumptuous banquets, state occasions, and tournaments which lasted for days. Elaborate gardens were designed — another art in which the French have excelled; an aviary with falcons and exotic birds, and a menagerie of wild animals added to the medieval splendor. Louis IX, the sainted king of France, administered justice in an enlarged room where the present Gallery of the Caryatids is located; he founded the library which, under Charles V, a hundred years later, was to become the nucleus of the present Bibliothèque Nationale.

The Louvre of the Middle Ages was doomed as a fortress, when, in the 1350's, a powerful group of rebellious merchants under Etienne Marcel took possession and reduced its military importance by extending the city walls beyond it. Once the master of Paris, the Louvre now became its captive. Though it was to continue to function as arsenal and prison through succeeding reigns, it now, under Charles V, became a part-time habitation of the royal family, filled with courtiers, artisans, and hangers-on. This king, "sage artiste et architecteur," as he was called by a contemporary lady of letters, provided the Louvre's final burst of medieval glory. An army of architects, masons, artists, and decorators was put to work. The hundred-and-fifty-year-old buildings were "modernized" and enlarged; two new wings were erected in place of the north and east walls. The quadrangle was at last completed, and according to accounts of the time, it was a marvel to behold: a forest of towers and turrets — round, square, conical, brilliant with glazed tiles — with picturesque outbuildings, gardens, trellises, and a menagerie. The famous contemporary miniature on the contents page preserves for us the fairy-tale appearance of this now-vanished Louvre.

Despite its increased size and elegance, Charles was obliged to sleep in the garret, when, in 1377, he entertained the Holy Roman Emperor, the King of Bohemia, and their suites of more than a hundred princes. It became painfully clear that the old Louvre could not serve as a royal residence for the growing nation. Succeeding kings lived and held court elsewhere.

During the reign of Charles' son, the sixth of that name, a madman, the English conquered the French at Agincourt in 1415, and occupied Paris. They plundered the Louvre. Marauders roamed

through the halls hunting for what was left. A large part of the ancient treasures, greatly enriched by Charles V, disappeared — reliquaries set with precious stones, enamels, crown jewels, vessels of crystal, chalices of gold, crucifixes, rare objects in glass, vases of alabaster, statuary painted and glittering with pearls, sapphires, emeralds, rubies — objects such as today the great museums of the world passionately desire. Indeed, a few of these original Louvre treasures are now the pride of various European museums, including the Louvre itself, and part of Charles' great library, as already noted, is in the Bibliothèque Nationale.

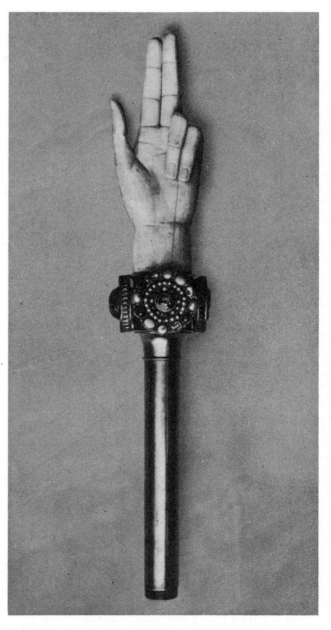

Gold scepter with ivory hand, the *"main de justice."* A French work of the fourteenth century, of exquisite craftsmanship and delicacy of form.

For almost a century and a half, the Louvre was neglected. Prison and arsenal again, its outbuildings falling into ruin, its walls moldering, it became a gloomy mockery of its one-time splendor. With Francis I, who came to the throne in 1515, the medieval stronghold was marked for obliteration. The Louvre we know today was born.

By 1527, the old tower, which had stood for more than three hundred years, was regarded as a grim nuisance, shutting out light and air. It was torn down in four months. The royal court was steadily consolidating its authority; it no longer had need of such antiquated reminders of the personal might of the ruler. The palace replaced the castle. Instead of a fortress, the royal residence must be made to symbolize the wealth and culture of a vigorous nation: resplendent and noble, an object of art and display, adaptable to luxurious living and vast administration.

Still, Parisians lamented the destruction of the historic tower. "What a pity it is," wrote a citizen in his journal, "to pull down the tower, for it was very beautiful, high, and strong, and well suited to imprison men of great renown."

But Francis, whose portrait is here reproduced (plate 62), was a cosmopolitan, "the first gentleman of France." Though occupied with interminable wars which drained the treasury, he managed to indulge his love of splendor. During his campaigning in Italy, he was enchanted by her art; he forthwith invited Italian artists to work for his court. Many came: Leonardo da Vinci, who lived the rest of his days in France and died, it is said, in the King's arms; Andrea del Sarto, Primaticcio, il Rosso, Niccolo dell' Abbate, and others. Francis was patron of the school of Fontainebleau, encouraging the painting of easel pictures; he began a collection which formed the nucleus of a national gallery. As yet, however, the collection was the private property of the king, never open to the public. Four of the Louvre's Leonardos and seven of its Raphaels are a legacy of this great monarch. As an indication of the severe blows which the museum-idea suffered while taking shape, it is noteworthy that the first catalogue of the royal art treasures, in 1642, showed that much of Francis' collection had mysteriously disappeared.

During his reign, Renaissance overwhelmed Gothic in France. Paris, the great representative center of the country, drew into herself all currents and became decisive for literature, art, architecture, fashion, and manners. For generations, the arts were to take their impulse from the court and royal palace; Francis cleared the way for his country to assume the cultural leadership of the world.

After having lavished huge sums on a futile rehabilitation of the old Louvre, in 1546 Francis put Pierre Lescot, architect, and Jean Goujon, sculptor, to work building a palace in "the new style." Eight months later the King died. Under his son, Henry II, Lescot and Goujon completed the new southwest angle, where three hundred and fifty years earlier Philip Augustus had erected the first Louvre. They built and decorated so gracefully, with such harmony and balance and charm, that their work very exactly conveys what is meant by the expression "French taste." Their Louvre was a jewel-case, worthy of the treasures it was to hold.

Indeed, according to some accounts, Henry's imagination was so inflamed by the work that he commanded Lescot to plan a Louvre of unprecedented magnificence and monumental size. They talked of quadrupling the size of the original courtyard, and of building a palace at the far west end of the Tuileries, where a tile factory once stood; the Palace of the Louvre and the Palace of the Tuileries were to be joined by enormous wings, which would enclose vast gardens. It was nearly three hundred and fifty years before the whole of such a "grand plan" became actuality; every sovereign after Francis and every administration after the Revolution was to make a fresh attempt at completion. The Louvre thus became not only the palace of the kings, the seat of government, and the repository of the royal treasures; it became also the continuing work-in-progress, at once training-ground and masterpiece, of the greatest talent in France. The creative life-blood of generations of architects, builders, painters, decorators, gardeners, and artisans in all arts was to be poured into it.

Yet the Louvre was still a weird melange in the sixteenth and seventeenth centuries: new buildings in the Renaissance style, finished and unfinished; ancient buildings standing amidst new construction; old towers, gates, and battlements; still stronghold as well as palace. "Zeste!" exclaimed one astonished ambassador to the court, "Such a main gate would be better suited for a

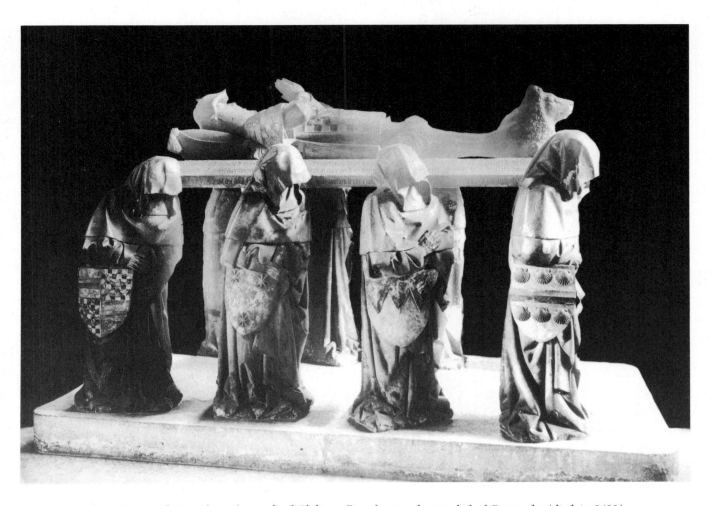

These stone sculptures from the tomb of Philippe Pot, the grand seneschal of Burgundy (died in 1493), represent the deceased in armor, in an attitude of prayer, on a slab carried by mourning figures with veiled faces. It is a work of intense realism, and at the same time architectural in conception and emotional through the power of the carving of the deeply furrowed, shadowy folds of the costumes. 71″ high, 8′ 8½″ long.

prison than for so great a Prince!" And an English visitor remarked, in 1598, that the Louvre had exactly the air of a jail.

Work had come to an abrupt halt about 1578. The treasury was emptied. Following the Massacre of Saint Bartholomew, when the halls of the Louvre were splattered with the blood of Huguenots, civil strife exhausted France. The court lived in fear: all the entrances to the palace were walled up except one heavily guarded gate. The Louvre was the scene of intrigue, violence, executions — and lavish entertainment, even including such hysterical entertainment as fights between wild animals. But the "grand plan" was only momentarily delayed by the difficult times: the museum-idea was not to be thwarted. Lescot soon was to complete part of the new south wing on the Seine; and for Catharine de Médicis, the queen-mother, was erected the *Petite Galerie* (the present Gallery of Apollo), which burned in 1661, and

part of the Palace of the Tuileries (destroyed in 1871), where she could keep an eye on her sons, "unseen but present."

These last two structures were outside the original quadrangle; the Louvre at last broke free of its medieval confines. The pace now quickened, as though the Louvre were anxious to hurry its destiny. Henry IV completed the work begun by Catharine; and in one tremendous leap, his architects, Jacques II Androuet Ducerceau and Louis Métezeau, spanned the distance from the *Petite Galerie* to the Palace of the Tuileries. Their *Grande Galerie*, paralleling the Seine, and familiar to millions of visitors to the collections, is more than a quarter of a mile long. With this structure, the architecture of the Louvre, first Gothic, then Renaissance, now turned toward classicism.

The "grand plan" was becoming actuality; and under Henry IV the Louvre began its career as the

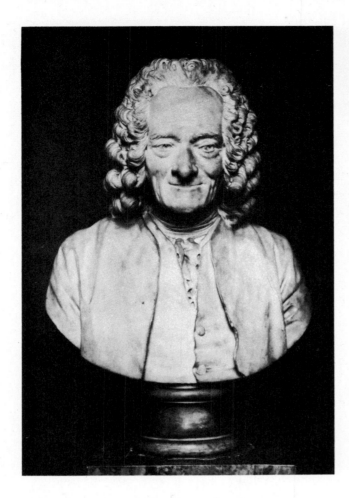

Voltaire (1694-1778) comes to life again, with his unique and fascinating intellectual vitality, his great wit and verve, in this masterly bust by Jean-Antoine Houdon (1741-1828). Houdon's style has the precision and lightness necessary for the portrayal of his mobile, subtle subject. 25″ high. Dated 1778.

artistic capital of the world. Despite wars, intrigue, religious strife, and financial troubles—and until he was cut down by the assassin, Ravaillac — this monarch built and planned greatly. The arts seldom had, in all history, such loving patronage. Hundreds of artists and craftsmen lived as his guests on the lower floors of the *Grande Galerie* — a precedent which was continued by all succeeding reigns until Napoleon I revoked these privileges. The original tapestry workshops of the Gobelins were housed here, and for Henry's queen, Marie de Médicis, Rubens painted a vast series of pictures — now in the Louvre.

Succeeding Henry, Louis XIII turned his attention to the old court of the Louvre. The ancient north and east sides, still standing in the midst of Renaissance grandeur, were torn down; almost all vestiges of Gothic vanished. The present Court

of the Louvre was planned, four times the size of its predecessor. Louis' architect, Lemercier, built the enlarged northwest corner, while elsewhere an enormous amount of decorating went forward. Poussin was called from Rome to do a series of paintings and stuccos, but he soon fled from the intrigues of the palace.

The Louvre now entered a period of intense activity in all directions. Colbert, minister of Louis XIV, spared no expense to glorify the reign of the Sun-King. The promotion of art became an affair of government. The royal collection, reduced from Francis' large number to about one hundred paintings, was built up to 2,403, according to a catalogue of 1709. Works of art poured in, from the collection of Charles I, beheaded King of England; from Italy; from the private collections of nobles. The Academy of Painting was founded in 1648. The first official exhibitions of French art were held, in 1667, 1669, 1671; from 1673 on, these exhibitions were held in the Louvre. A school for drawing from the nude was established — to become later the Ecole des Beaux Arts. And in 1681, many of Louis' paintings were put on semi-public view in the Louvre itself. During this period extensive work on the Louvre was resumed. Le Brun, Le Sueur, and others were called in to decorate the rooms, while important changes were made in the exterior arrangements of the buildings. New wings were built for the Palace of the Tuileries, where Louis lived and had his throne; the *Petite Galerie* was greatly enlarged; north, east, and south buildings were added to the quadrangle of the old Louvre. The palace called *Le Petit Bourbon* was demolished in order to make room for Le Vau's replica of the wing built by Pierre Lescot. The Gallery of the Kings, destroyed by fire in 1661, was quickly replaced by Le Brun's masterful Gallery of Apollo.

The Louvre was at last approaching completion. It still lacked an outside facade on the east. To build this, the great Bernini, who had designed much of the Rome of the Baroque age, was invited, but he suffered the same treatment as Poussin. He was received with great pomp, a pretence was made of laying the cornerstone; then he was sent back to Rome. The commission was finally given to Le Vau, Le Brun, and Claude Perrault; and their colonnade, at once simple and majestic, was completed in 1670. The work of decorating the facade stopped abruptly in 1678,

not to be resumed until the time of the Empire: the Sun-King had moved to his beloved Versailles.

The Louvre was taken over by a curiously assorted population and fell into a state of disrepair which aroused the indignation of many Parisians. Its courtyard was littered with rubbish and hovels, its entrances were turned into shops and stalls, and its unfinished buildings were inhabited by the poor. The Louvre began to resemble the ruins of ancient Rome. Courtiers moved into the apartments, which they transformed to their own taste and at the King's expense. They ripped out the paneling, defaced the ceilings, and opened skylights in the attic roof. The Academies of Painting and Architecture now occupied the quarters in the *Grande Galerie* which Henry IV had assigned to the artisans; after 1725 the Academy of Painting held its exhibitions in the *Salon Carré* of the Louvre: thus the name "Salon" for these exhibitions.

Paris attempted to save the Palace by making it a city hall, but the proposal was rejected by the King. Toward the middle of the eighteenth century the idea forcibly presented itself of using the Louvre as a public museum. The success of a public exhibition of paintings at the Luxembourg Palace in 1750 was encouraging, and in 1756 plans were presented for a showing of the King's pictures in the *Grande Galerie* of the Louvre.

It was not until after the Revolution, however, that the idea came to fruition, and on November 18, 1793, the museum was inaugurated. Its guiding concept was frankly educational, reflecting the democratic ideals of the Revolution. Works of art were no longer to be assembled for the delectation of the privileged classes; they were to be available to all. The painter David was president of the commission appointed to administer the Louvre and its annual purchase fund of 100,000 francs.

The royal collections were supplemented by numerous paintings and *objets d'art*, previously confiscated from the Church and the émigrés, and stored in the former convent of the Petits-Augustins. For the next twenty years the collections of the Louvre reflected the fortunes of Napoleon's army. In 1794, the pictures looted from Belgium arrived, and these were followed by works ceded by Italy; in December, 1797, a banquet was held in the *Grande Galerie* in honor of Napoleon and his victorious forces.

In July, 1798, "the triumphal entry of the memorials of the sciences and fine arts" took place; masterpieces such as the *Laocoön* were driven in chariots from the Petits-Augustins, to be installed in the Louvre. With the proclamation of Empire in 1804, the museum — now known as the "Musée Napoléon"—expanded rapidly; antiquities from Naples, the Borghese collection, the *Venus de Medici,* and groups of paintings from Germany and Spain, were acquired by its director, Baron Denon, who was exceedingly sharp in ferreting out works of art.

After Waterloo, the victors took from the

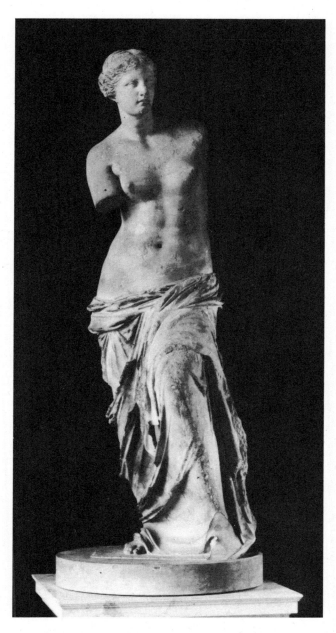

Aphrodite, called the *Venus de Milo,* after the place of its discovery, the island of Melos. Regarded by many as the finest example of the Greek ideal of feminine beauty, it belongs to a late period of Greek art. The end of the second century B.C. 6′ 6″ high.

Louvre the greater part of the collections acquired by conquest or treaty — and much besides, for good measure. But the French had collected vastly: soon the walls were covered with the Rubens paintings transferred from the Luxembourg Palace, with additional paintings formerly assigned by the Convention to provincial museums; the final transfer of works from the Petits-Augustins and churches occurred now. Throughout the nineteenth century and since, the Louvre has been enormously enriched by gifts from generous collectors, after many of whom various galleries are named. In addition to its paintings and drawings, the Louvre of today is renowned for its collection of Greek, Roman, Egyptian, and Oriental antiquities. Archaeological finds came from excavators in Myrrhina, Chaldea, Persia. By its purchases, the Society of Friends of the Louvre continues the work of filling the gaps that still remain in the Louvre's vast panorama of civilizations and cultural epochs.

During the nineteenth century, work on the building of the Louvre was resumed. As new collections were acquired, new rooms had to be opened; and a program of renovation of both interiors and exteriors was begun by Napoleon. The excrescences of the eighteenth century — the hovels and stalls in the courtyard and entrances — were removed, and the artists who had taken up residence in the Palace were evicted, David and Fragonard amongst them. Napoleon's architects, Percier and Fontaine, made changes in facades and redecorated the *Grande Galerie;* they began another wing on the north, along the rue de Rivoli, to complete the enclosure of the entire area between the Louvre and the Palace of the Tuileries. The triumphal Arc du Carrousel, which stands in the Gardens of the Tuileries and is modeled on the Roman Arch of Domitian, is also

by Percier and Fontaine, during the First Empire.

Construction continued during the Restoration, but it was Napoleon III who gave the Louvre its final form. His architects, Visconti and Lefuel, were commissioned to erect two new blocks of buildings which join the wings running from the Louvre to the Tuileries. Logical as this plan was, the new buildings, replacing many of the older facades, suffer from the excessive ornamentation of the Second Empire.

Although the Louvre survived without damage the revolutions of 1830 and 1848, it was not to be so fortunate during the struggles of the Commune. In 1871, fanatical Communards set fire to the Tuileries and the Library of the Louvre. With a battalion of infantry called to the rescue, the fire was checked before it could reach the *Grande Galerie,* and the collections were saved.

The Third Republic took on the work of restoring the damaged buildings, but after much debate and vacillation, it ordered the complete demolition of the gutted Palace of the Tuileries. It is ironical that at the very time when the goal of enclosing the entire area with palatial buildings had finally been achieved—at such tremendous expenditures of effort and money—a major element of the scheme should be destroyed. Violent controversy still continues between those who believe that the "grand plan" lost its *raison d'être,* and those who believe that the Louvre has gained a most magnificent vista, across the Gardens of the Tuileries, the Place de la Concorde, the Champs Elysées, to the Arc de Triomphe.

The Louvre is a glorious monument, unique to French culture and sensibility; but because of the universality of its idea and its treasures, it belongs also to mankind: a shrine, to which pilgrimage must sooner or later be made.

MILTON S. FOX

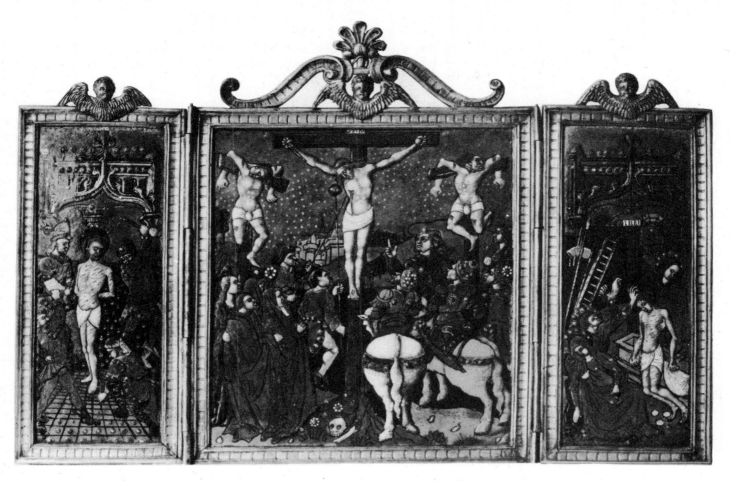

An enamel triptych painted about 1500. The central panel represents the Crucifixion; the left, the mocking and flagellation of Christ; the right, Christ's descent from the Cross. Done in Limoges, where the older medieval tradition of enamel painting, with its characteristic deep blue, was revived in the fifteenth century. 7½″ high.

Western Painting

ITALIAN PAINTING

WITH THE TRIUMPH OF EARLY CHRISTIANITY, Western art was eclipsed. Once given an exalted expression by classical Greece and Rome, it now fell into a sterility that was to last for centuries; not until the Middle Ages did it come to life. Then, steeped in a new and dynamic religious sensibility, it burst forth in the glory of the Gothic cathedral, a creation of glass and sculptured stone.

Painting played only a minor role in this revival in the North. It was Byzantium which developed pictorial art, in the form of the icon, mosaic, and fresco. For centuries, after it had split off from the rest of the Roman Empire in 395 A.D., this Eastern branch of Christendom preserved the great traditions of Western art, gradually transforming them with its own Near-Eastern taste and character. Byzantium created an art of hieratic images scintillating with gold, images whose shapes and colors were designed to induce contemplation and ecstasy, impressing the believer with their high religious solemnity rather than with their representation of nature.

Under the influence of this Byzantine art, Italy made her first attempts to create a style of painting. Cimabue's *Madonna of the Angels* (plate 3), which hangs before the entrance of the Louvre's Hall of Italian Primitives, departs only slightly from the Byzantine model. Yet at the end of the thirteenth century, when Cimabue in Florence

17

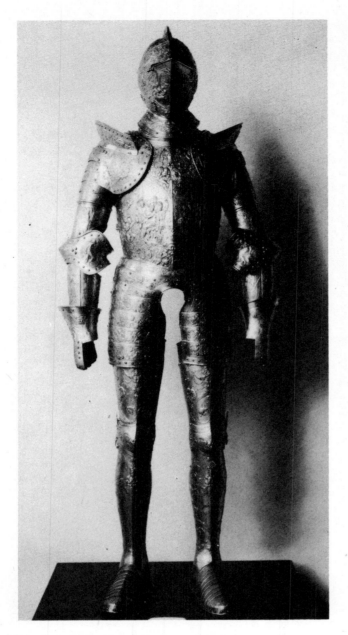

This suit of armor belonged to the French king Henry II (1503-1555). A work of high craftsmanship, it is richly decorated with ornament and pictorial scenes in low relief illustrating the story of the great Roman general Pompey. 72½" high.

and his rival Duccio in Siena were painting their great icons, the entirely new fidelity and the liveliness of the faces of the Virgin and Child delighted their contemporaries. Byzantine as they may seem to our eyes, these icons signaled the advance by which the West was to regain awareness of its true vocation: the mastery of nature, the achievement of a direct sense of reality.

Only a few years after Cimabue, Giotto, also in Florence, painted his *Saint Francis Receiving the Stigmata* (plate 4). What a step forward it records! The fourteenth century was beginning, and with

it Italian painting began to image the real world. The first impetus came from Saint Francis, who asserted that God should be worshipped in His creation and His creatures. He extended to birds and plants, as well as to "our brother the Sun," the love he had for God; the monk from Assisi had affirmed a simple faith in nature. No longer was there need to veil reality with conventional forms, with a whole abstract liturgy; one could proclaim and love it as it was, as one saw it.

Instead of combining sumptuously colored surfaces on backgrounds of gold, Giotto sought to make the panel or wall he was decorating speak the language of vision. Through the understanding of simplified masses, through the play of modeling and outlines which together created the illusion of form, he gave relief and depth to his images, new dimensions to the single plane on which he painted. And yet, the precepts of Byzantine painting were not to be forgotten: Giotto knew that although painting must rediscover nature, it must not be nature's slave, minutely recording detail upon detail without meaning. The human intelligence commanded, it selected what seemed significant, it simplified, and it extracted the essential. The spirit, not the eye, was master.

Throughout the fourteenth century, Giotto's revolutionary approach dominated Florentine painting. But Florence was not alone; Siena, her great rival, was not to be outdone. The Sienese school of painting, different in temperament and outlook, brought another kind of vitality to art. It is enough to look at the *Christ Carrying the Cross* (plate 5) by Simone Martini, the greatest Sienese since Duccio, to realize this difference. In Giotto's work, truth, strength, and clarity made their appeal to the mind. In Simone's work, the expressiveness of the pictorial conception, the vivacious color, and extreme grace of line were combined to enchant the sensibilities. To the virile genius of Florence, Siena—over whose wide city gate is the motto "Siena opens her heart still wider to thee"—opposed a genius tender and feminine. By the end of the fourteenth century, however, Siena had blossomed and faded, and Florence was to dominate the fifteenth century and determine its direction.

Florence claimed the heritage of Greece and Rome, a heritage both realistic and humanistic. On the one hand, man's goal was to divine the laws of nature so that he might master and reproduce

nature; on the other hand, he sought to mold it to his needs, to impose on it order and harmony. This has been the motif of Western civilization, and Florence took possession of it, absorbed it, proved herself worthy of it. Then she applied it to her art.

Early in the fifteenth century, Italian art was still groping its way in a maze of paths and by-paths. It began to find direction in the paintings of Fra Angelico, of whom the Louvre possesses a work of supreme mastery, the *Coronation of the Virgin* (plate 6). In his ardor for his faith, in the dream that he pursued of an earthly paradise in which all the mystic graces would flourish, the Dominican monk prolonged the spirit of the Middle Ages; but, like the men of the new age, he was also fervently concerned with the apprehension of reality. With all the clarity and rigor of his Order, whose glory was Saint Thomas Aquinas, Fra Angelico brought to realism all the spontaneous tenderness of heart and eagerness of eye which Saint Francis had taught the rival Order. Thus he was ready to reconcile and unite the picturesque and narrative realism of the Sienese school with the more intellectual realism of the Florentine school to which he belonged. His realism, with its simplicity and delight, could revel in the spectacle of flowers or hills bathed in the morning light, while initiating the study of the mathematical laws of perspective. Moreover, he was receptive to the influence of the Renaissance revival of antiquity, which was to enable the fifteenth and sixteenth centuries to create a secular art liberated from the Christian obedience of the Middle Ages.

Renaissance humanism insisted that liberation from Byzantium and its abstractions should be accompanied by liberation from the Middle Ages. First of all, man had to cease conceiving of nature as a symbolic spectacle in which the divine presence manifested itself. He had to feel an equality with nature and see that it offered, at first, enchantment for his eyes, and later, stimulus to his mind. This new orientation was to reflect the ideal of ancient paganism which had been revived by the flood of Greek scholars fleeing from the Turks, by the manuscripts they brought with them, and by the researches they undertook. Thus from medieval faith, through the intermediary stage of realism, art was to pass to humanism and a revival of paganism. The narrative and pictur-

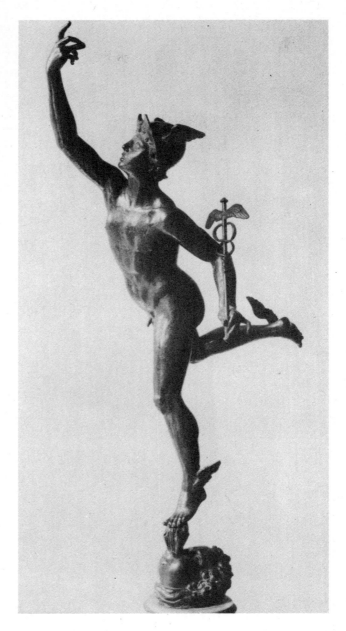

Mercury Taking Flight, by Giovanni da Bologna (1524-1608). French by birth—he derives his name from Boulogne in France—Giovanni setttled in Italy; his work shows the influence of both Michelangelo and the classical sculptors. The bronze statue of Mercury, the messenger of the gods, lightly poised on the breath of a zephyr, has all of the traditional symbols: the winged feet and helmet and the caduceus.

esque realism, which had already made its appearance in the religious scenes of the Sienese, was emboldened to frank secularity by the court civilization developed in France during and after the thirteenth century, a civilization whose pictorial gifts became known outside its own frontiers through its ivories, tapestries, and other arts.

Florence gave this secular trend a deliberately humanistic character. Its art became a measure of man and his aspirations, expressing the logic

19

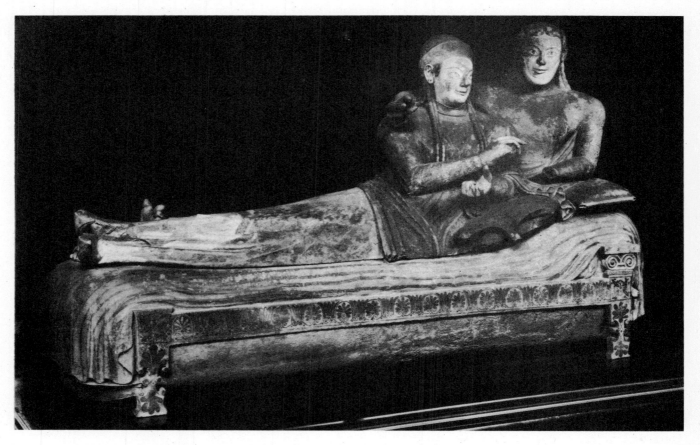

Etruscan sarcophagus, end of the sixth century B.C. Painted terra cotta, 6'4½" long, 3'8½" high. From Cervetri, in Italy. The figures represent husband and wife, with a mingling of primitive and realistic features in the carving. The art recalls the ancient Greek, but has its own rude savor.

and clarity of his thought. In the new art, the world was simply a field for human investigation and enterprise. Already Masaccio, following Masolino, was taking an interest in human anatomy and, under the pretext of painting Adam and Eve or the Baptism of Christ, he studied its volumes and proportions.

Little concerned with divine matters, the man of the fifteenth century was far from content merely to survey nature with an eye eager for amusement and distraction. He scrutinized it with a firm, cold intelligence, intent upon formulating its laws and triumphantly applying them. Two problems seemed to absorb his intention: perspective and harmony. By the study of perspective, space and modeling came under a system of logical laws; by the study of harmony, the elements of pictorial composition came under conscious control.

A successor to the generation of Fra Angelico, Paolo Uccello, perhaps even more strongly than the bitter and sculptural Andrea del Castagno, reasserted this spirit of secular humanism. In his

Battle of San Romano (plate 8) he brought the mind of a geometrician to the task of expressing forms and their disposition in space, and of compelling nature to accommodate itself to his simple and beautiful combinations of lines and colors. His junior, the Umbrian Piero della Francesca, devoted himself to virtually the same program. These artists had a close kinship with the scientists, who, motivated by similar ambitions and methods, were the precursors of the modern era.

Indeed, Leonardo da Vinci, one of the world's greatest painters, was also an engineer and inventor, one of the world's greatest pioneers of science. In order to understand the ambition and will-power that inspired these men of the fifteenth century, we need only look at the *Condottiere* (plate 10) whose portrait Antonello da Messina painted in 1475. With his implacable and piercing eye, sensual yet scornful mouth, and square, indomitable jaw, this soldier of fortune seems to personify the Renaissance, its audacities and its fierce demands.

Concurrent with these bold innovations, there

were more gradual transitions. Many painters still adhered to the religious ideal of preceding centuries. Nonetheless, while remaining devout, they yielded little by little to the pervasive spirit of secularism. Filippo Lippi painted Virgins as robust and earthy women. Benozzo Gozzoli, the pupil of Fra Angelico, invested episodes from Christian history with solid truthfulness. He did not hesitate to include handsome lords mounted on horseback. Such rugged realism was to blossom out at the end of the century in the work of Ghirlandaio, whose *Old Man and His Grandson* (plate 14) is as notable for the implacable interest in its subject as for the brilliance of its rendition.

This carefree vigor, however, was already tending to become refined. The newly revealed graces of classical art helped direct it toward secular subtleties, such subtleties as were to appear in Baldovinetti's Madonna (plate 9) who stands, tall and slender, with tapering neck, long, pale hands, and protuberant, lowered eyelids, in the foreground of a landscape whose background, with its sinuous rivers, wanders off into daydream. Here we can foretell the coming of Botticelli, in whom, at the end of the century, religious and pagan inspirations were to fuse and create an art in which delicacy sometimes borders on mannerism, and sensibility on a sharp and almost morbid nervousness. Botticelli's *A Lady and Four Allegorical Figures* (plate 13) marks the achievement of a new mode of vision: painting could now devote itself entirely to its own researches, to its interplay of line and shade through which the personality of the painter would seek to interpret itself to the point of confession. This intrusion of a new element—individual sensibility bent upon self-discovery and self-assertion—brought to a close the era of exploration.

The triumphant march of the Renaissance begins at this point. It is a magnificent procession advancing in two files. We have already seen how, since the fourteenth century, Florence, facing and opposing Siena, preferred the firmness of the intellect to the tenderness of the heart. Thus we were able to distinguish between the two opposite but related factions into which Italian art is divided. In the fifteenth and sixteenth centuries Florence, and later Rome, were to continue the devotion to an inspiration that was primarily intellectual, while the schools of Northern Italy were to direct their appeal to the sensibility.

Northern Italy, and particularly Venice, had in fact long known an art different from that of Florence. The North was concerned with the concrete, the study of material substance. This, in the middle of the fifteenth century, was the dominating spirit of the Mantuan school, personified by Mantegna, and of the great painters of the Ferraran school.

Admittedly, Mantegna was more directly inspired than his contemporaries by classical antiquity. He painted Parnassus, and he bound his Saint Sebastian to Corinthian columns, which he studied with the passion of an archaeologist. Admittedly, too, he devoted himself more than any other painter to the demands of sculptural form. But all this contributed to his displaying a new

Hera of Samos. Ionian, of the mid-sixth century B.C. (Dedicated to Hera by Cheramyes.) Oriental in its rigid, columnar posture, this archaic figure is already Greek in its subtly swelling forms, in the strongly modeled upper body, in the search for varied surfaces and lines, with strong shadows and delicate grooves, and in the natural proportions. 6'5" high.

and passionate interest in the material substance of his pillars and statues, in the stone itself; notice in his *Calvary* (plate 12), the crucified limbs, the cuirasses, and the angular rocks of his landscape. He is not content to define form by means of its outline and relief; he seeks to convey the feeling of its weight, its firmness, even its hardness to the touch. Form is no longer, as it was in the work of Giotto or Uccello, mere colored volume, but consists of bodies or objects which one perceives to be smooth, cold, or heavy, as if one were experiencing the sensation of them in one's hands or fingers. In his obsession with these qualities Mantegna gives his material substance the maximum of density, whether he is depicting flesh, wood, or cloth. The "tactile values" of which Berenson has spoken acquire here an insistence that addresses

The precious rock-crystal body, an older vase, was set in the twelfth century in a rich mount of silver-gilt with filigree and gems of contrasting texture, luminosity, and color. This exotic, hybrid work was offered by Queen Eleanor of Aquitaine to King Louis VII who presented it to his adviser, abbot Suger of Saint-Denis. 13″ high.

itself not only to the mind but also with great persuasiveness to the experience of the senses.

One feels this same quality in the pictures of the related Venetian school which was dominated, in the second half of the fifteenth century, by Mantegna's brother-in-law, Giovanni Bellini. Through its commercial trading Venice had maintained contact with the East. Here more than elsewhere in Italy the influence of Byzantium had endured, preserving a taste for the visual enjoyment of sumptuous and brilliant richness. Lorenzo Veneziano's Madonnas, glittering with gilt, had gradually given way to pictures in which painters like Crivelli and the Vivarini had delighted in suggesting to the eye the illusion of beautiful materials—marbles and brocades, fruit and garlands. Following on these painters, Giovanni Bellini could skillfully shade the coloring of a pink cloud against a sunset; everything that affected the visual sense conveyed to him a message as clear as that which the Florentines received from the clarity and the harmony imposed by thought.

Partly through Antonello da Messina, the Venetians of the fifteenth century became interested in the technical discoveries which were being made by the Flemish artists. These discoveries enabled painters, by the judicious use of oils, to create with marvelous accuracy the illusion of substance—of metal, cloth, wood, or stone—and of the varied play of light. But where the Flemings would open their eyes with the docility of a mirror that reproduces whatever is reflected in it, Mantegna and Bellini, remaining thoroughly Italian, preferred the idea one has of things to the passive registering of them. Seeking to reproduce substance, they *thought* of its hardness, its solid texture, and voluntarily accentuated these qualities to the point of giving to whatever they painted the cold solidity of marble or flint.

The sixteenth century developed the fundamental program which Western painting had laid down for itself: to reproduce nature as it appears, but to compel these appearances to accommodate themselves to order and to harmony. At the beginning of the new century Leonardo da Vinci was realizing this program. To the rendition of form, which his predecessors had perfected, Leonardo added an incomparable resource: light, with its infinitely subtle play of fugitive and variously blended shadows. *Il sfumato*, to use the Italian word for it, almost interprets life itself; by im-

perceptible mutations of brightness it seems to give movement to a glance, to a smile on the lip, or to the trembling of a hand. A painting like the famous *Mona Lisa* (plate 15) takes on animation, creates the illusion of a real existence; and in the mystery of chiaroscuro this existence, by reason of all its suggestions of the indeterminate, the unfathomable, the fascinating, becomes more compelling than if it had been only real. By going beyond the fixed and palpable aspects of reality to the impalpable, the insubstantial, the fleeting illusion of life, Leonardo completed the task that the Renaissance had set for itself. In addition, he taught it new possibilities. He opened art to mystery, to what can be suggested but not explained. He consciously exploited that dominion which, before him, even the greatest painters had approached only unconsciously; he was to enable every artist to interpret his own emotions and dreams, to make manifest that unknown world which is perceptible only to himself and is his secret.

Beyond doubt, the most representative genius of the Renaissance is Raphael, whose work is the culmination and flowering of the researches of his predecessors. With a sovereign ease he captured reality but imprinted upon it all the dreams of perfection and harmony cherished for more than a century. He inherited all of Florence's infallible certainty of order and elegance; but also, as an Umbrian and a pupil of Perugino, he added to it the sweetness and tenderness with which Umbria —like Siena in the century before—tempered the occasional severity of the art of the city of the Medici.

If humanism is first and foremost the perfect understanding and harmony of mankind with itself and with nature—such harmony and understanding as had been achieved by Greece— Raphael may be said to have given humanism new life. Not that he was incapable of expressing a personal soul; but his sensibility vibrated in unison with the spirit of his time. In his *La Belle Jardinière* (plate 18) Christian fervor is blended with a pagan ardor for beauty: the human form, the poetry of nature, the composition of the panel —all combine in balance and serenity. Raphael's spirit is conciliatory. It does not express itself, like the modern spirit, by contrast and opposition within and between the world and the individual; it seems to reveal that life has a center of gravity,

an abiding stability. This ideal has now lost much of its meaning for us; but it was the essential ideal both of humanism and classicism, and by his embodiment of this ideal Raphael attained the highest peak of the Renaissance.

In Michelangelo, Raphael's great Roman rival, Italian painting quickened its advance and entered its modern phase. Humanism, ambitious of universality, gave way to individualism; dynamism supplanted serenity. Already Michelangelo was beginning to infuse the human form with the obsessions of his own soul, his own tormented and insatiable greatness, his own personal pathos. With him the age of the Baroque begins.

We must look farther north, to Parma, to find again, in Correggio, the ideal of happiness. But in

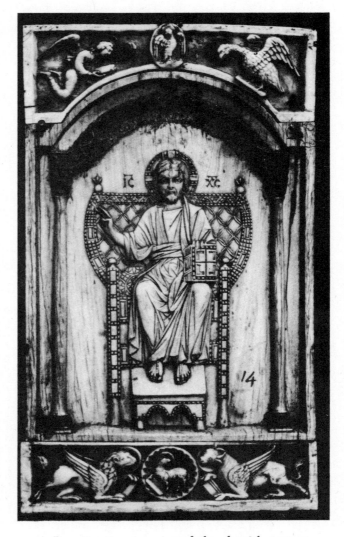

A Byzantine ivory carving of the eleventh century, representing Christ enthroned. Brought to the West, it was framed in the twelfth century by two panels representing the symbols of the evangelists, the Holy Spirit, and the Lamb. The Byzantine carving shows the typical Greek refinement and clarity in representing Christian figures in solemn postures of religious dignity and authority. 6½" high.

23

A late Gothic *Madonna and Child* from the monastery of the Antonites at Isenheim in the Rhineland. Mary's robe, richly crinkled and broken, forming a complicated field of lights and darks, is the chief means of expression. Wood, 68" high.

accord between Raphael's Virgins and their fragile vernal landscape becomes in Correggio's work a complicity between shadowy foliage and unashamed carnalities. His successor Parmegianino, who took his inspiration from both him and Raphael, was to incline their art toward the mannerism which invariably is at first the rejuvenation and then the fatal end of all classicism.

Correggio leads us back to Venice. While pursuing the ideal of the Renaissance—the flowering of mankind in harmony with the universe—Venice brought to the task her own special emphasis. Even more deliberately than Correggio she addressed herself to the sensibility rather than to the intellect. Venetian art combined all that stirs the senses—color, its iridescences under light, its oily gleam in the dusk; the splendors of material, of flesh, of tresses. Venice was to disregard the sculptural beauty of the male body, to which Roman art had devoted itself, and to prefer the sensual charm of the female.

Giorgione, in his *Pastoral Concert* (plate 16), assembles all the pictorial magic of Venice: the richness of foliage and flesh, the evocation of a life of refined pleasures, and all this amidst the sumptuous warmth of an autumn sunset. Dying young, Giorgione was succeeded by his friend Titian, who with his own sovereign and triumphant power, was to use the same evocations, the same poetical themes. Titian stands in the middle of that great Venetian triad whose other members were Veronese and Tintoretto. He represented the height of the Renaissance for Venice, as Raphael did for the rest of Italy. Like others before him he established a majestic balance of all the resources on which he drew: his intelligence gave him mastery of large, ordered arrangements, while his sensibility gave him mastery of expressive harmonies of color and substance. In his treatment of the life of the senses he was equally skilled at animating the pleasures of sensation and at revealing profundity of emotion. And as shown by his *Entombment* (plate 17), he commanded the orchestration of all these elements in a supreme harmony.

If Titian has the deep and brilliant sumptuousness of sunset, Veronese has the bright keenness of sunrise; if Titian is gold, Veronese is silver. More facile, more of a narrator, and also more superficial than Titian, Veronese was primarily a decorator. But in his inexhaustible fecundity he

Correggio's work this ideal is, so to speak, transposed into a sensuous key. Whereas in Florence Fra Bartolommeo and Andrea del Sarto remained obedient to the law of balanced, symmetrical, and pyramidal forms—forms as serene as those of architecture — Correggio translated harmony for the spirit into pleasure for the senses. He contorts the pose of his *Jupiter and Antiope* (plate 20) to give more emphasis to her suppleness; he stresses the relief to suggest the warmth of her body. The

(Continued on Page 73)

3. CIMABUE [*1240?-1302?*] *The Madonna of the Angels* · Florentine School
Painted last quarter, 13th Century · Tempera on panel, 166⅞″ x 108⅜″ · Commentary on page 154

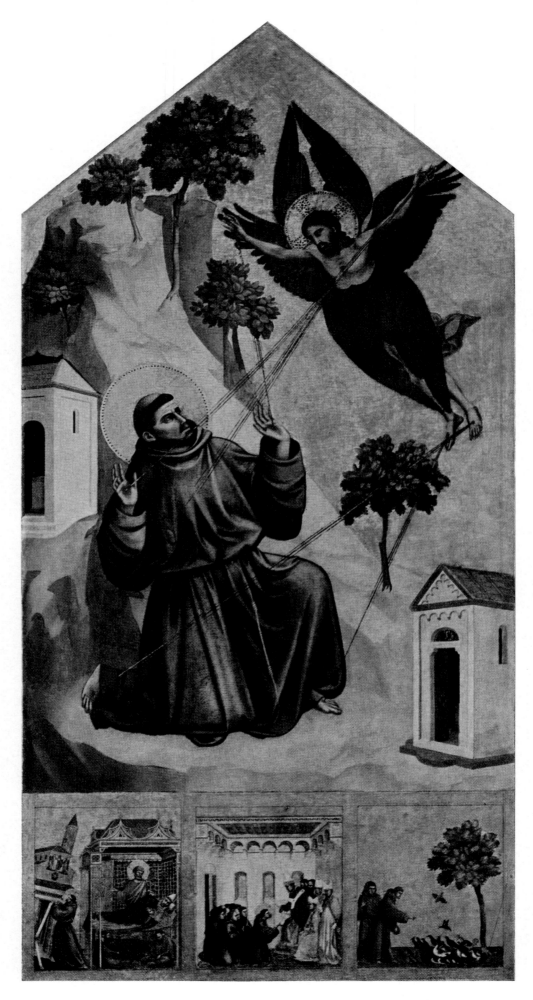

4. GIOTTO [*1266?-1337*] *Saint Francis Receiving the Stigmata* · Florentine School
Painted about 1320 · Tempera on panel, 123⅜″ x 63¾″ · Commentary on page 154

5. SIMONE MARTINI [1285?-1344] *Christ Carrying the Cross* · Sienese School
Painted about 1340 · Tempera on canvas, 11¾″ x 7⅞″ · Commentary on page 155

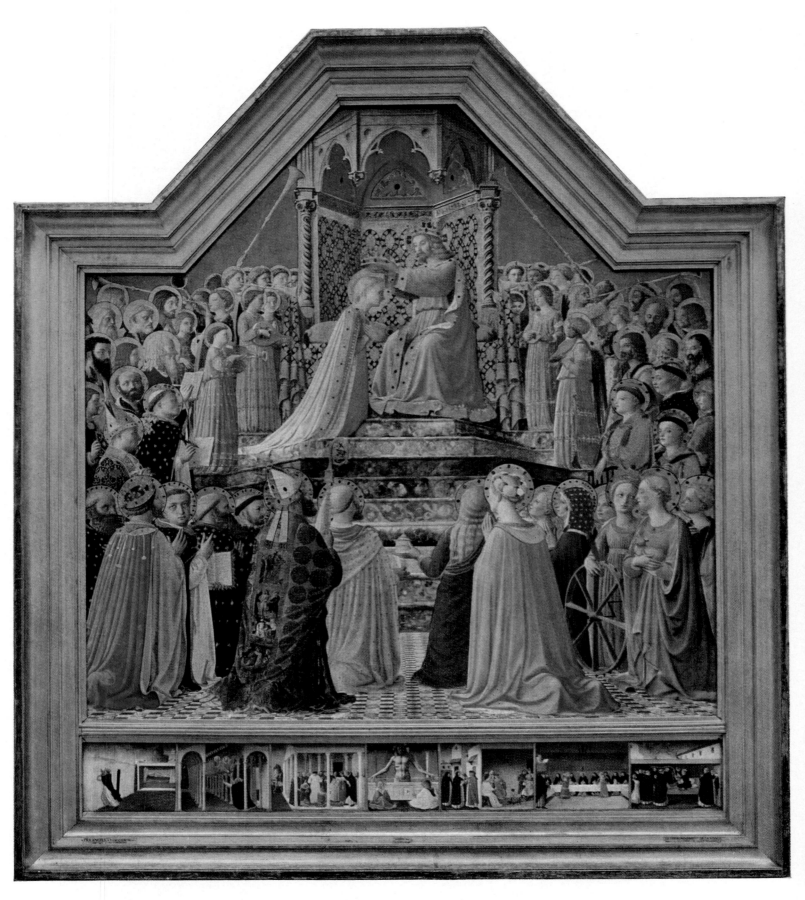

6. FRA ANGELICO [1387-1455] *The Coronation of the Virgin* · Florentine School
Painted about 1430 · Tempera on panel, 83⅞″ x 83⅛″ · Commentary on page 155

7. PISANELLO [*1395?-1455?*] *A Princess of the Este Family* · North Italian School
Painted about 1440 · Tempera on panel, 16⅞″ x 11¾″ · Commentary on page 155

8. UCCELLO [1397-1475] *The Battle of San Romano* · Florentine School · Painted 1456 · Tempera on panel, 70⅞″ x 124⅞″ · Commentary on page 155

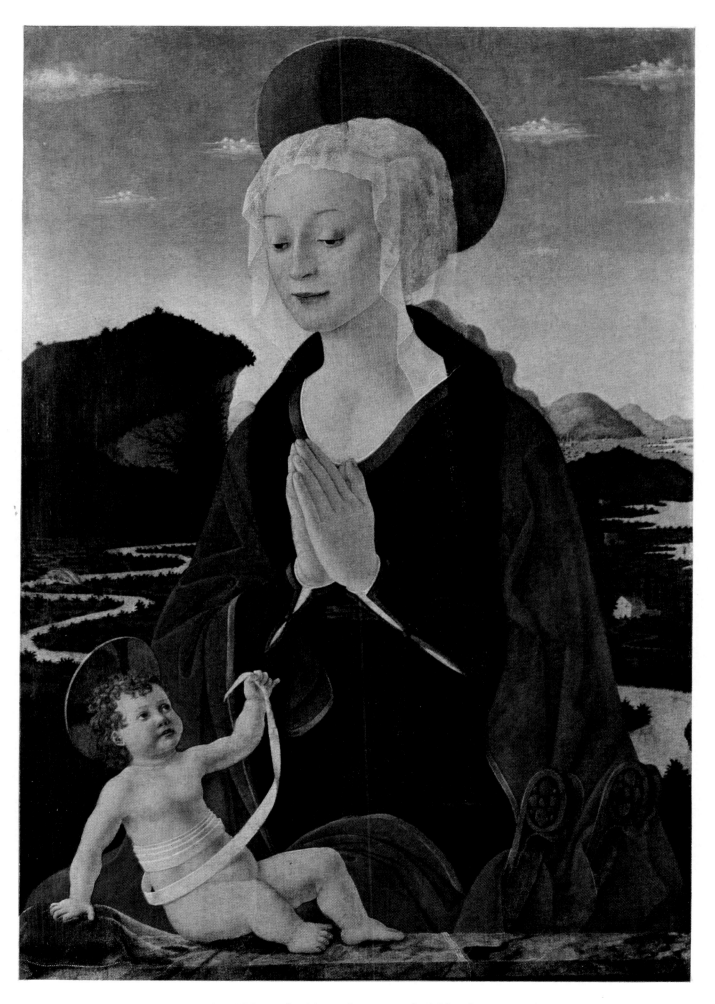

9. BALDOVINETTI [*1425-1499*] *Virgin and Child* · Florentine School
Painted mid-15th Century · Tempera and oil on canvas, 41″ x 29⅞″ · Commentary on page 156

10. ANTONELLO DA MESSINA [*1430?-1479*] *A Condottiere* · North Italian School
Painted 1475 · Oil on panel, 13¾″ x 11″ · Commentary on page 156

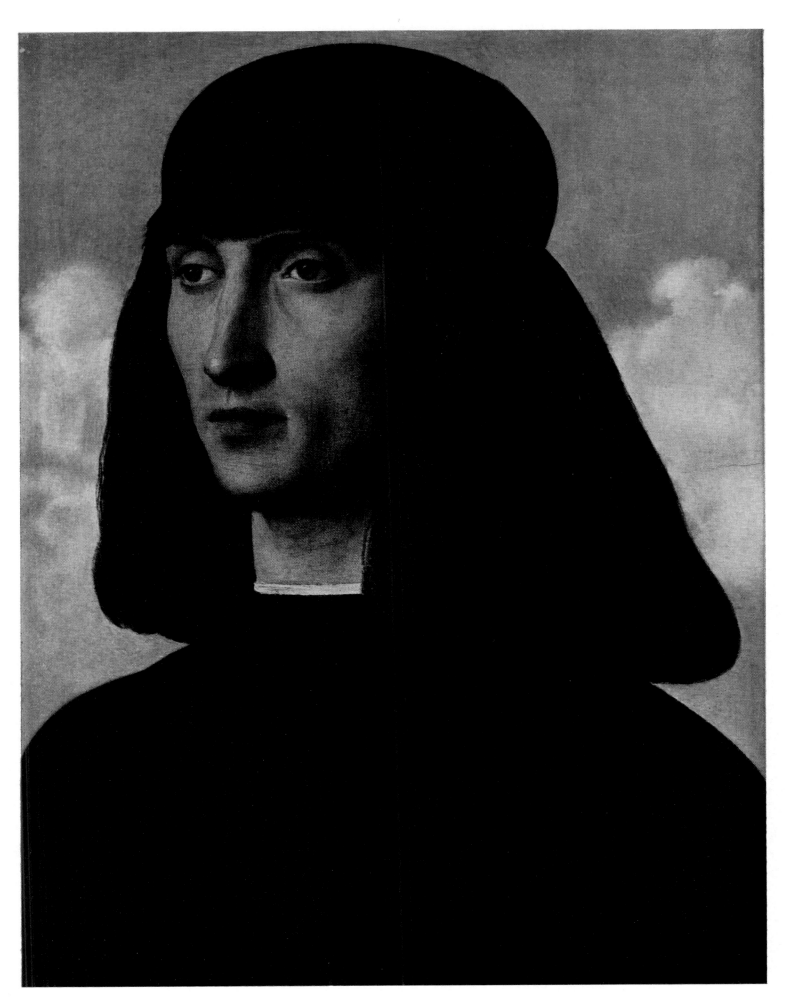

11. GIOVANNI BELLINI [*1430?-1516*] *Portrait of a Man* · Venetian School

Painted about 1485 · Tempera and oil on panel, 12⅜″ x 10¼″ · Commentary on page 156

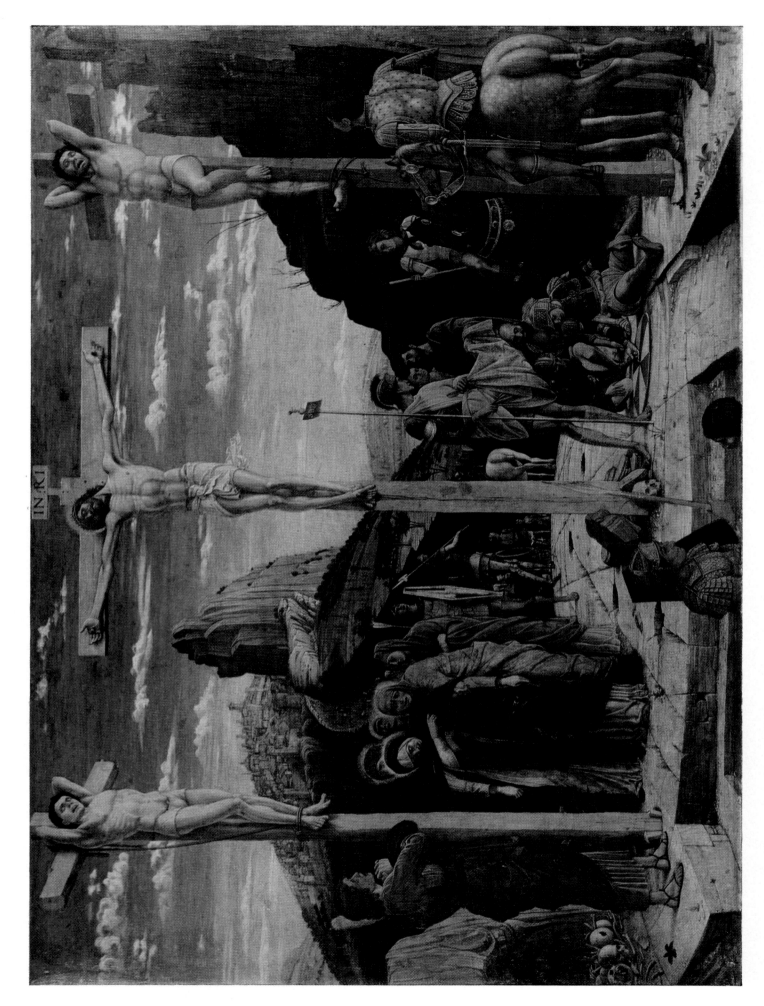

12. MANTEGNA [1431?-1506] *Calvary* · North Italian School · Painted 1456-1459 · Tempera and oil on panel, 26⅜″ x 36⅜″ · Commentary on page 156

13. BOTTICELLI [1444?-1510] *A Lady and Four Allegorical Figures* · Florentine School · Painted about 1484 · Fresco, 83½″ x 111¼″ · Commentary on page 157

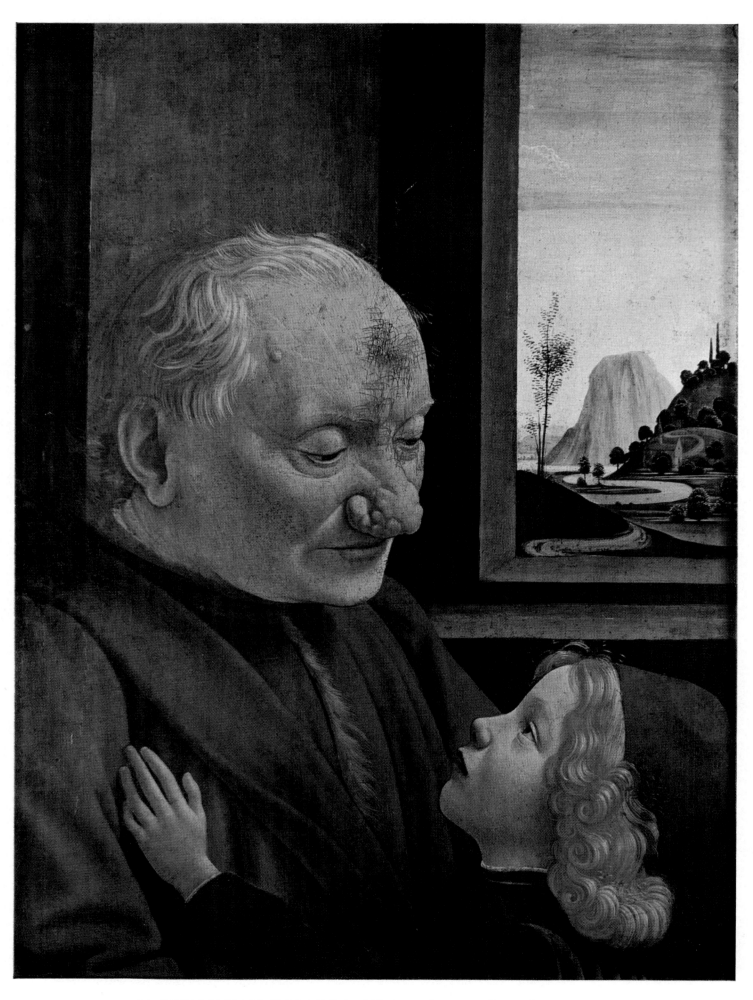

14. GHIRLANDAIO [*1449-1494*] *An Old Man and His Grandson* · Florentine School
Painted about 1480 · Tempera and oil on panel, 24⅜″ x 18⅛″ · Commentary on page 157

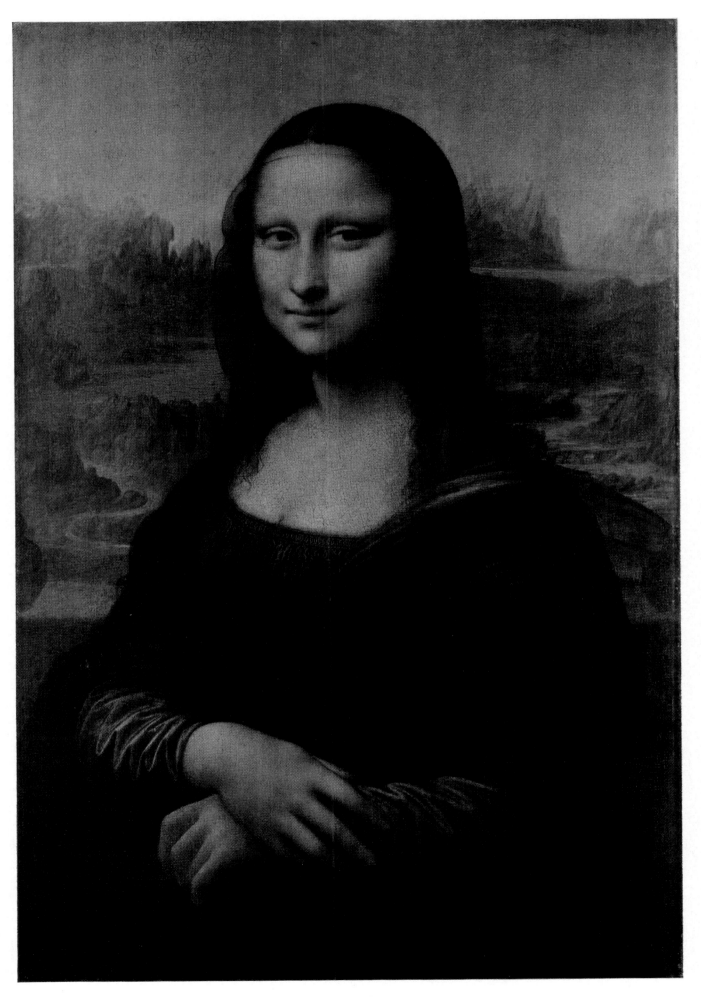

15. LEONARDO DA VINCI [1452-1519] *Mona Lisa* · Florentine School

Painted about 1505 · Oil on panel, 30¼″ x 20⅞″ · Commentary on page 157

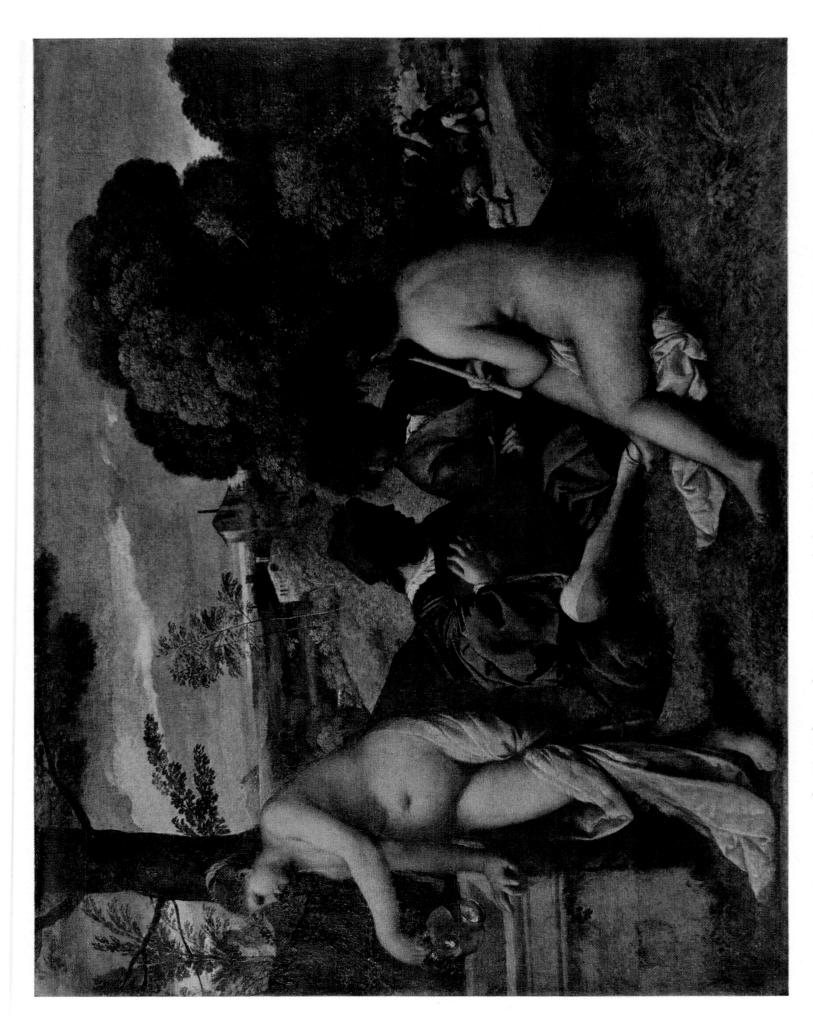

16. GIORGIONE [1477?-1510] *Pastoral Concert* · Venetian School · Painted about 1510 · Oil on canvas, 43¼″ x 54⅜″ · Commentary on page 158

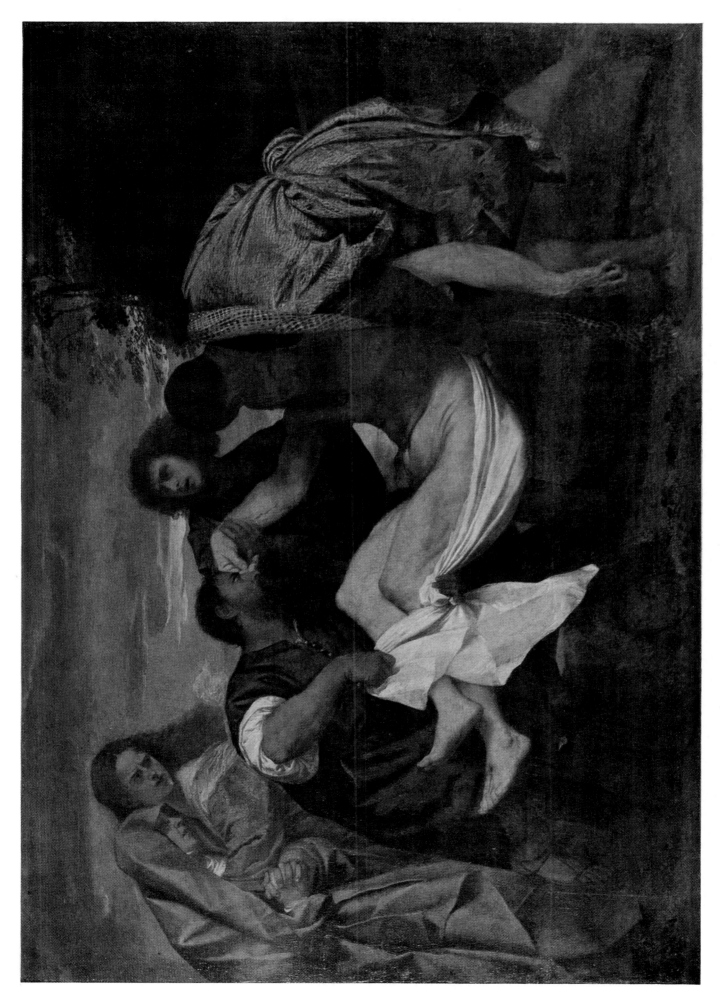

17. TITIAN [1477?-1576] *The Entombment* · Venetian School · Painted about 1525 · Oil on canvas, 58¼" x 84⅞" · Commentary on page 158

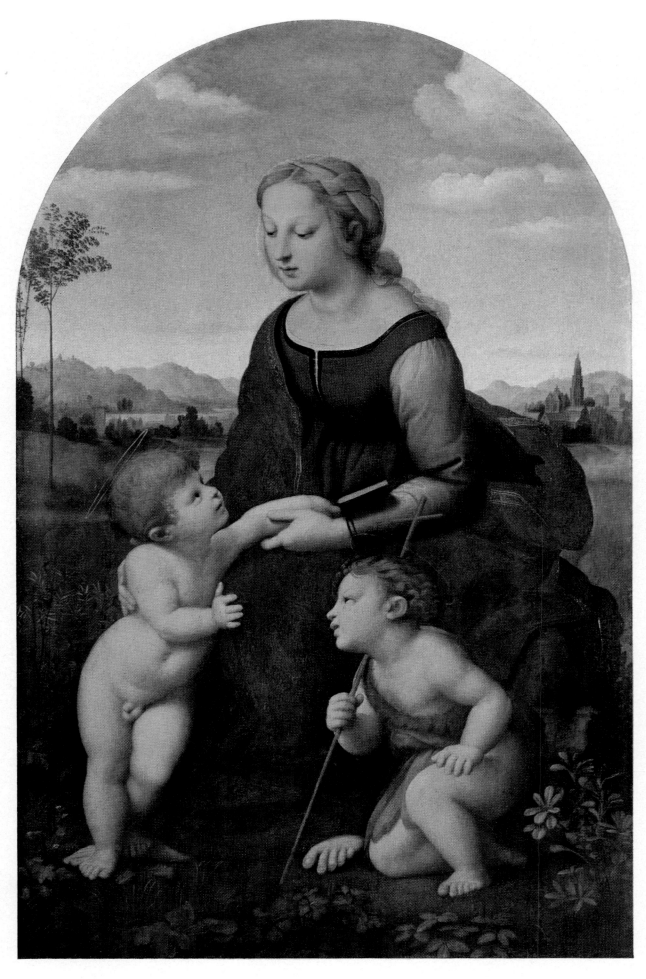

18. RAPHAEL [*1483-1520*] *La Belle Jardinière* · Florentine School

Painted 1507 · Oil on panel, 48″ x 31½″ · Commentary on page 158

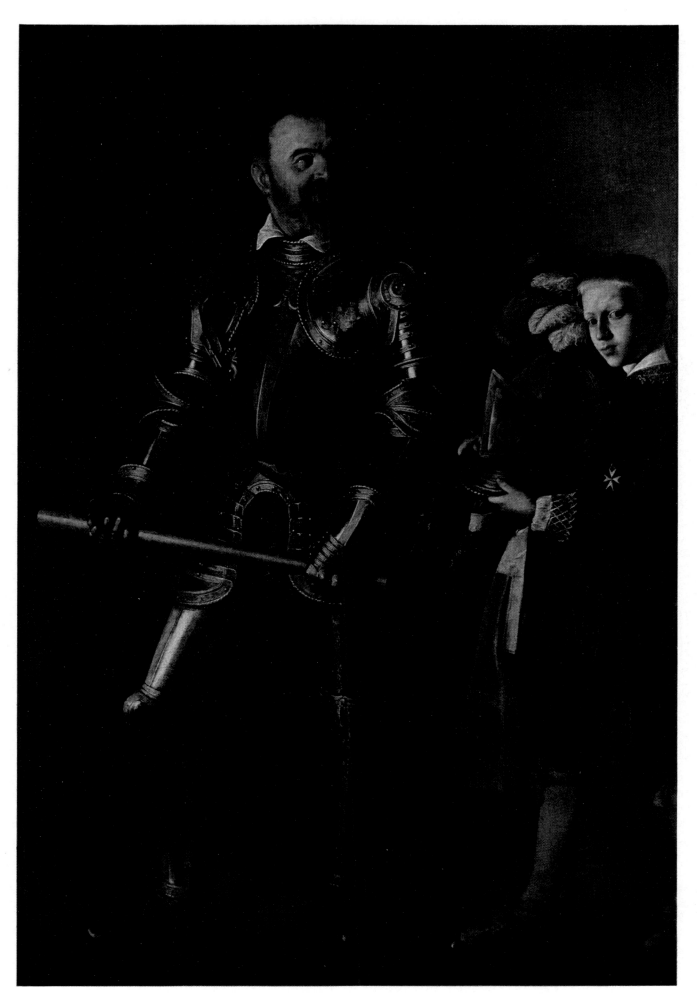

19. CARAVAGGIO *[1562?-1609] Portrait of Alof de Wignacourt* · Neapolitan School

Painted 1608 · Oil on canvas, 76¾″ x 52¾″ · Commentary on page 158

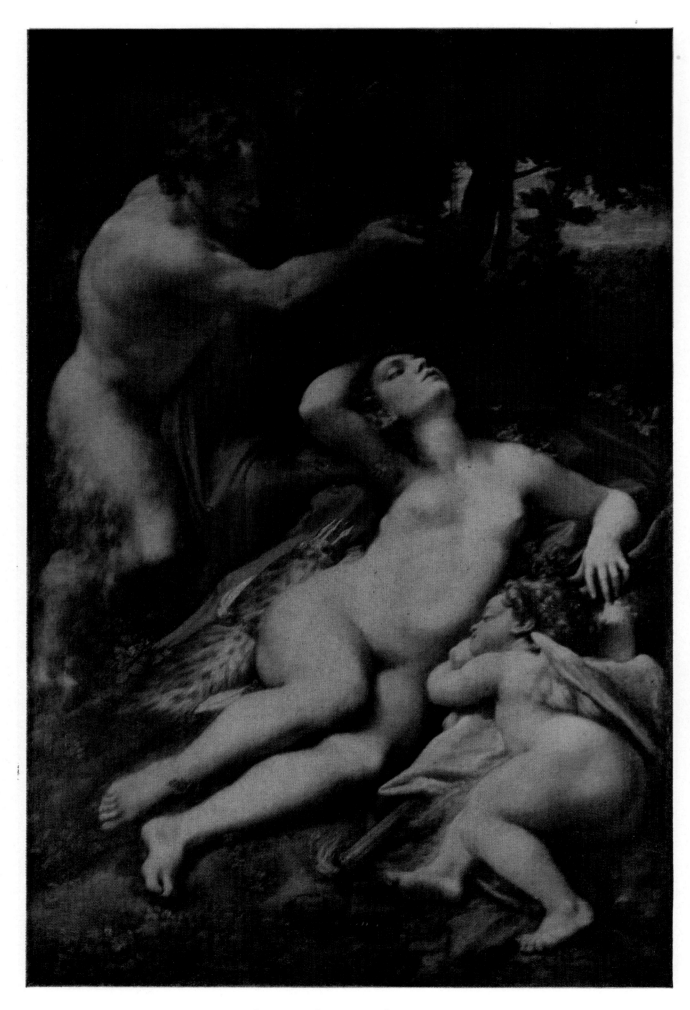

20. CORREGGIO [1498-1534] *Jupiter and Antiope* · North Italian School

Painted about 1525 · Oil on canvas, 74¾″ x 48⅞″ · Commentary on page 159

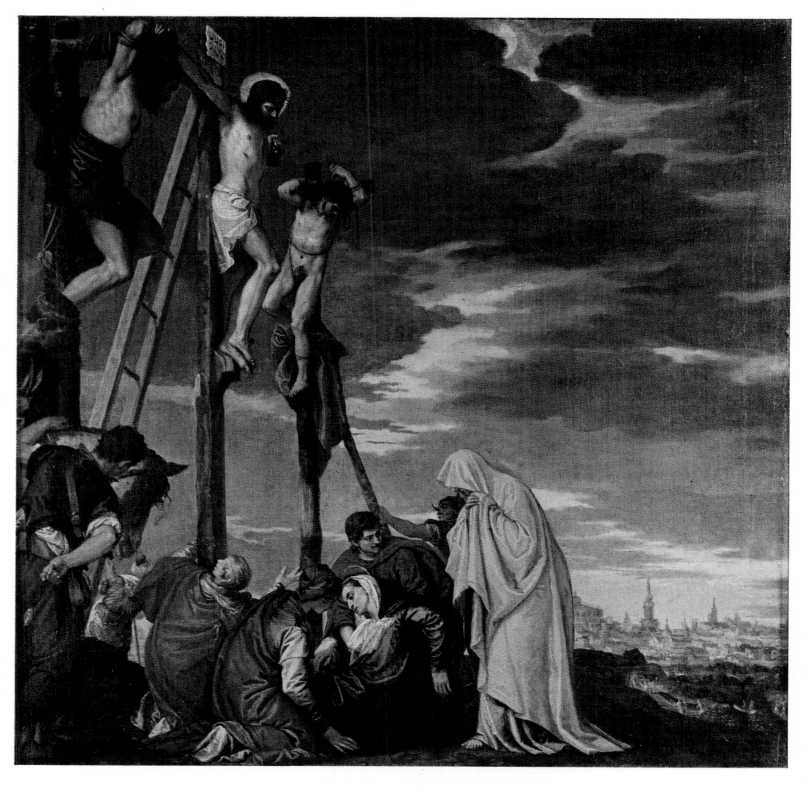

21. VERONESE [*1528-1588*] *Calvary* · Venetian School

Painted about 1570 · Oil on canvas, 40⅛″ x 40⅛″ · Commentary on page 159

22. DELL' ABBATE [1509?-1571] *The Rape of Proserpine* · Italian School · 16th Century · Oil on canvas, 77⅛″ x 85⅜″ · Commentary on page 159

23. TINTORETTO [1518-1594] *Paradise* · Venetian School · Painted 1588-1589 · Oil on canvas, 56¼" x 142½" · Commentary on page 159

24. ANNIBALE CARRACCI [1560-1609] *Fishing* · Bolognese School · Painted about 1595 · Oil on canvas, 53½″ x 99⅝″ · Commentary on page 160

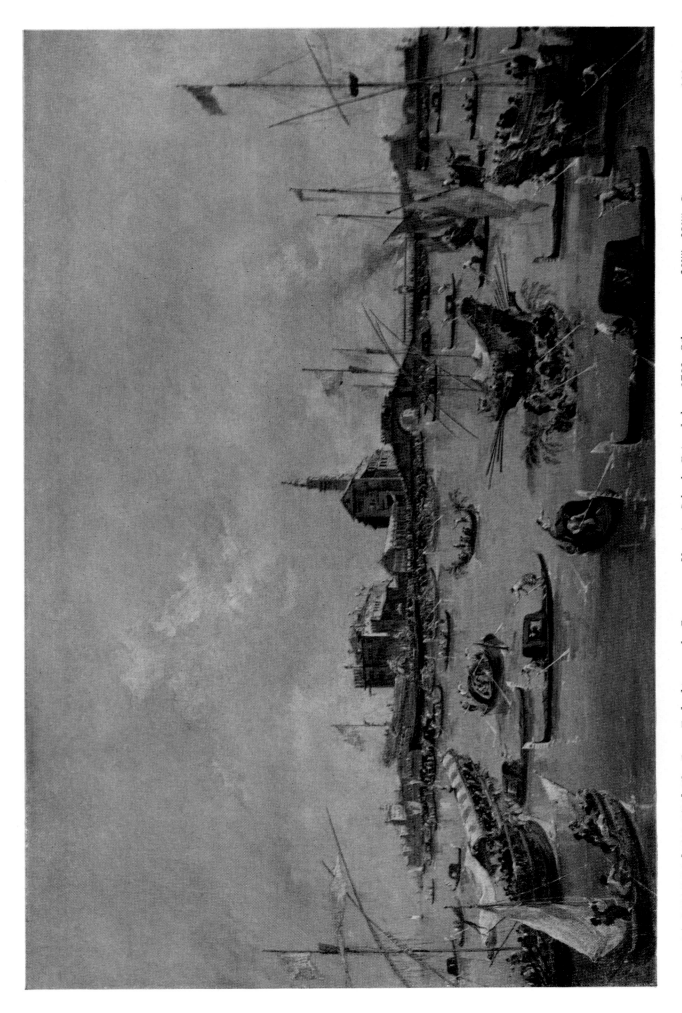

25. GUARDI [1712-1793] *The Doge Embarking on the Bucentaur* · Venetian School · Painted about 1763 · Oil on canvas, 26⅞" x 39⅞" · Commentary on page 160

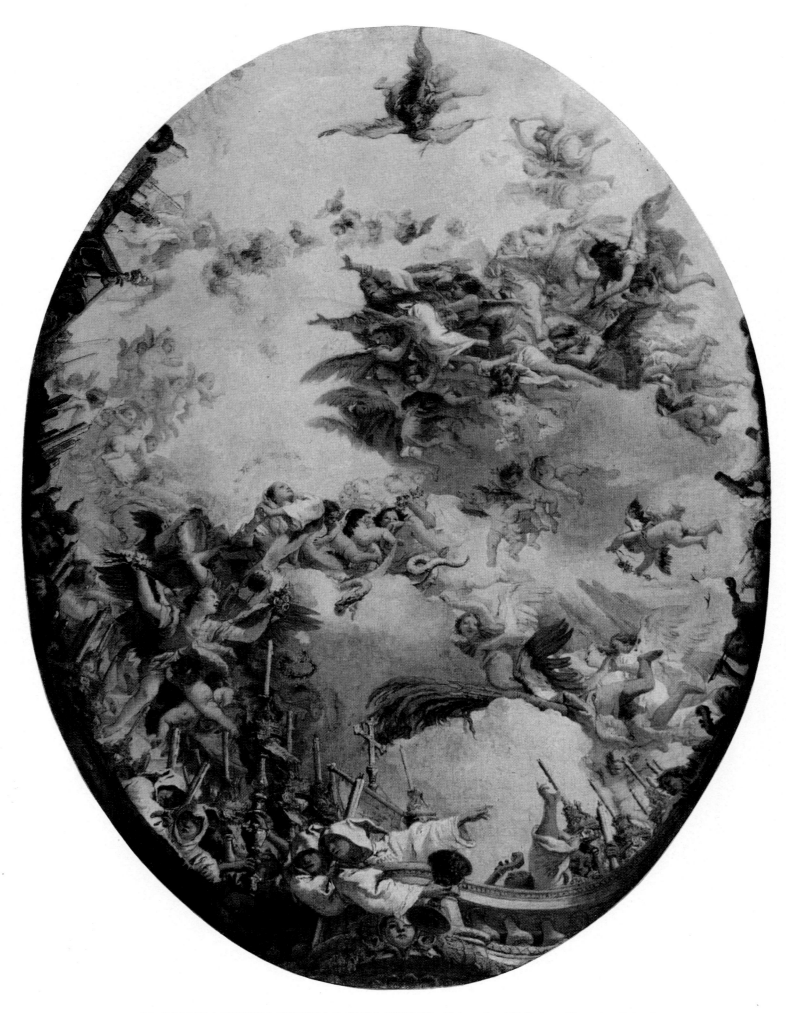

26. GIAMBATTISTA TIEPOLO [*1696-1770*] *The Triumph of Religion* · Venetian School
Painted second half 18th Century · Oil on canvas, 67¾" x 59" · Commentary on page 160

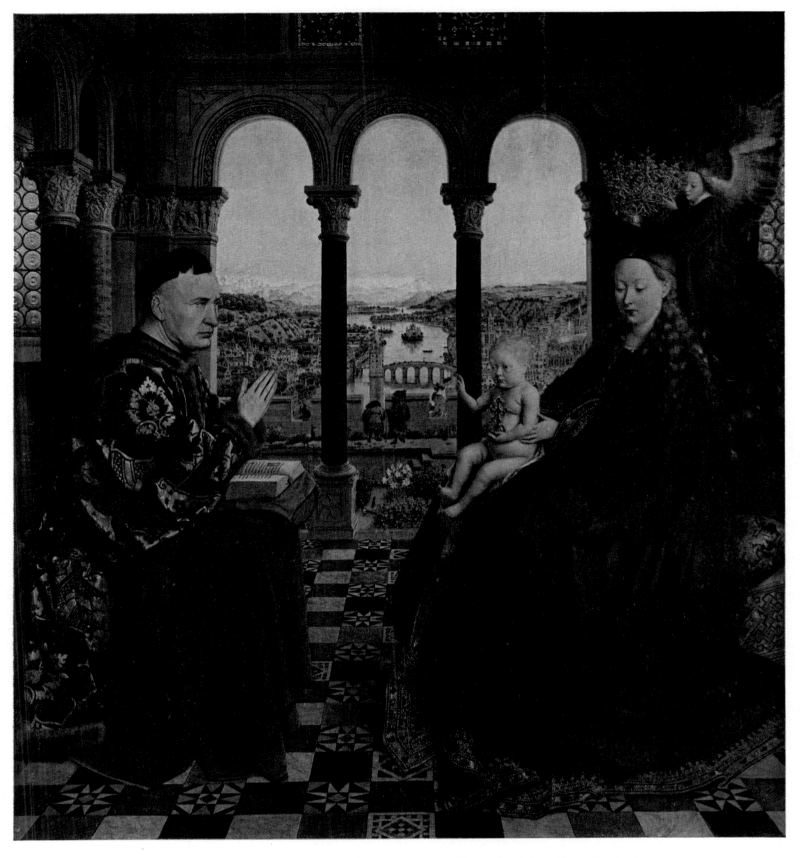

27. JAN VAN EYCK [1390?-1441] *The Virgin and Chancellor Rolin* · Flemish School
Painted about 1433 · Tempera and oil on panel, 26″ x 24⅜″ · Commentary on page 160

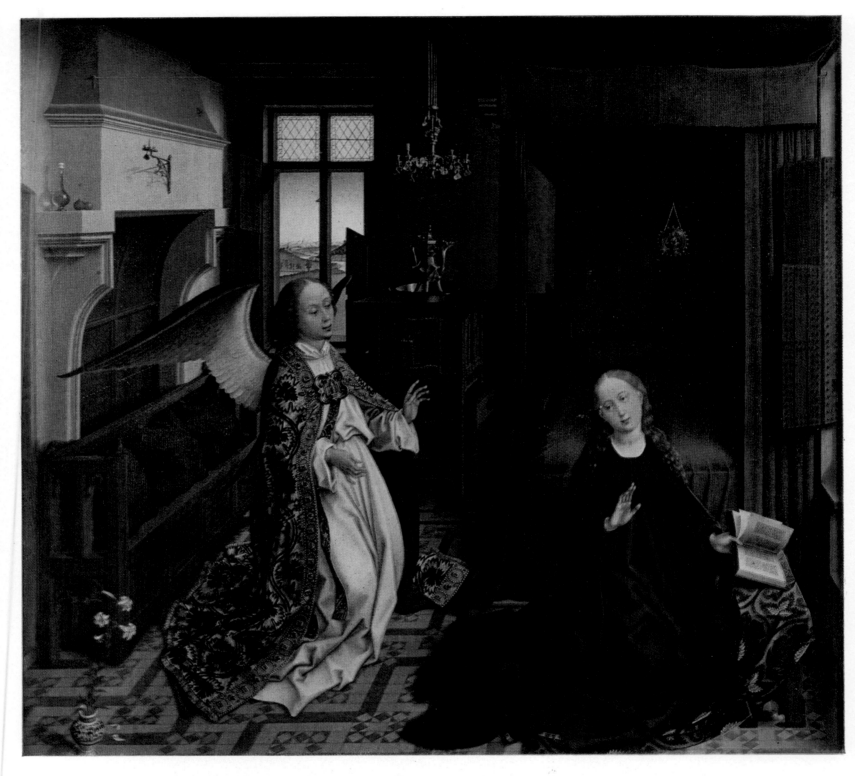

28. ROGIER VAN DER WEYDEN [*1399?-1464*] *The Annunciation* · Flemish School
Painted 1432-1435 · Tempera and oil on panel, 33⅞" x 36¼" · Commentary on page 161

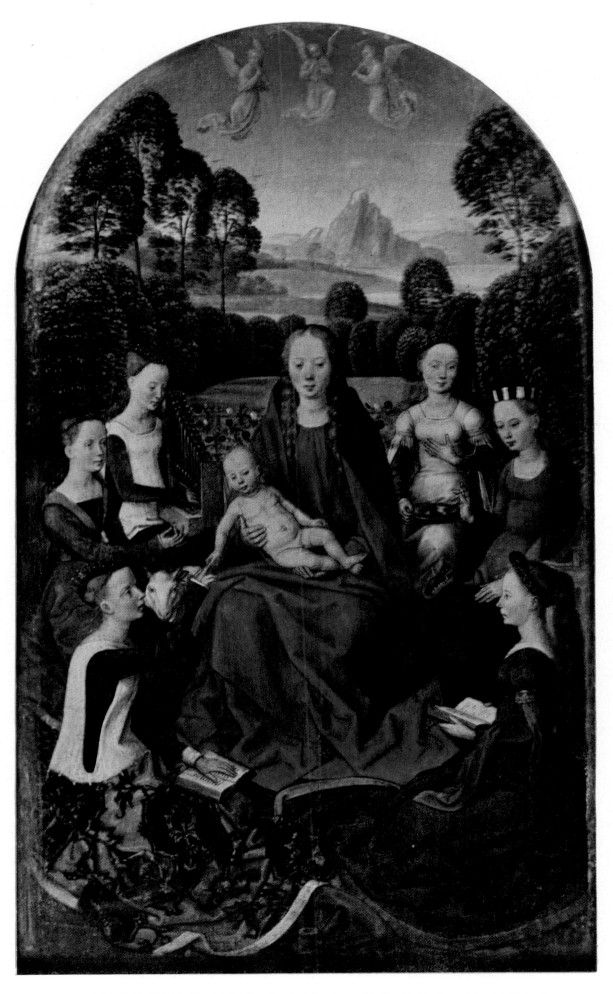

29. MEMLING [1433?-1494] *The Mystic Marriage of Saint Catharine* · Flemish School
Painted about 1475 · Tempera and oil on panel, 10⅝″ x 5⅞″ · Commentary on page 161

30. GERARD DAVID [1450?-1523] *The Wedding at Cana* · Flemish School · Painted 1503-1505 · Tempera and oil on panel, 37⅞″ x 50⅞″ · Commentary on page 161

31. BRUEGEL [1525-1569] *The Beggars* · Flemish School · Painted 1568 · Oil on wood, 7⅛″ x 8¼″ · Commentary on page 161

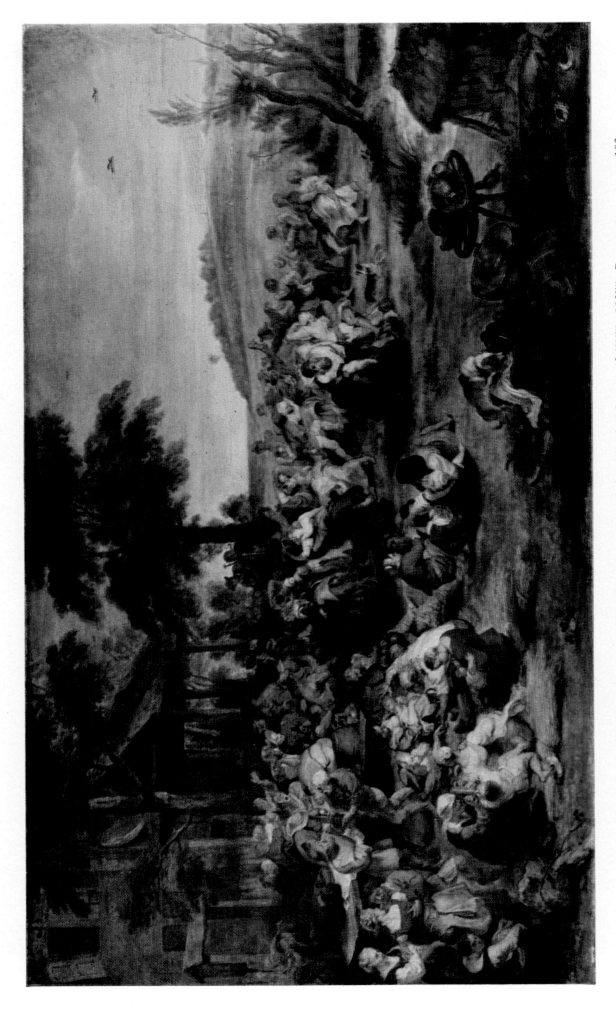

32. RUBENS [1577-1640] *Country Fair* · Flemish School · Painted about 1635 · Oil on panel, 58⅝" x 102¾" · Commentary on page 162

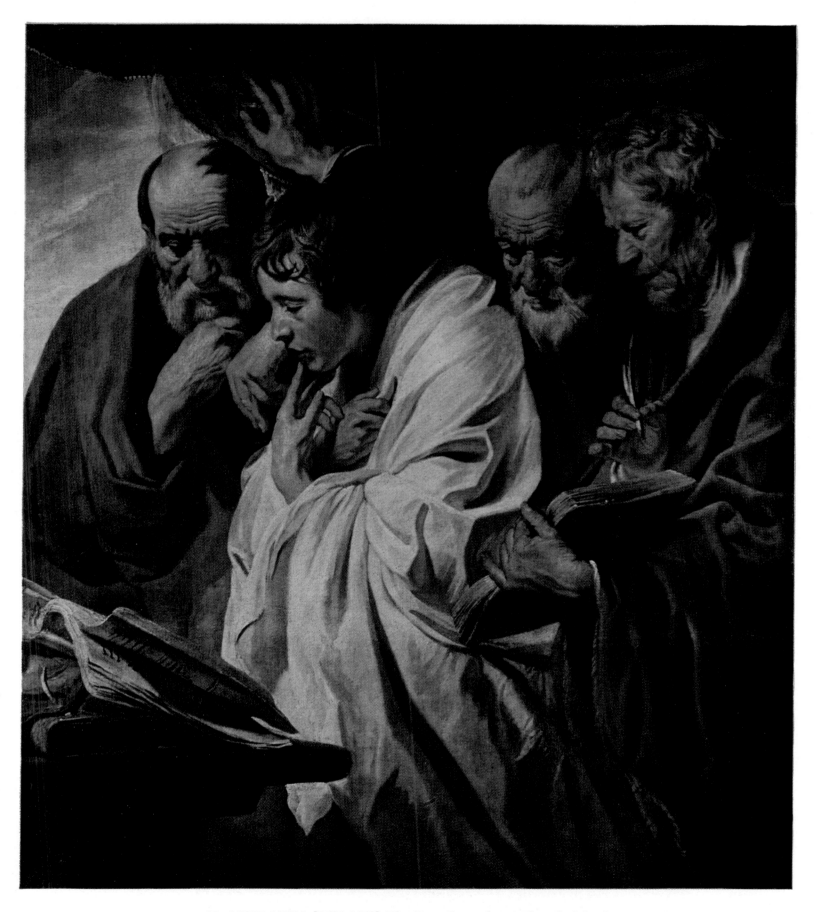

33. JORDAENS [*1593-1678*] *The Four Evangelists* · Flemish School
Painted about 1620 · Oil on canvas, 52¾″ x 46½″ · Commentary on page 162

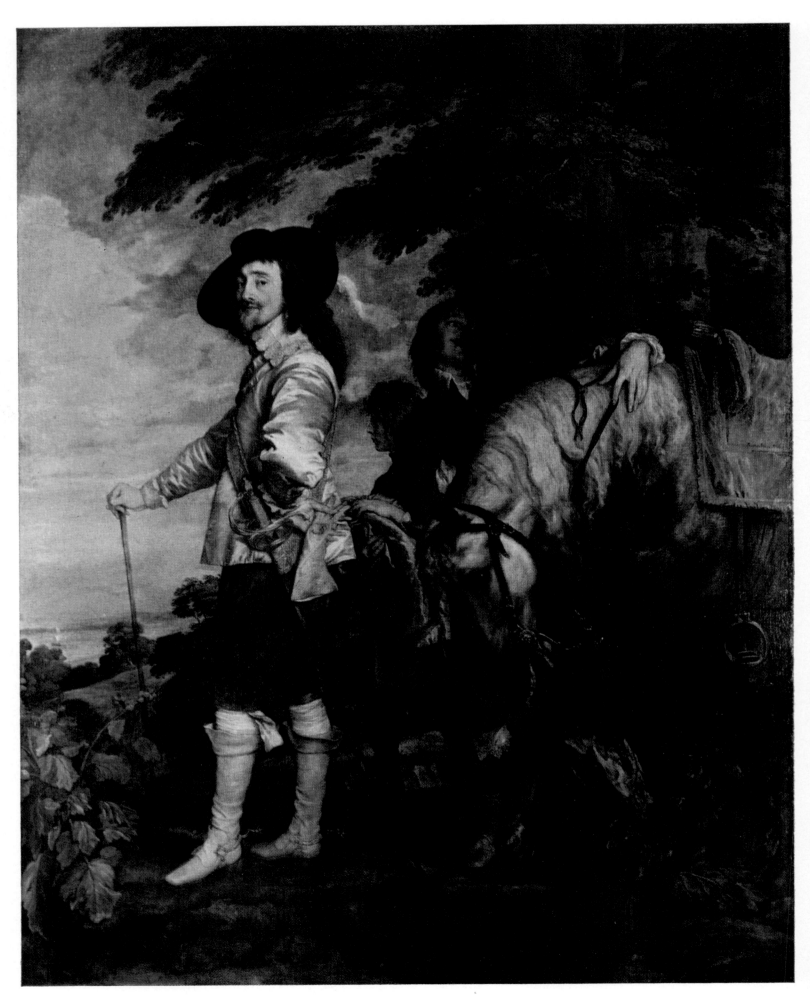

34. VAN DYCK [*1599-1641*] *Portrait of Charles I of England* · Flemish School

Painted about 1635 · Oil on canvas, 107⅛″ x 83½″ · Commentary on page 162

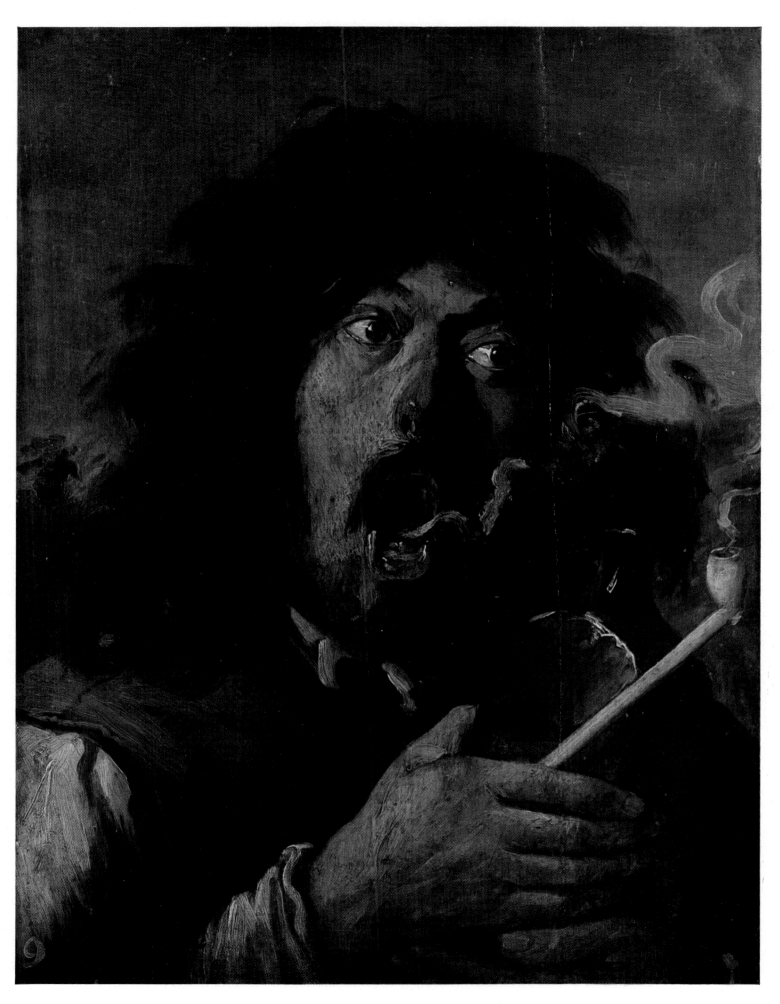

35. BROUWER [*1605?-1638?*] *The Smoker* · Flemish School

Painted about 1628 · Oil on panel, 16⅛″ x 12⅜″ · Commentary on page 162

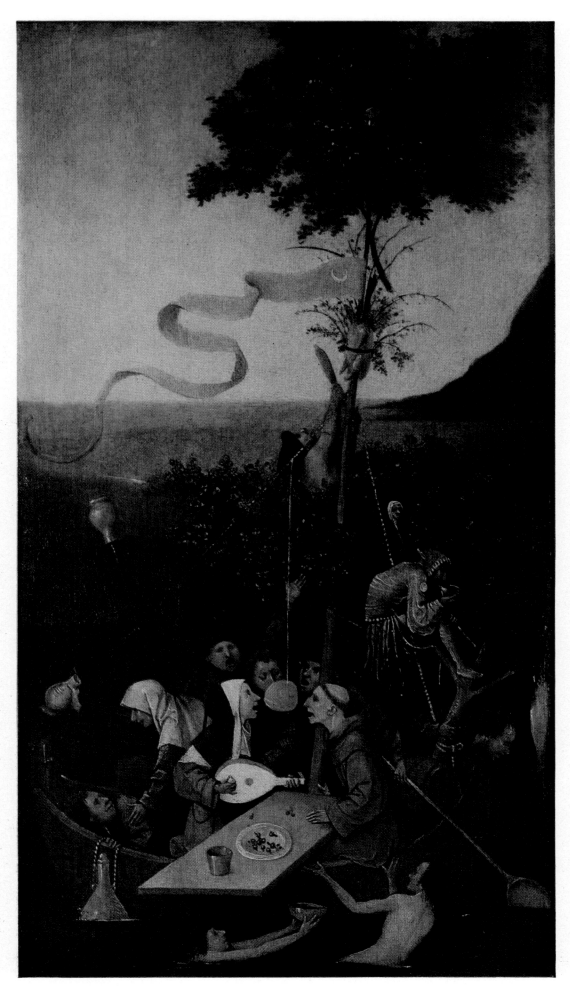

36. HIERONYMUS BOSCH [*1450?-1516?*] *The Ship of Fools* · Dutch School
Painted about 1500 · Tempera and oil on panel, 22″ x 12⅝″ · Commentary on page 163

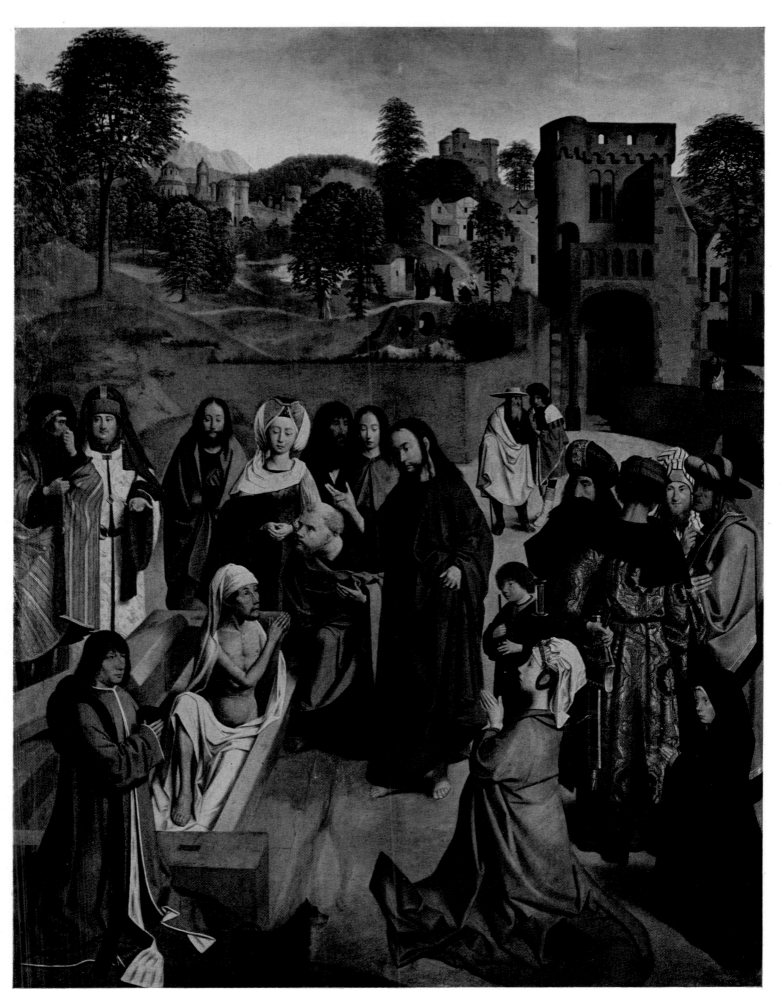

87. GEERTGEN TOT SINT JANS [*1465?-1493*] *The Resurrection of Lazarus* · Dutch School

Painted last quarter 15th Century · Tempera and oil on panel, 50″ x 38⅛″ · Commentary on page 163

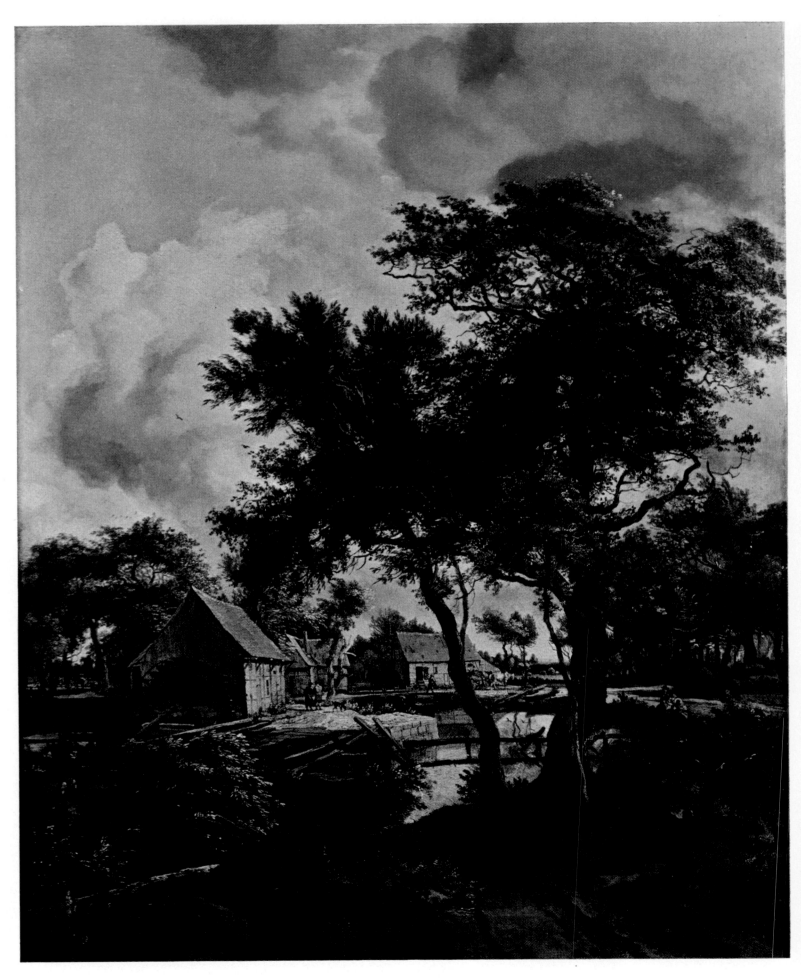

38. HOBBEMA [*1638-1709*] *The Watermill* · Dutch School

Painted 1664 · Oil on canvas, 31½″ x 25⅜″ · Commentary on page 163

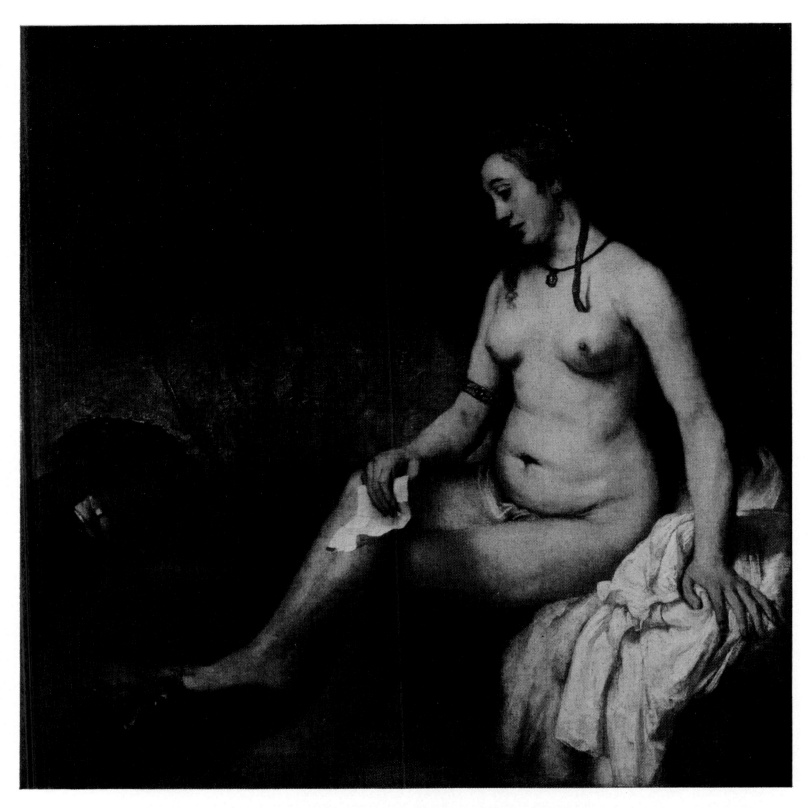

39. REMBRANDT [*1606-1669*] *Bathsheba* · Dutch School
Painted 1654 · Oil on canvas, 55⅝″ x 55⅝″ · Commentary on page 163

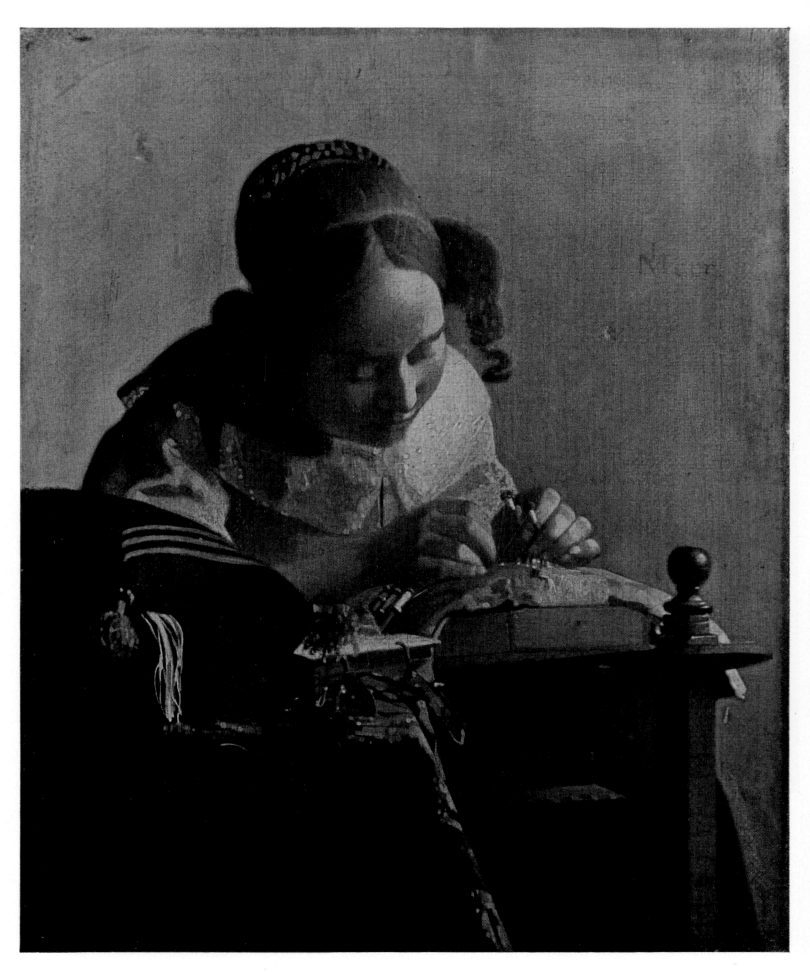

40. VERMEER [*1632-1675*] *The Lacemaker* · Dutch School

Painted about 1665 · Oil on canvas, 9½″ x 8¼″ · Commentary on page 164

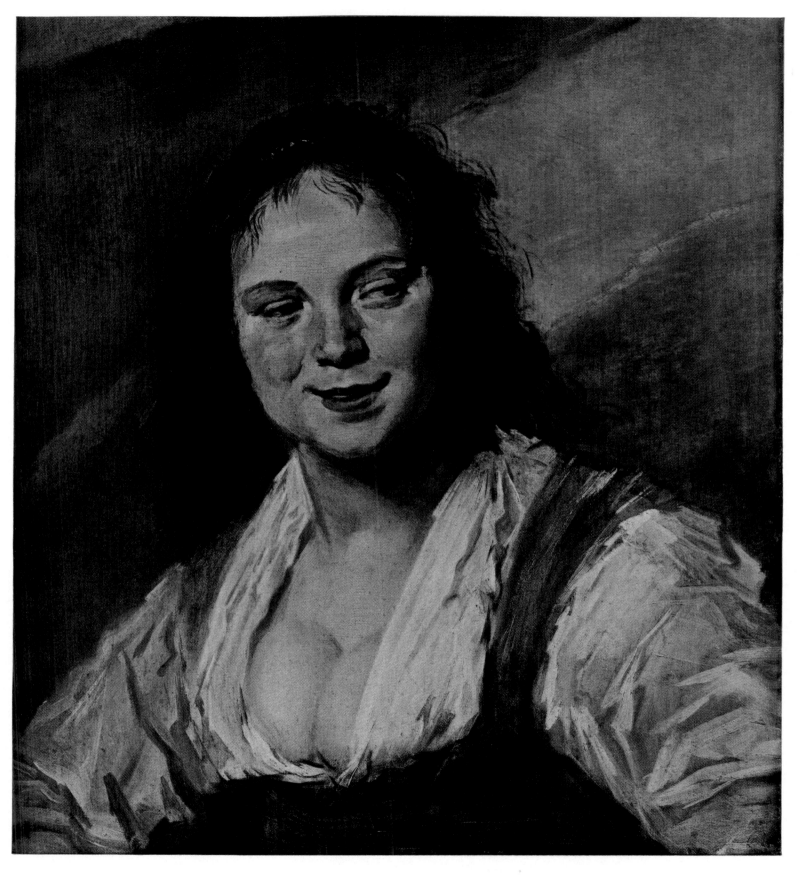

41. HALS [*1580?-1666*] *La Bohémienne* · Dutch School

Painted about 1625 · Oil on panel, 22⅞″ x 20½″ · Commentary on page 164

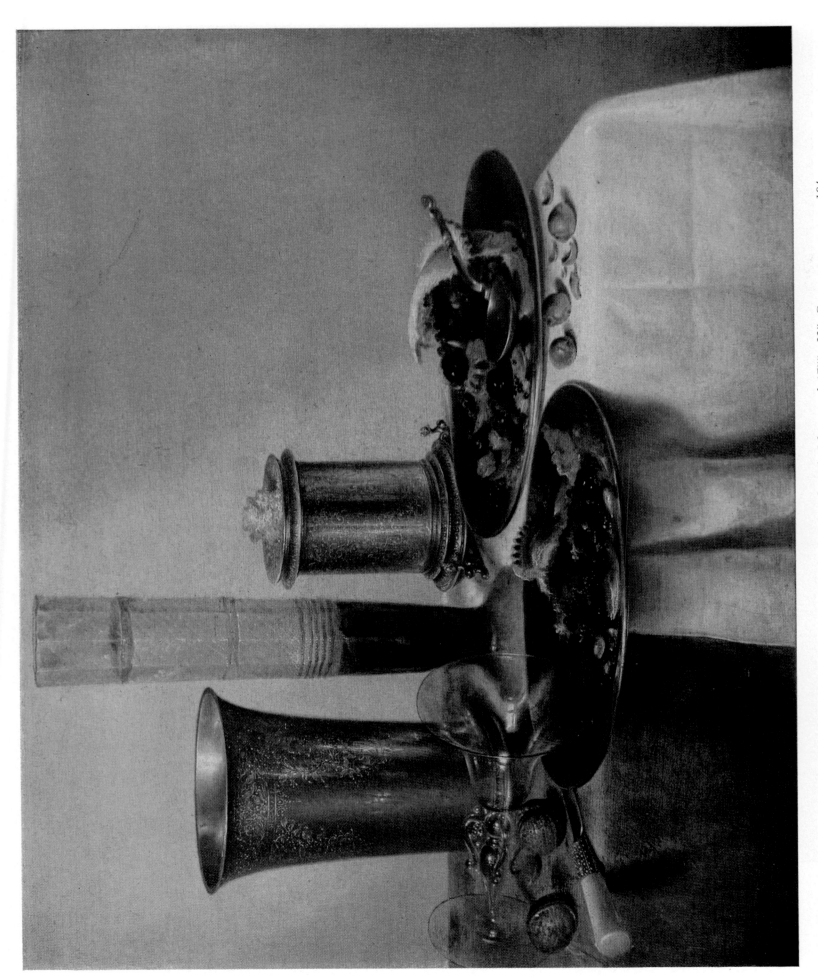

42. HEDA [1593?-1682?] *Still Life* · Dutch School · Painted 1637 · Oil on panel, 17⅞″ x 22″ · Commentary on page 164

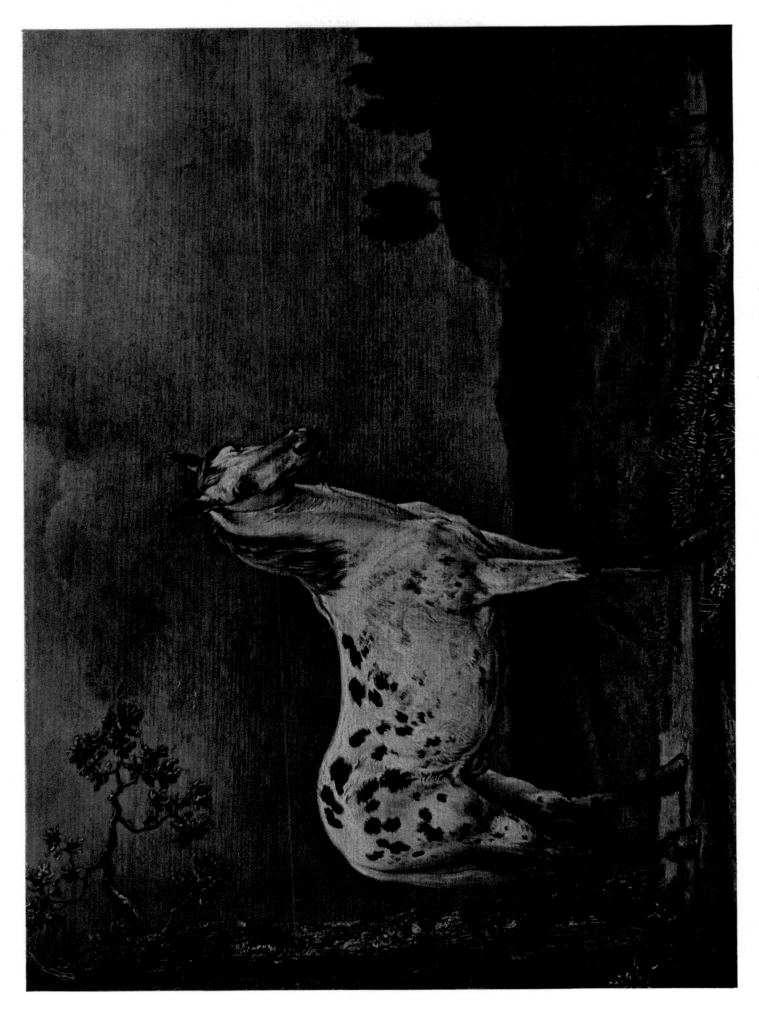

43. POTTER *[1625-1654] The White Horse* · Dutch School · Painted 1653 · Oil on panel, 11¾" x 16½" · Commentary on page 164

44. RUISDAEL [1628?-1682] *The Burst of Sunlight* · Dutch School · Painted 1670-1675 · Oil on canvas, 32⅞″ x 38⅝″ · Commentary on page 165

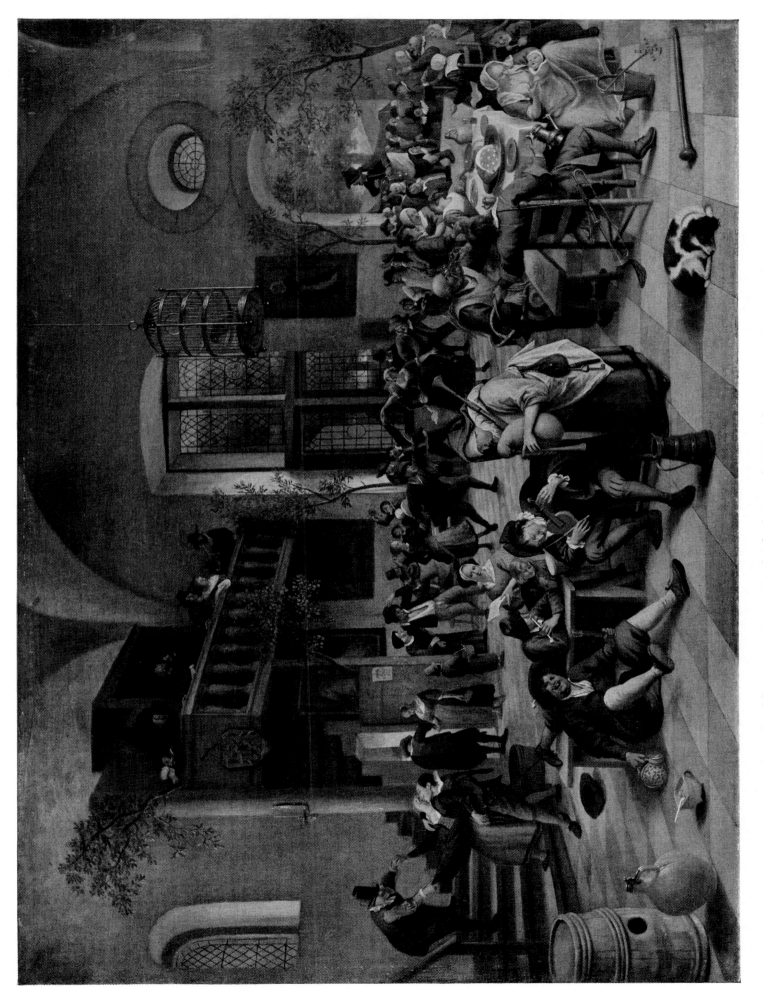

45. STEEN [1626?-1679] *Celebration in a Tavern* · Dutch School · Painted 1674 · Oil on canvas, 46½″ x 63⅜″ · Commentary on page 165

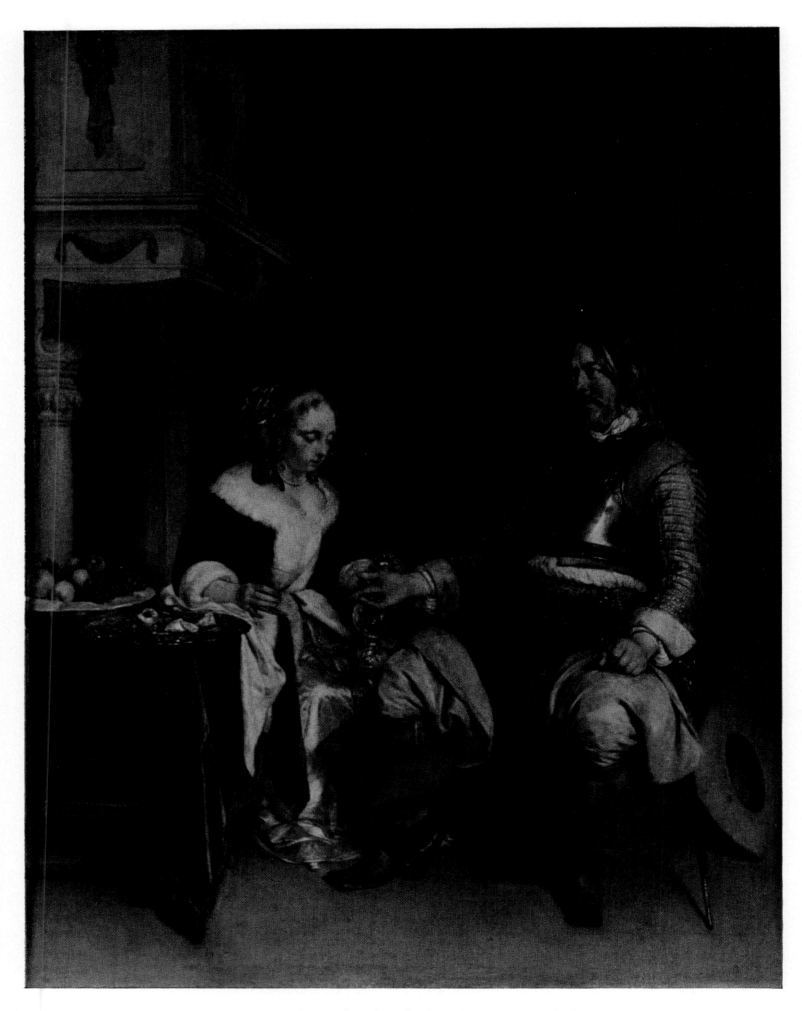

46. TER BORCH [*1617-1681*] *The Gallant* · Dutch School
Painted about 1650 · Oil on canvas, 26⅝″ x 21⅝″ · Commentary on page 165

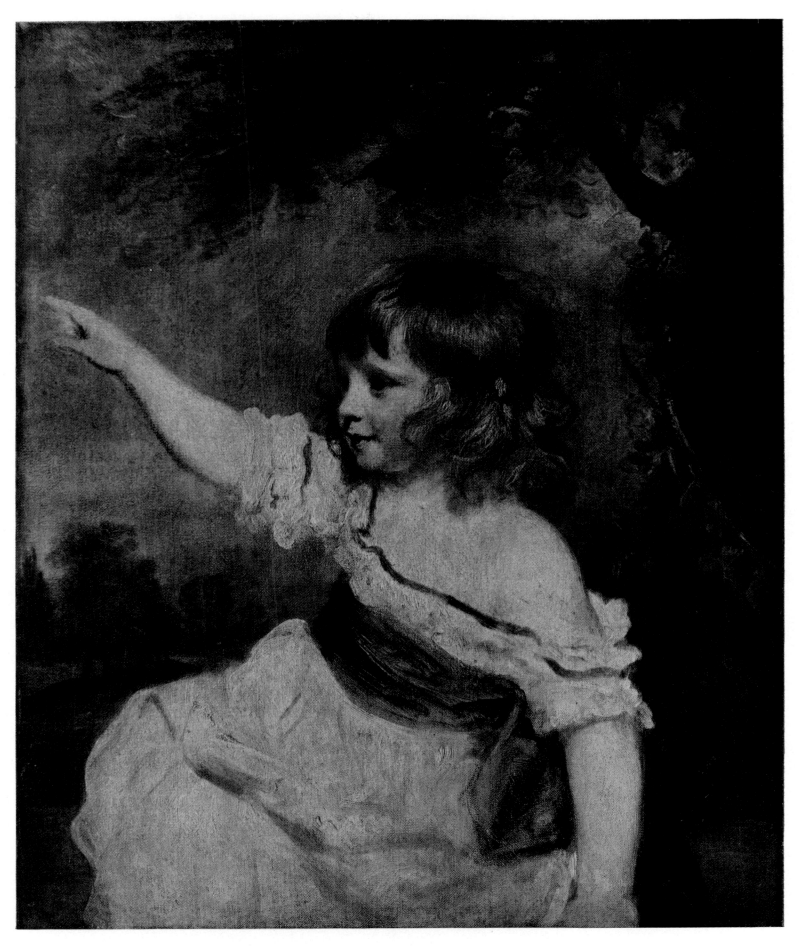

47. REYNOLDS [*1723-1792*] *Master Hare* · English School
Painted 1788-1789 · Oil on canvas, 29⅞″ x 24⅜″ · Commentary on page 165

48. CONSTABLE [1776-1837] *Helmingham Park* · English School · Painted 1800 · Oil on canvas, 40½″ x 50¾″ · Commentary on page 166

49. BONINGTON [1802-1828] *View at Versailles* · English School · Painted about 1820 · Oil on canvas, 28½″ x 32½″ · Commentary on page 166

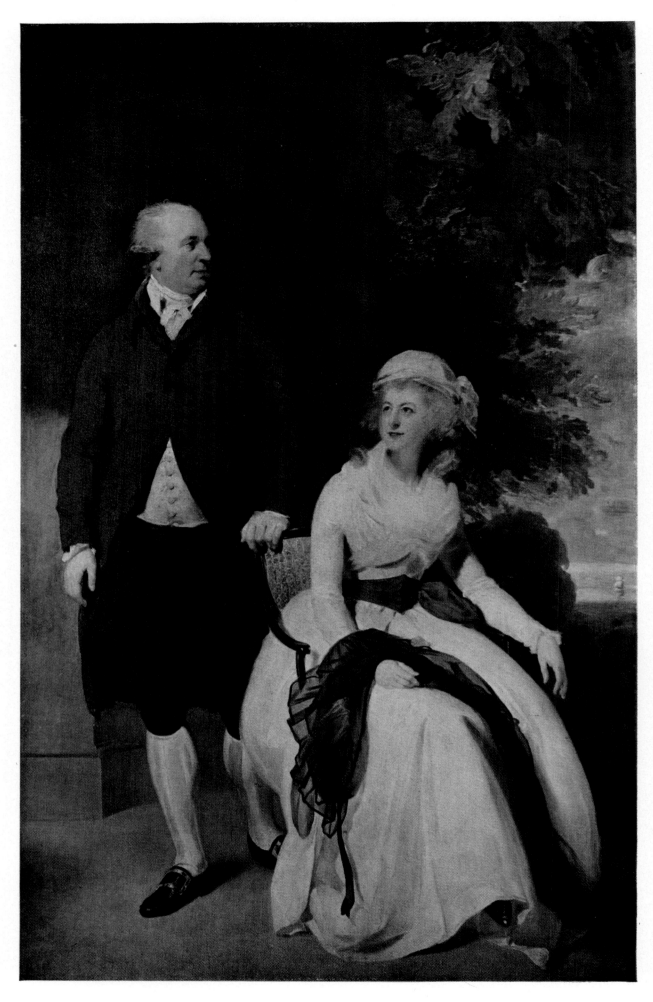

50. LAWRENCE [*1769-1830*] *Julius Angerstein and His Wife* · English School

Painted 1792 · Oil on canvas, 100″ x 62½″ · Commentary on page 166

(Continued from Page 24)

was to find the inspiration to paint the *Wedding at Cana*—the largest canvas in the world—teeming with crowds, riches, and colors. In his *Calvary* (plate 21) he was also to show himself capable of revealing unexpected depths in which color is no longer a mere visual pleasure but a cry which pierces to the heart.

In Tintoretto we find repeated the same phenomenon that we observed in Michelangelo: the transition from humanistic classicism to baroque individualism. More somber, more tragic than Titian, and shaken by unknown inward struggles, Tintoretto was no more capable than Michelangelo of accepting an immobile perfection. He ventured out upon the life of action and all its unchained forces.

Venice was the culmination of the Renaissance, but already she was passing beyond it and creating the art of modern times. From the Venetian school, as personified by Titian, were to spring such men as Velasquez and Rubens, and indeed the future masters up to Delacroix. By using colors to stir the spectator's senses and immerse him in daydreams, gaiety, nostalgia, or desire, Titian presented this art with fateful new potentialities. The painter was to seek less and less to reflect the laws of harmony and balance implicit in the human mind and more and more to communicate to others all that lay deepest in his heart and was unique to himself. He was to use his paintings to disclose the private nature of his soul.

Italian painting had reached its heights. By the end of the sixteenth century its decline, although gradual, was already apparent. Men like Carracci and Guido Reni, among others, seemed to think that there was nothing more to do than to make an eclectic assembly of the qualities revealed by the masters who had preceded them. It would be unjust, however, to deny the eminent gifts by which several of them were redeemed: the sustained and wholesome realism of Annibale Carracci (plate 24); the purity of Domenichino; or that feeling for pathos, both of drama and of color, which, as displayed by Guercino, heralded the coming of Romanticism.

In Rome, and afterwards in Naples, one man refused merely to repeat what had been said before him. This was Caravaggio. Italian painting had successfully sought to present an image of the world which would conform both to truth and to the ideal of beauty which the mind would

A ewer from the treasures of the royal monastery of Saint-Denis, donated by its great abbot Suger (died in 1152). The main body, of a beautifully mottled dark sardonyx, is an ancient classic work; the mount, of gilt silver and gems, with slender elegant forms, is of the twelfth century. 14″ high.

like to extract from it. Caravaggio perceived that this effort would succumb to academicism, would gradually degenerate into mechanical formulas and mechanical methods. He decided to grapple with reality in order to make it reveal whatever it could of material and brutal fact, of concrete weight. For ideal light he substituted violent gleams which, with unexpected shadows and patches of brightness, cut sharply across the expected appearance of forms. He enlisted in his service all the truculence and vulgarity which nature had to offer—models from the gutter, men with knotted, muscular limbs and tanned, wrinkled skins — in order to save nature from insipidness, to arouse surprise and stir a painter's vision to life. From this art was to come a revolution in all of European painting: the revolution of naturalism.

Renaissance painting had come to an end, yet at the close of the seventeenth and during the

73

This Romanesque relief of the second quarter of the twelfth century, from Nevers in Burgundy, representing the struggle of Saint Michael and the dragon, is remarkable for intense activity and dramatic oppositions of the lines and the rich play of the varied surfaces of the stone carving. 33½″ high.

eighteenth centuries, Italian art continued to exert an important influence on the rest of Europe. At the council of Trent (1545-1563) the Church had redefined its attitude toward art, again enlisting painting in the service of religion. By means of religious subjects treated with vivid pathos, painting was to stir in the spectator emotions corresponding to the ecstasy of the saints and the agony of the martyrs. The result was that in an evolution parallel to that of Jesuit architecture, painting was to let loose the whirlwind of the Baroque — the style of which Michelangelo and Tintoretto had sown the seeds.

Venice, however, always enamored of its independence, gave this new art its only expression of value, for only Venice had learned how to play with the colors of luxury and seductiveness without falling into empty rhetoric. Tiepolo (plate 26), with his vertiginous ceiling decorations, whether Christian or mythological, continued the tradition of Veronese, but set his compositions awhirl in clouds of dazzling splendor. Other painters concentrated more exclusively upon the daily life of Venice, of which they were the enchanted observers. Guardi (plate 25), sparkling and poetic, and Canaletto, precise and cold, recorded the

play of light upon the city's crowds and buildings with a sharpness and subtlety which already presaged the art of Impressionism.

FLEMISH PAINTING

FLANDERS CONCERNED ITSELF LITTLE WITH THE abstractions which obsessed Italian Renaissance art. It was above all a bourgeois society, a country of powerful merchants who delighted in their prosperity. Philosophy and abstract principles were looked upon as encumbrances; reality was the greatest challenge, and this western program of conquering it had a special appeal in the practical Flemish culture.

For the French or Italian painter, to master reality meant to grasp the laws which govern its appearance; it meant also to improve upon reality by imposing on it a certain idea of perfection. The Flemish painter had little patience with theories. For him reality was what he saw, as he saw it. Whatever was tangible and had weight was real. While an Italian painter depicted his subject with highly stylized line and modeling, the Fleming, with his emphasis on commercial value, was sure that the character of an object depended less on its shape than on its substance. A cylinder of wood and a cylinder of gold, identical in volume and shape, were nevertheless profoundly different to him. For the Fleming, therefore, to capture reality on canvas or panel was essentially to depict what things were made of.

Flemish painting did not rise to its true height of perfection until it abruptly turned its back on medieval techniques. The brothers van Eyck provided the means — a new use of oils. It was the first time that they had been employed with precision and effectiveness. Oils could represent as faithfully as a mirror the texture of wool or silk, of fur or human hair, the transparency of crystal or the glint of gold. Unlike fresco or tempera, with oils color could be laid on either in thick impasto or in transparent glazes, could be molded by the brush either smoothly or in corrugations, so that it became possible to imitate the whole play of light on an object; there were no longer any limits to representation. Jan van Eyck's prodigious masterpiece, the *Virgin and Chancellor Rolin* (plate 27), shows that the grain of the human skin can be as adroitly imitated as the gleam of tiles or the rich vistas of space. There is exact rendering of atmosphere and a microscopic atten-

tion to detail. Van Eyck combines a mastery of composition with a psychological penetration to give his dazzling realism a power which belongs to both art and poetry.

This achievement is the culmination of the medieval miniature, just as the Italian primitive was the culmination of the Byzantine icon. The spiritual tension and depth of religious feeling of the Gothic cathedral is still present in van Eyck's works and is perhaps even more evident in the paintings of his greatest successor, Rogier van der Weyden (plate 28).

Hans Memling turned this tension into something more tender, something closer to the mysticism of the Rhineland, where he was born. In his *Mystic Marriage of Saint Catharine* (plate 29) angels hover overhead while against the background of a hedge of roses Catharine and other saints surround the Virgin and Child.

During the fifteenth century commercial exchanges, so highly developed at this time, could not fail to encourage artistic exchanges also; and the art of the North made inevitable contact with the art of Italy. Confronted by the elegance and ease of Italian art, the Flemish painters began to regard their own highest virtues — their perfect probity and simplicity — as mere awkwardness and provincialism. Too many artists applied themselves servilely to what could only be an imitation of the Italian Renaissance. Its deep spirituality escaped them, and they could only grasp its most superficial mannerisms.

Some men, however, remained true to the Flemish tradition. Gerard David's *Wedding at Cana* (plate 30), for example, retains the placid sweetness of the primitives and betrays no sign of the luxury and fashion of Italy. Because of this he was regarded as an anachronism, and with him passed the last of the great painters of Bruges. In the rising school of Antwerp, which was fully open to Italian influence, men like Quentin Matsys also continued the Flemish tradition. His *Moneylender and His Wife* (frontispiece) preserves the realistic magic of the primitives, but is aloof from the religious fervor which was their glory.

Despite these men, Flemish art seemed in danger of surrendering itself completely to the Italian example. The genius of Pieter Bruegel saved the situation and justified the Flemish sixteenth century. He felt that the realistic perfection of the fifteenth-century primitives could be

pushed one step further. To him painting had become static, forever fixed in its appearance; reality, on the other hand, was continually shifting and changing. Just as the Italians had created the illusion of depth, Bruegel, discovering a dimension of reality which had escaped his predecessors, created the illusion of movement and life.

Instead of posing his subject, Bruegel concentrated on its mobility. He sought to capture it in its busy and varied action, in the instantaneousness with which one attitude gives way to another. In his *Beggars* (plate 31), the wretched cripples move; each figure is in a different phase of the same movement.

Thus at the very beginning of the seventeenth century Flemish painting had returned to its true vocation. It was to develop in unforseen ways under the hand of Rubens, a universal genius. While expressing the Flemish genius in all its truth, he also integrated it with the lessons of classical Italy; he achieved a mighty synthesis of these two great and different traditions.

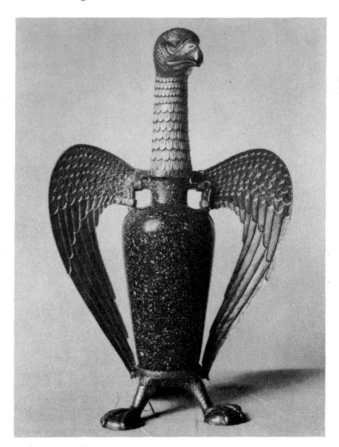

The dark purple body is an Egyptian porphyry vase; the head, wings, tail, and feet in contrasting silver-gilt are of the twelfth century, an example of the superb craftsmanship of the metal workers of Romanesque France. This powerful fantastic eagle was a gift of the abbot Suger to the monastery of Saint-Denis. 17″ high.

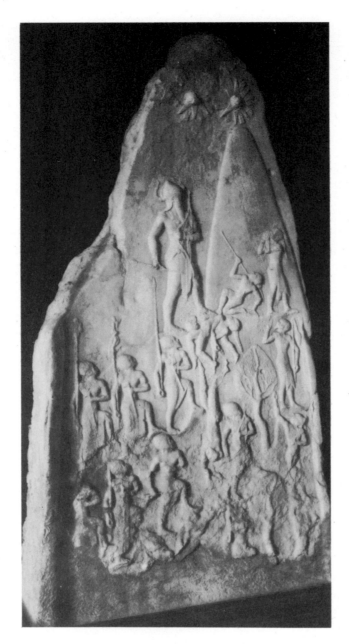

Stele of Naram-sin, king of Agade, Chaldea, about
2700 B.C. Red sandstone, 79″ high, 41½″ wide. The
stele was set up to commemorate a victory of the king.
It is interesting as an early example of representation
of landscape in sculpture.

To begin with, Rubens carried the recording
of life to the point of lyricism. His work, like a
huge torrent, carries along with it life in all its
forms: the flesh of women or children, fruit, fields
undulating to the horizon, clouds, rainbows. He
displayed the forces of life in the joyful dance of
his *Country Fair* (plate 32), in hunts and battles,
in the amplitude of magnificent episodes from
pagan myth or the Christian religion.

Rubens had been in Italy. In Venice he had
learned a freedom of execution in which the brush
seems to sweep across the canvas with all the
colors of the palette. He replaced the cunningly
spread and blended tones of classical Italian
painting with a visible movement of the hand
employing all the various ways of applying paint:
a fluid, rapt, nervous, or swirling movement which
makes the colors splash and surge and come alive.

Rubens completely satisfied the ambition of
Flemish painting to master not only the outward
aspects of reality but also its animating force. He
had too much greatness of spirit not to realize
what he lacked, and this was precisely what Italy
had achieved: style. He could set down his great
lines, balance his masses, and control the elements
of his picture; but even so, in his fidelity to the
Flemish genius, he could not lay out his forms in
cunning symmetries, as the Italians could. He
gave his pictures unity by asserting the command
of his mind over the creative urge. He is the ful-
fillment not only of the aspirations of Flanders,
but also of the program of the Counter Reforma-
tion, which in Italy had culminated only in a hol-
low over-emphasis. In his work it became a tri-
umphal song of life.

The personality of Rubens crowned the rise of
Flemish art; but like every success that is too
complete, it also exhausted it. He was followed by
men who were little more than imitators. Jordaens,
nevertheless, cut out a place for himself at the
side of Rubens. Heavier, more down-to-earth, in-
fluenced at first by Caravaggio and later carried
away by the example of Rubens, Jordaens is, in a
way, the plebeian offspring of Rubens' princely
fecundity. But what rude and generous sap rises in
his *Four Evangelists* (plate 33), whose solid truth-
fulness gives them a solemn devotion and com-
posure!

As for van Dyck, Rubens' prodigious pupil, his
subtler nature as well as his long stay at the Eng-
lish court gave him an aristocratic quality that
gains in dreamy delicacy what it loses in power.
His portraits — his *Charles I* (plate 34), for ex-
ample — concentrate less on physical exactitude
than on the expression of the inner life. Rubens
had belonged to the age of humanism, when the
artist seemed to be the spokesman and herald of
the beliefs of his time; van Dyck, by immersing
himself in inner solitude, in the suggestion of the
incommunicable at the bottom of every man's
soul, marked the transition to a new age. Art was
to lose its collective character and to become the

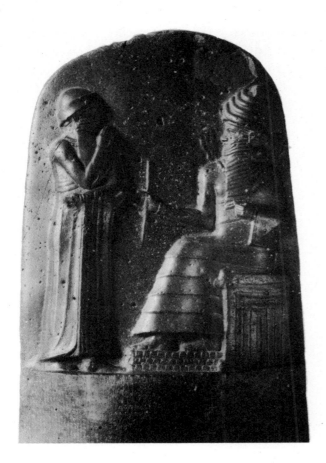

The Code of Hammurabi (detail, upper part). Basalt relief, about 2100 B.C., 88½" high. The Babylonian king is shown standing in prayer before the enthroned sun god, Shamash. Below is inscribed the oldest known code of laws.

instrument of communicating the private secrets of the soul.

Other painters uneasily forced themselves to imitate Rubens' epic example. Wiser ones, more aware of their own stature, were content to remain, in the line of Bruegel, observers of local life, with its drinkers and rustic smoking-dens. All of them, however, benefited by the freedom of pictorial technique that Rubens had revealed. Teniers, with some monotony but also with an amused delicacy of touch and vision, an attention to the subleties of light, posed his peasants as shriveled gnomes; these were the peasants whom Louis XIV banned from his sight, disdainfully describing them as "Barbary apes." Painting with the rapt and audacious spirit which bursts forth in his *Smoker* (plate 35), Adrian Brouwer gave to similar subjects a decisive crispness of execution which often turns his tiny panels into impressive paintings. But does Brouwer belong to the Flemish or to the Dutch school? He was a successor to Bruegel, but he was also Frans Hals's pupil in

Haarlem. This duality is a reminder that the two schools, despite their deep divergencies, derive from a common stock.

DUTCH PAINTING

ORIGINALLY THE FLEMISH AND THE DUTCH schools were indistinguishable. They were two aspects of the art of the Low Countries. It was not until the beginning of the seventeenth century that religious and political conflicts brought about the split into two distinct regions. The northern Low Countries became Protestant Holland; the southern Low Countries, remaining under the authority of Catholic Spain, formed what was later to become Belgium.

Until 1572, however, when the struggle for independence began, the art of the Low Countries in the North could at best only reflect the particular spiritual characteristics of a region which was distant from the great artistic centers of Europe. The *Resurrection of Lazarus* (plate 37), painted by Geertgen tot Sint Jans in the second half of the fifteenth century, gives us the feeling that the painter was isolated, little in touch with the refinements of the urban centers. His figures are somewhat lumpish and clumsily built. But in solitude and isolation, undistracted by worldliness, man is closer to nature; and in Geertgen's work there is a direct feeling for the countryside, a feeling that presages the major concerns of Dutch art.

Toward the end of the fifteenth century appeared that strange genius, Hieronymus Bosch. More than a century in advance of his time he exploited the possibilities which Holland was later to expand. With a spirit of sarcasm which revels in such subjects as the temptation of Saint Anthony and the mocking of Christ, Bosch brutally called an end to the Middle Ages. There is nothing mystical about his work; his astonishing and tortured imagination expressed itself in obscure allegories which owe to religion almost nothing but its moral teachings. The sense of the divine, which was to be foreign to almost all of the Dutch painters, had already disappeared in Bosch; and the secular, practical spirit of the bourgeoisie had begun to break through. But his "morality," as in his *Ship of Fools* (plate 36), means much more. Perhaps, as a point of departure, he takes some maxim or proverb with the intention of illustrating it; but very quickly he transcends his theme

77

and thrusts into it, with the same liberty the unconscious mind exploits in sleep, the most secret and inexplicable dreams. He is not content to paint familiar legends and themes of a common heritage. As he paints, Bosch holds intimate conversation with himself, and gradually he sinks into the depths of his own unconscious. For him, to paint is to liberate his own demon. Thus this amazing inventor launched out upon yet another exploration of the human personality, an exploration toward which art was more and more to turn as it approached modern times.

To this development no school of painting has contributed more than the Dutch. Their Protestantism encouraged the spirit of free inquiry and substituted for the Christian sense of the miraculous an emphasis on conscience and morality. By its practical attitude, its repudiation of myths, and its confrontation of the individual with himself, Protestantism hastened the birth of the modern world. With this force behind it, art was to be concerned, on the one hand, with strict reality and, on the other, with the personality of the artist. Of these two components the more widespread, the more universally evident, was realism.

The greatest Dutch painter at the beginning of the sixteenth century was Frans Hals. We should not forget, however, that he was born at Antwerp and so had links with the Flemish. Like Brouwer, upon whom he had a profound influence, he was obsessed by the desire to record life in all its action; and he chose a technique in which the movement and even the speed of the brush helped to make his painting sparkle and glow. Moreover, he was endowed with an almost frenetic energy; he slashed his canvas with sure, quick touches, touches which—in *La Bohémienne* (plate 41), for example—interpret a face in action and capture each intense and fugitive expression. More nervous and more prosaic than Rubens, and working on a different level, he helped, as Rubens did, to subjugate life to painting. He fathered that line of portrait painters which was to concentrate its art on the individual.

At the beginning of the seventeenth century Protestant Holland was gradually growing stronger. Its art was on the way to maturity. We feel this in Hals and also in the painters he shaped, in Brouwer, who vacillates between Flanders and Holland, and in Adrian van Ostade, another painter of the clowns and rustics of the tavern

This Egyptian figure of a woman bearing an offering is distinguished by great elegance and simplicity. It belongs to the Middle Empire, at the end of the XIth or the beginning of the XIIth dynasty, towards 2000 B.C. 41″ high. Stuccoed and painted wood.

and tobacco shops. We feel this also in the school of Utrecht, to which Gerard Honthorst introduced the popular naturalism of Caravaggio, so congenial to these men of the North as yet unacquainted with Italy.

Very soon public taste turned against these boisterous and rustic spectacles. Protestantism banned them as immoral, while the bourgeoisie, striving to raise itself to a more aristocratic level, preferred not to be reminded of its plebeian origins. As a result painting returned to a greater gravity and restraint and also acquired a greater degree of worldly pretentiousness. Almost alone Jan Steen persisted in presenting, with an irony which was less noisy but more incisive, the old themes of easy debauch, as in the *Celebration in a Tavern* (plate 45). The generation that followed Hals

was more wary of frequenting guardrooms and the company of young women of easy virtue. In their work the houses of ill-fame took on an air of respectability; and so did their brushwork, which became more studied and scrupulous.

By the middle of the century the bourgeoisie was left in full possession of the field. Painters occasionally pictured a young officer offering a glass of wine to a young lady, but offering it with modesty, even with gallantry; and it would take great courage to challenge the virtue of his fair partner in Ter Borch's *The Gallant* (plate 46). To do so, we would have to take note of the act of offering money. As a rule we are introduced into comfortable, wealthy, and silent rooms into which

Stele of King Zet (about 3000 B.C.), called the Serpent-King, after the serpent that served as the hieroglyph of his name. This beautifully precise sculpture, found in the king's tomb at Abydos, was a symbol of royalty. The falcon was the bird of the god Horus, who was the incarnation of Egyptian kingship; the two doors of the palace symbolized an earlier stage of the kingdom when Egypt was divided between the Pharaohs of the North and the South. 57" high, limestone.

the light discreetly enters in order to lend brilliance to the newly waxed tiles, the furniture, and the gleaming silks worn by elegant ladies. Here we are in good society, where an obvious effort is being made to ape the aristocracy. Often a spinet or a violoncello will suggest an atmosphere of music in these scenes in which reality, precise, refined, and in meditative composure, will rise to the heights of poetry. Such is the nature of the peaceful and mellow interiors offered for our inspection by Gerard Ter Borch, who was the real originator of these conversations and concerts, by Gabriel Metsu, and especially by the masters of Delft, Pieter de Hooch and, above all, Vermeer.

In Vermeer we encounter a true poet. Everything he touches seems to acquire a unique and unforgettable quality. He tells us nothing about himself; he is silent on that subject, yet he bestows upon the scene he paints, even if it be the simple *Lacemaker* (plate 40) at her work, an accent of purity, a pious concentration, a modesty combined with emotion, all of which suggest crystal. Everything in his paintings—from the harmony of colors dominated by fawn and blue to the technique by which he applies colors without revealing any sign of a brush stroke—conveys the same music, born of the encounter between the outer world and his heart.

It is at this point that we can confirm how closely realism and lyricism are united in the work of the great Dutch painters. In the work of their lesser colleagues we feel only a faithfulness to reality. Indeed, from Gerard Dou to Metsu and Mieris extends a line of scrupulous and pious observers who are prodigiously adroit, but whose art is no longer fired either by the emotional faith of the Flemish primitives or by the personal sensibility of a Vermeer or a Ter Borch.

In confining themselves to realism, or in adding to it their personal emotion, the Dutch were not concerned with great mythical, religious, or historical subjects. The humblest objects provided them with sufficient material. The result was that they developed the still life to an unprecedented degree; its immobility was especially well suited to that intimate meeting between the object and the painter's contemplative sensibility. The *Still Life* of Heda (plate 42), tells us of all the grave ecstasy a Dutch painter could derive in painting the transparency of a glass, the yellow curve of a lemon peel, or the rich fur of a dead hare.

79

Objects, however, speak only the language of matter; the voices of nature are innumerable and universal. Some Dutch painters turned to nature in reaction against bourgeois positivism. Landscape painting produced some of the most brilliant successes of Dutch realism; but while the peaceful Potter may have seen in nature little more than an opportunity to display his *White Horse* (plate 43), nature also offered the painter solitude in which he could develop his most private emotions. The contemplation of nature turned into daydream. While the painter lost him-

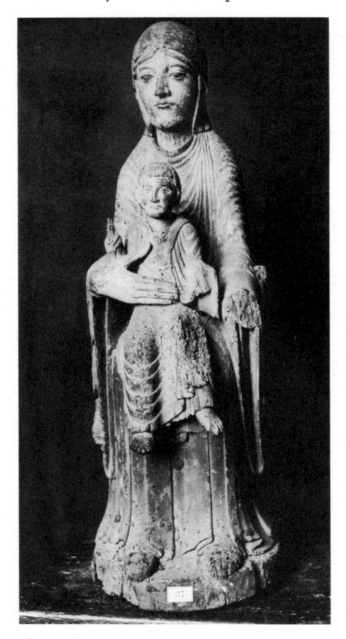

A fine example of the wooden reliquary statues of the Virgin and Child common in the twelfth century in the Auvergne. The head is movable, and in the breast is an opening designed to hold relics. The primitive rigidity of the figures is softened by the rounded modeling and the rhythmical lines of the folds. 33″ high.

self in boundless horizons and immense forces, he also withdrew into himself. He discovered in his soul new vistas.

Now the art of emotion and of personal poetry began to find free scope; two centuries in advance, it sowed the seeds of Romanticism. Hobbema, for example, although devoid of lyricism, has such sharpness of perception in his famous *Watermill* (plate 38) that he conveys to us an excitement which he himself may not have felt because of his great concentration upon his subject. Even more poetry began to appear in the vast and rainy horizons, in the monochrome scale of the creators of Dutch landscape, Jan van Goyen and Salomon van Ruisdael; and in the work of the latter's nephew, Jacob van Ruisdael, who ranks with the great painters of Holland, Vermeer and Rembrandt.

Like Vermeer, Ruisdael converts every object he paints into a deep emotion and pours out his secret and taciturn sensibility. Broken by shallow reliefs his plain extends beneath the immense void of the sky; but the driven clouds which cause the sun to shine upon the ground in flitting patches, the water endlessly foaming and rushing, the brightness ceaselessly varying — all these, in his *Burst of Sunlight* (plate 44), express the evanescent beauties of nature. From these grave, subdued colors emanates a perpetual, silent melancholy. In painting of this kind there is only mood —no longer a subject, a story, or even an aesthetic idea or principle.

By detaching the painter from all conventions and traditional aspirations, absolute realism actually turned him back on himself, in all his solitude. If he possessed an inner richness he was compelled to reveal it and to nourish his art on it. It is not paradoxical, therefore, that out of the seeming material flatness of Dutch realism should arise one of the loftiest geniuses of Western art, Rembrandt.

Rembrandt was undoubtedly the first painter to have made the soul and its expression the purpose of his art. He comes at the end of the age of humanism, in the sense that his subjects are most often taken from the Old or New Testament. His work is steeped in the collective consciousness, whose traditional religious themes he interprets with an unprecedented depth of understanding. In him Christian inspiration is given perhaps its most sublime expression equal, at the very least, to that of the Middle Ages. And

whether he paints portraits, nudes, or Biblical scenes — his *Bathsheba* (plate 39) combines all three — he always glorifies humanity and the love and goodness which bind men together.

Nevertheless, while giving eloquent expression to the age of humanism, he also introduces the age of individualism. From the very start he imbues it with a note of astonishing intensity, for it was by exploring himself that he acquired the power of affecting other men. Love, goodness, humanity — he experienced them all within himself. To make them manifest it was sufficient for him to study his own face, which each year grew more deeply furrowed by cares, unhappiness, and the increasing incomprehension of his aims by his contemporaries. He offers us, it may be added, a revealing symbol of his self-exploration in his obsession with the mirror; he constantly scrutinizes and questions himself in his long series of self-portraits. He opened the way for those after him who would turn their gaze inward, bringing to light their personal secrets and making of them the shaping force of their art. Rembrandt's miracle is that even while he immersed himself in his inner depths, he revealed and stirred the deep sources of others' sensibility.

He was also an innovator in technique. Even more than the Venetians he exploited the special beauties of oils. He succeeded in making of his colors an enamel, a blended wash, a substance either smoothly flowing or expressive of vehemence, according to his inspiration.

Just as the genius of Rubens left Flanders almost exhausted for many years, so the genius of Rembrandt seems to have exhausted the creative energy of the Dutch school. Until the end of the nineteenth century and the appearance of van Gogh, Holland was to produce minor painters only.

ENGLISH PAINTING

ENGLISH PAINTING WAS THE LAST TO MAKE ITS appearance. Hesitating to assert itself, for several centuries it followed in the wake of other schools. The primitives were influenced by the French, so deeply, in fact, that a fifteenth-century panel, for a long time thought to be French, has only recently been given its proper English ascription by the Louvre. English painters in the sixteenth century were disciples of Holbein, court painter to Henry VIII, while in the seventeenth century

they followed van Dyck, the court painter of Charles I, almost to the point of pastiche. England's most successful portrait painters were a Fleming, Sir Peter Lely, and after him a German, Sir Godfrey Kneller. It was only in the eighteenth century that England produced her first great native masters.

At the same time that the aristocracy of England was finding expression in Sir Joshua Reynolds' portraits, the middle class was finding its voice in the art of William Hogarth. Realistic,

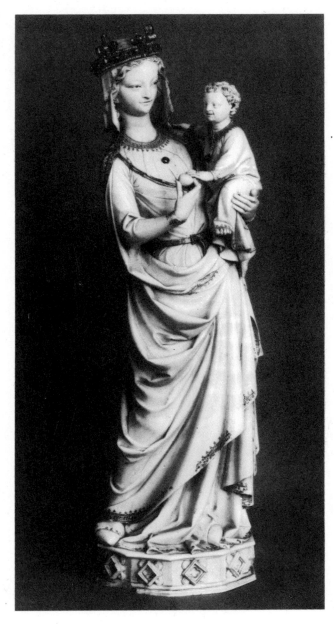

Ivory Virgin and Infant Christ. French, early fourteenth century, 16½″ high. The Virgin's crown is of gold, with filigree, precious stones and pearls; her collar is also gold, the brooch a garnet, the belt of leather. The costume preserves many traces of gilding and painting. A charming example of the sweet and aristocratic conception of the holy figures in French Gothic art, amiable, graceful, and rich.

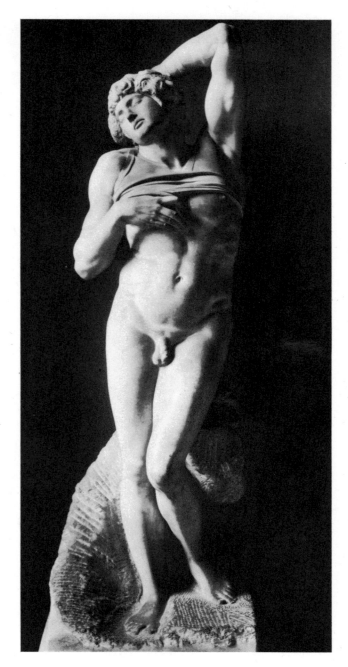

The marble *Slave* of Michelangelo (1475-1564) was intended as part of his great unfinished project, the tomb of Pope Julius II. The meaning of the fettered nude figure, powerful yet relapsing in weakness, is unclear. As one of a group of such slaves it has been interpreted as a personification of conquered provinces, in a whole that conveys the triumph of Pope Julius; it may also represent the enslavement of man to his animal nature. 90″ high.

moralistic, and anecdotal, as befitted the class he represented, Hogarth ranks among those pictorial creators who have discovered the expressive force of the brush stroke as well as of color and its harmonies. He makes his entry into art as a reflection of Hals and Velasquez.

Hogarth is unfortunately not represented in the Louvre, which does, however, possess a charming work by Reynolds, his *Master Hare* (plate 47). A man of superior intelligence and skill, Reynolds had patiently studied the Venetians and van Dyck. He created a facile and dazzling style, a style of dependable effects; it enabled him to arrange human likenesses, in simplified, appetizing harmonies of white, black, and red, against settings of autumnal verdure. With this style Reynolds ushered in the great era of English portrait painting. Those who followed him, Romney, Hoppner, and, in a more rugged way, the Scotsman Raeburn, were to govern their work by the formula he had developed. The double portrait of *Julius Angerstein and His Wife* (plate 50) shows that by the nineteenth century Sir Thomas Lawrence had brought this formula to its highest point of dexterity and distinction.

In the eighteenth century, however, Reynolds had a great rival in Thomas Gainsborough. A more personal painter and also more of a poet than Reynolds, Gainsborough had been influenced by Watteau's visit to London. His *Lady Alston* displays the gentle charm and the refinement of technique with which he would enhance the grace of his models. To Reynolds' virtuosity of brush he added an indefinable accent of tenderness and of reverie steeped in emotion. In his landscapes Gainsborough looked rather to the Dutch painters than to Claude Lorrain. He was the real founder of that line of landscape painters who were to dominate the English school of the nineteenth century, just as the portrait painters had dominated that of the eighteenth.

Constable's *Helmingham Park* (plate 48), which has been recently acquired by the Louvre, helps us realize how large a part this artist, and indeed all of the great English landscape painters, have played in the creation of modern painting. Bonington, delicate and attentive to the most subtle values, and Constable, nourished by a more generous sap: these two revolutionized the vision of nature. After them Turner, a visionary who was sometimes bold and sometimes merely artificial, ventured upon a series of astonishing anticipations of later developments. With a variegated palette and a brush heedless of restricting notions of form or outline, he painted pictures as brilliant and as dazzling as iridescent mirages.

Benefiting in turn from the pictorial audacity achieved by Venice, exploited by Velasquez and

Rubens, and in England assimilated by Reynolds, the English landscape painters were interested only in the interplay and the precise application of colors; they were free from concern with relief and volume. They discovered effects equivalent to light and thus prepared the way for Impressionism.

SPANISH PAINTING

THE LOUVRE OFFERS US A BRIEF, SWEEPING VISTA of Spanish painting with its main landmarks indicated by a few principal works. A peripheral school like the German, the Spanish was equally slow in asserting its independence. Its primitives, like those of Germany, tried to borrow their style from the dominating painters of Europe. Spain looked first toward Gothic France, then fell into the wake of Italy, and after that, through van der Weyden, turned toward Flanders. The Renaissance found her once more taking sustenance from Italy, although a few Castilian or Catalonian primitives which the Louvre possesses show us that the Spanish painting was beginning to seek its own path.

A land of passionate intensity, Spain seems to be drawn in two directions. The implacably brilliant sunlight makes all the sights of reality vividly evident while it seems to encourage men to retire within themselves and, in that interior darkness, explore the living sources of mysticism. But whether naturalistic or inspired, Spain always fills her creations with the same intense passion.

Remarkably enough Spanish art burst into flower only after the arrival of a Cretan, El Greco, who found on the burnt soil of Toledo a reminder of his native country, but remained uncomforted by it. In the work of this expatriate, Spanish painting let loose upon the world the equivalent of the mystical lightning of Saint Teresa or Saint John of the Cross.

Perhaps it was his sense of isolation and the profound tension it developed in him which gave El Greco the strength to create a wholly personal vision, disdainful of all the respected conventions and forged in the inward fire of his soul. Three centuries before the beginning of modern art, he was the first man to dare to disregard appearances as other men saw them. He invented a reality distorted to suit his own needs and vision, transfigured from conventional reality as freely as the wildest dreams. All of his figures, even those of

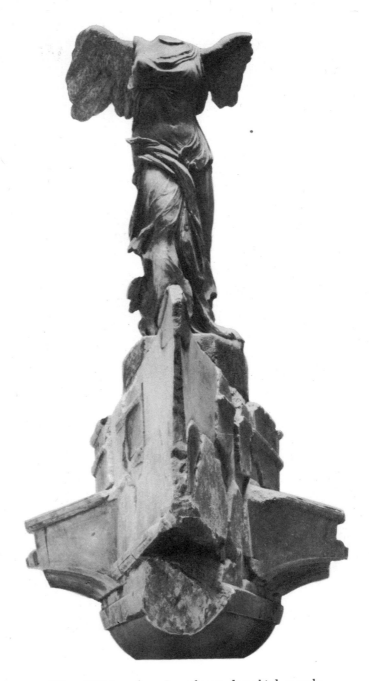

Winged Victory, from Samothrace, date third or early second century B.C. It was originally set up on a cliff facing the sea to commemorate a naval victory. The figure is of marble, the pedestal, in the form of a ship's prow, is of a stone from Rhodes, the probable home of the sculptor. Height of the figure: 6′ 9½″.

his portraits — his hallucinatory *Covarrubias* (plate 51), for example — seem to be phantoms of his imagination.

His contribution as a pioneer was immense. In a century when art was still engaged in reproducing reality, El Greco had the audacity to distort in order to express. Furthermore, having been trained in Venice, El Greco brought to Spain the technique of Titian and Tintoretto. This was pre-

Bust of Dietisalvi Neroni, Florentine patrician and condottiere. Signed and dated, 1464, by Mino da Fiesole (1431-1484). Inspired by Roman art, this marble sculpture represents a Renaissance counterpart of a "classic" man confident of his intelligence and will. 23″ high.

cisely the technique in which the artist dares to break away from literal imitation and lays his emphasis rather on the beauties of paint and color. No less a painter than Velasquez was soon to exploit this manner of execution and to find in it unsurpassable resources.

El Greco's immediate successors, however, were not so farsighted. Italian influence still dominated, and the seventeenth-century schools of Valencia and Seville were faithful to the example of Caravaggio. In following him they were not only following an Italian model but also one which did not thwart the Spanish inclination toward a realism which approached violence. Moreover, Caravaggio's keen sense of lighting was congenial to dwellers in a country of brilliant and sharply contrasted light.

Like his master Ribalta, Ribera actually visited Italy, and during his long stay in Naples he steeped himself in Caravaggio's powerful naturalism. He applied it to cruel scenes of martyrdom, to the wrinkled bodies of old men, and to such deliberately naturalistic subjects as his *Clubfoot* (plate 53), a shapeless and jovial ragamuffin of the Neapolitan gutter.

In Seville, Herrera carried the passion for the real to the point of vehemence. But he was soon eclipsed by Zurbaran, of whom the Louvre has several powerful masterpieces, among them *The Funeral of Saint Bonaventure* (plate 52). Ribera and Herrera had a fiery strength of realism which expressed only one aspect of Spain; retaining this strength, Zurbaran combined it with a spiritual greatness which his two predecessors lacked. What in them quickly degenerated into a carefree truculence became in Zurbaran a strict, concentrated firmness. He uses sharply juxtaposed contrasts of hard light and black shade to unify his forms and fix them in their essential aspect. In his work strength of outward appearance is not a mere bravura of the brush. It corresponds instead to an internal strength, to a keen spiritual tension.

In 1599, one year after Zurbaran's birth, Velasquez was born in Seville. One might almost say, with slight exaggeration, that his birth was really the birth of painting as we think of it today: an art whose chief merit is not so much its realistic fidelity as its means of expression.

This is not to deny that Velasquez was a realist. Few painters have been better able to concentrate on the object seen and to create the illusion of its reality. Faithful to the Spanish tradition, Velasquez chose the sights of daily life; and of these, with a Spanish predilection for the brutal, he selected sick people, dwarfs, blacksmiths, or drunkards. They remained brutal even though Velasquez feigned a concession to the classical tradition by presenting them in the form of an invocation to Vulcan or Bacchus.

The secret of his potent originality lay elsewhere than in the subjects he chose: he discovered painting, painting for its own sake. It was no longer to be a means of reproducing or idealizing, but it was an end in itself. By his own definition it was to be the art of combining colored paints on a white surface for the most delectable pleasures of the eye. His great portrait of Queen Mariana of Austria (plate 54) shows to what an extent the spectacle of a woman royally attired can be made a source of visual delight by the mere juxtaposition of a black, a silvery white, and a red, all of these applied with the vivacity of an infallible hand. This was to inspire Rubens, who returned from his visit to Madrid dazzled; it was to be the basic inspiration for all that is best in painting up to the present time.

Velasquez left Seville early in his career to be-

come the court painter at Madrid. Perhaps because he was much less of an innovator, his compatriot Murillo remained faithful to their native city. The generations which preceded ours and were molded by Latin classicism were unreserved in their admiration for Murillo's idealism; his heavenly graces, full of the spirit of the Counter Reformation, a spirit eager to please and seduce, may now seem rather insipid. But his pink cherubs and his Virgins with lofty, swooning gazes still have something lacking in the ecstatic visions of his Italian contemporaries. Murillo possesses that prodigious pictorial quality which seems to be the special gift of Spain; even so his combinations of blues and pinks appear saccharine to us and we prefer his paintings of vigorous and popular types.

One might expect that the Spanish school, in its turn, would be exhausted after its "golden century"; but its supreme expression was to come in the eighteenth century, with Goya. Thrown back upon himself by his deafness, Goya was no longer content to be a successor to Velasquez. In portraits such as his *Woman in Grey* (plate 55) he had already developed his predecessors' prodigious technique with a more nervous audacity. But he was not content to apply this technique to the treatment of realistic subjects in the Spanish tradition. Instead he used it to depict his own personal dreams, or rather nightmares, in which his passionate and tormented being is stripped bare. He led art toward expressing the private agonies of the individual; thus while he consummated and concluded the development of Spanish art, Goya also made an essential innovation for modern art.

GERMAN PAINTING

THE GERMAN SCHOOL REFLECTS THE NORTHERN spirit and its realism. To these it adds an accent of disquiet and bitterness, giving to its painting a graphic, tormented style and violent, crude coloring. For a long time Germany sought for a style of her own; her political fragmentation — which encouraged a longing for unity — and her bourgeoisie, with its materialistic outlook, imposed a provincial character upon her from the beginning, and urged her to seek guidance from her more fortunate neighbors. At the end of the fourteenth century and at the beginning of the next century the Rhineland, that mystical "monks' road," succumbed, like the Northern provinces, to the pres-

Marble bust of the Roman emperor, Geta (211-212 A.D.). Distinguished by its power of portraiture, Roman sculpture in the later centuries of the Empire became increasingly occupied with the expression of the inner man, although it never lost its Greek tradition of balanced, clear natural forms. Acquired by Napoleon from the Borghese Palace in Rome. 35½" high.

tige of the gentle Parisian arabesque, which was well adapted for the expression of medieval religious fervor. But by the fifteenth century it was the Flemish primitives who provided models whose compact and direct realism was well suited to the German temperament.

The few Rhineland primitives the Louvre possesses are not enough to give an idea of the richness and complexity of the German school in the fifteenth century. We must await until the Renaissance and the appearance of Albrecht Dürer, the Nuremberg master, whose *Self-Portrait* (plate 56), painted in 1493, is an admirable likeness, tormented and contorted in style, but entirely sweetened by the inner dream in the subject's eye. Dürer has gathered within himself the whole medieval Germanic soul: the graphic training of the engraver, with which all the German painters were familiar, is combined with an inner disquiet in such a way as to lend to the minutiae of realism a shaggy, tormented character, with a line that incessantly writhes and turns upon itself. The celebrated etching of *Melancholia* fully expresses the metaphysical anguish produced when the race of Faust is confronted with the intellectual aspi-

rations of the Renaissance. But Dürer's philosophical spirit, like that of Goethe three centuries later, experiences in its quest of the absolute that nostalgia for perfection which is so typical of the Mediterranean cultures. Faust dreamed of Helen: Dürer twice visited Italy and sought to capture there the secret of serene harmony and ideal proportion. Thus he anticipated Rubens in his effort to achieve a complete art which would blend the two directions of European art: the Northern sense of the profundity of life and the sovereign intellectuality of the Latins. This breadth of view, this audacity of thought—which was contemporary with the spread of Protestantism in Germany —this passionate desire to broaden his understanding of his art—these characteristics entitle Dürer to be ranked with the great humanists.

His illustrious junior, Holbein, had one stage less to travel; in him the inner struggle that gave Dürer his greatness had subsided. Born at Augsberg, to which the Italian influence had already penetrated, and a pupil of his father, upon whom

Seated Gudea. Sumerian, twenty-fourth century B.C. The ruler Gudea is represented with his hands folded in a ritual gesture. The inscription on his robe tells us that the statue is dedicated to the temple of the god Nin-Gizzida. The simplification of form relates this ancient masterpiece to the sculpture of our own times. 17¾" high.

the art of Venice had left its mark, Holbein shows no sign of the Germanic pathos. Although in a more superficial manner than Dürer, Holbein lived and enacted this epoch of humanism, traveling over Europe from Italy to England, where he painted the portraits of those ephemeral queens, Jane Seymour and Anne of Cleves (plate 57), and consorted with the greatest minds of his day, of whom he has left unforgettable portraits, such as his *Erasmus.* A humanist by tradition, he was also a humanist in the pre-eminence he gives to the human countenance. He brings to it the exact realism of the Northern primitives, but blended into a harmonious breadth that reveals the influence of the Renaissance.

A year younger than Dürer, Lucas Cranach perceived and reflected the diversity of elements that Dürer succeeded in fusing together. In borrowing from antiquity the subject for his *Effects of Jealousy,* Cranach sees Hesiod's Age of Silver as populated by savages in the heart of the primitive forest. In his numerous paintings of Venus he gives her the dainty graces of the wife of a Saxon bourgeois and sacrifices the study of forms to a complication of petty details. But it is in portraiture that he, too, discovers a moving sincerity and achieves both perspicacity and depth.

No mention has been made of Altdorfer, Grünewald, and Baldung Grün, among others, but the few masterpieces we have considered should be sufficient to acquaint us with the chief problems which have presented themselves to German painting since the age of its flowering.

FRENCH PAINTING

FRANCE OCCUPIES A VERY SPECIAL POSITION IN THE development of European painting. Thanks to her central situation, to the numerous frontiers which connect her, by land or sea, with all of the major European countries and with England, France is open to the most diverse influences. Encouraged by a fertile soil and a gentle climate, she asserts her genius by developing a spirit of harmony and conciliation, by merging foreign influences with the tender and tranquil sensibility of her people.

French art is allied to the art of the North by its innate realism, a realism, however, which can temper the severity of strict observation by blending it with emotion. It shares the respect of the Mediterranean peoples for the supremacy of the organizing intellect; while it also accepts their

classicism, it avoids the aridity of abstraction by trust in its own senses. From all this derives an art of fine shades, open-minded, and possessing the almost unique quality of constant self-renewal. Scarcely has it exhausted one tendency when it turns with unexpected vigor in a new direction.

It is only within the last half-century that the French primitives have been given attention in art histories. This long neglect is partly explained by their rarity and mistaken attribution to other schools. As a result of a stubborn reaction against the art of the Middle Ages, a reaction which persisted into the nineteenth century, the majority of primitive works, panels as well as murals, were despised and destroyed. Yet France had been the undisputed center of medieval civilization. The Flemish painters of the fifteenth century were the natural development of France's art of the miniature; and it was from this art also that fifteenth-century Italy originally derived its secular and courtly inspiration.

In feudal society a school was formed in almost every important provincial court, but Paris, the seat of royal power, constituted the principal school. The *Portrait of John the Good,* painted toward the end of the fourteenth century, is perhaps the oldest French painting in existence. It immediately confronts us with the essential and unchanging element of France's art: a deep-seated realism marked by an intimate understanding between man and nature, between the inner life and the outward appearance, between thought and feeling. This element is apparent in Jean Malouel's discreetly moving *Pietà* (plate 59).

The disasters of war, especially the defeat by the English at Agincourt in 1415, ruined Paris and encouraged the spread of art to the regional centers. At Avignon, in the fifteenth century, there arose a truly great school whose characteristic masterpiece is the *Villeneuve-les-Avignon Pietà* (plate 60), by an unknown painter. In this work the soul of the Middle Ages is given one of its most sublime expressions. Its decisive concentration of form gives it a plastic intensity which is almost sculptural.

On the Loire, in Touraine, where Charles VII had sought refuge, the dominant influence was that of Jean Fouquet, whose glory spread past the borders of France. The highly abstract simplification of masses in his pictures is combined

The Crouching Scribe. Painted limestone, from a tomb of the Vth dynasty at Saqqara, between 2750 and 2625 B.C. This Old Kingdom figure represents a governor of a province. The eyes of opaque white, with quartz cornea, rock crystal iris, and ebony pupil, are set in bronze. 21″ high.

with a very subtle naturalistic truth which is conspicuous in his miniatures and in the Parisian scene which he uses as a setting for his *Saint Martin* (plate 58). He creates a typically French balance of two opposite tendencies: the realistic tendency of the North and the abstract, intellectual tendency of the Mediterranean countries.

This same balance and harmony mark the work of a great, anonymous painter, known as the Master of Moulins, who worked at the court of the Duchess of Bourbon. In his *Saint Mary Magdalen and a Donor* (plate 61), we find a more minute sharpness of observation, reflecting the growing prestige of the Flemings.

With the outbreak of the Italian wars, however, France swung into its southern orbit. Dazzled by the refined and luxurious civilization which the Renaissance had developed in the peninsula, France broke off her spiritual alliance with Flanders and fell under the influence of Italy. Italian masterpieces, and even Italian masters, were freely imported. To his court Francis I attracted Leonardo da Vinci, who died near Amboise, and Andrea del Sarto; these men were followed by il Rosso, Primaticcio, and Niccolo dell' Abbate, who established themselves at Fontainebleau, the residence of the royal court. Here a school was to flourish throughout the sixteenth century. Fon-

tainebleau came to be known as "the second Rome," setting a new direction for French art.

Although it now swore only by Italy, French art quickly assimilated the new influence and added to it its own sensibility. The harmony and plenitude of forms and the plastic mastery which were so typical of Italian art now acquired a new character of delicacy and elegance. For the male anatomy, in which Italian art had sought an almost abstract beauty of proportion, France substituted the grace of the female with its more slender form, its subtler and more caressing lines, creating an art of enchantment, as seen in the *Venus and the Goddess of the Waters* (plate 63), by an unknown master of the school of Fontainebleau.

But even while French painting was inspired by the ambition to rival Italy, the portrait painters preserved the strict truthfulness of Northern art and applied it to the study of the human face. The connection with the North is confirmed by the origins of the most famous of these painters. Jean Clouet, the father of François, came from the Low Countries, while Corneille de Lyon came from The Hague. Yet they were as profoundly transformed and assimilated by France as their Italian rivals at Fontainebleau.

In the work of these portrait painters (plate 62 and cover) naturalism loses its tension and is animated by a flame of the spirit; an implicit excitement passes into the model's eyes, lips, and hands. The phlegmatic, precise objectivity of the Flemings acquires a more tender, more delicate note. Thus the French school of the sixteenth century was far from being exhausted by its twofold Italian and Northern allegiance. Preserving the realistic vein and at the same time studying to acquire the lofty style of Italy, France adapted both of these to its temperament and prepared for the advent of a new and classical art in the next century.

An art so firmly established in the Gothic now proceeded to adapt itself to the new era of the Renaissance. Realism, which the great portrait painters of the sixteenth century had already charged with humanity, was to be identified with an intense but restrained poetry, glowing with spirituality. The France of the cathedrals was not dead; from this France came the gift of combining the love of the real with the most ardent impulses of the soul. The new art was characterized by emotion, grave, pious, almost austere.

The brothers Le Nain — Antoine, Louis, and

This painted wooden half figure of Eve is a German work of the end of the fifteenth century, a masterpiece of shy grace, sweetness, and naivete. 68½″ high.

Mathieu, of whom Louis is the most profound—depicted the humblest scenes of peasant life, but they did not seek in them either the anecdotal or the picturesque. They gave an almost religious concentration to those lovely faces chiseled by the nobility of harsh toil accepted as a high duty; there was no need to transform these faces in order to make them serve for the *Pilgrims at Emmaus* (plate 64).

Whereas the Le Nain family came from Laon, Georges de La Tour was a man from the east, from Lorraine. The realism of La Tour had relatively little connection with that of Flanders; he appreciated the lessons of Caravaggio and his sharp, nocturnal lightings. La Tour's scenes are quite simple: a new-born child around whom the family holds its breath in excitement; sometimes a religious episode, a Magdalen or a Saint Peter, or

Louise Brogniart, a terra cotta, dated 1777, by Jean-Antoine Houdon (1741-1828), 14" high. A revelation of the charm of the child by the most sophisticated of French portrait sculptors, the author of the *Voltaire* (p. 14).

a child Jesus standing beside Joseph, a rough carpenter. These religious paintings might be taken to depict ordinary scenes of daily life amongst simple people; indeed, the last-mentioned is sometimes called *The Carpenter's Family* (plate 68). Here realism achieves its highest significance by its devotion, simplicity, and dignity.

All of the first half of the seventeenth century was inspired by the austere fervor that blossomed with Pascal and his Jansenist adherents of Port-Royal. Philippe de Champaigne was their recognized painter. Entirely Flemish in origin, and closely associated with Poussin, he personifies the spirituality that illuminates the most direct kind of truth. It shines out in his lovely portraits, such as his *Arnauld d'Andilly* (plate 69), which are worthy successors to those of Clouet. Le Sueur, in his *Death of Raymond Diocrés* (plate 70), achieves

tragedy combined with sobriety. When he turned, like almost all his contemporaries, to the example of Italy and to experiments with classicism, he brought to these the qualities of sweetness and gentleness.

After the elegant but as yet superficial art of Fontainebleau, classicism approached maturity with Simon Vouet, whom his contemporaries recognized as the great painter of the beginning of the century. But it was to reach its highest point with two artists who spent almost all their lives in Rome: Nicolas Poussin and Claude Lorrain.

In Poussin we find a complete synthesis of France. Born of Norman peasants, he has that deep, rustic love of nature characteristic of French realism. His generous landscapes are rich in earth and sap, in calm waters and blue skies. He most appreciated the terrain of Roman art, a terrain fertilized by the genius of antiquity. Out of the materials that nature offered him he fashioned the ordered architecture of his compositions, their cadences and balance, and he interpreted his love of the countryside in the *Triumph of Flora* (plate 65).

Claude Lorrain is richly supplied with the same qualities. Less cultivated than Poussin, Lorrain gave free rein, and with greater freshness and gushing energy, to his sensibilities. He, too, rigorously controls the composition of the masses of his trees and the facades of his palaces, but with an art that dazzles us with the play of golden and caressing light. He lets himself glide off into dreams when he beholds the sea, laden with vessels, stretching to the horizon. These dreams are what we find in his *Seaport at Sunset* (plate 66).

Poussin's disciples in France—who claimed him as the founder of that classical art which intoxicated the Academy of Painting established by Louis XIV—adhered to the most dogmatic elements of his teaching. Le Brun, whom the King had appointed a sort of regent of the arts, used his influence to direct classicism toward a formalistic and doctrinaire academism. Yet his great *Equestrian Portrait of Chancellor Séguier* (plate 67), a youthful work, proves that he was a painter of vigorous, healthy talents and a wealth of rugged power of observation, which he later sacrificed to his official preconceptions.

Under Le Brun's influence, reflecting the taste of Louis XIV, there developed in France at the

Five Archers. Susa, fifth century B.C. A frieze of enameled brick, representing members of the Persian king's guard of ten thousand men. In this complex art of glazed tile and brick, perfected in the Near-East, the color, modeling, and imagery of each brick must be exactly calculated for its place. 72″ high.

end of the seventeenth century an art of pomp and grandeur, which aroused amazement and admiration in the decoration of palaces, especially of Versailles. Because sensibility was so stifled, these skilled and conventional artists, Le Brun's pupils or rivals—men like Mignard—have left us almost nothing of value.

Yet at the end of the "great reign," the portrait painters were creating likenesses of incomparable sweep and breadth. Rigaud, for example, with his *Louis XIV* (plate 71), calls to life all the majesty of the period. His younger rival, Largillière, enlists in the service of a similar theme an entirely different ambition, to glorify color and achieve emotional impact by technical brilliance—an ambition that is explained by his training at Antwerp.

Actually a great struggle had begun and was carried to the heart of the Academy, that bastion of tradition: a struggle between the *Poussinistes,* who were pure classicists enamored of the teachings of Italy, and the *Rubénistes,* who, invoking the Venetians and after them the Flemings, rebelled against a discipline that had become sterilizing. A reaction was setting in. The eighteenth century was dawning and was about to assert the rights of a sensibility that had been bullied by an excess of cold reason. Against grave seriousness, it was to set the lightest of charms; against sober and solid qualities of design and composition, it was to set the most dazzling and unrestrained fireworks of color and paint; against virile grandeur, it was to set feminine seductiveness; and against reason, it was to set sensuousness. And, in order to do all this, it was to take as its guide the painting of the North.

Watteau, generally recognized as the real founder of eighteenth-century painting, passed the important part of his short life under the reign of Louis XIV. But he radically rebelled against the spirit which the old King had imposed. Born at Valenciennes, which had recently been rejoined to France, he was a man of the North, enamored of Rubens; yet for a long time he dreamed of going to Italy to perfect his art. For lack of a *prix de Rome,* he attentively studied the Venetians at the home of his patron, the banker Crozat. He began as a painter of military scenes, which he treated with a direct realism that links him with the brothers Le Nain; but he quickly passed on to the poetic evocation of the seductive charms of women and love—a mode that had been experimentally practiced in the sixteenth century, and had afterwards been developed, under Louis XIII, in the literature of pastoral gallantries. Watteau's particular achievement was to carry art a definite step forward. He strove to give substance to the most intimate yearnings, the most expressive fancies of his being. In a delicate daydream of the isle of love, his imagination created the *Embarkation for Cythera* (plate 72). He laid

the groundwork for Romanticism by regarding his works as the language and confession of his soul, and thus inaugurated not only the art of his century, but the very spirit of the modern era.

His immediate successors did not attain his stature: Pater and Lancret adroitly preserve his gracefulness, but not his deep poetry. In the middle of the century, François Boucher was to bring unity to the French school at a time when it was split between the heirs to the great official decorators and the heirs of Watteau, who devoted themselves to the themes of gallantry. Bringing the light and sensuous inspiration of the latter into the domain of the former, Boucher accomplished this unity. Under his alert and easy, all too easy, brush, ancient Olympus itself yields to the new taste. As in his *Bath of Diana* (plate 75) Boucher borrows from Greek mythology his naked goddesses, his Venuses, and his nymphs as chubby as female opera-singers and attended by sprightly Cupids. Thus even the gods of classicism lend themselves, in an atmosphere of blue and rose tints, to the universal seductiveness of love and easy bliss. Within a century French painting had gone from the most austere seriousness to the most delicate gracefulness.

Boucher's pupil Fragonard dominated the following generation, which was to fall into the chasm opened at its feet by the Revolution of

1789. At first sight he seems merely to improve upon the vivacity of his master. He, too, thought only of love, of graceful nudes blossoming in the brightness. Fragonard carried the virtuosity of the brush to such a point that some of his brilliant portraits in the Louvre were painted "within the space of an hour," as he himself recorded in a manuscript note. He glorifies the joy of living: the figures in his *Bathers* (plate 78) are intoxicated by their contact with the water and the delights of the mild, sunny air; they are coquettish and frisky; and the painter seems to share their pleasure by lending his brush the same playfulness and vivacity.

But he surpasses Boucher. Although he seems quite as frivolous, Fragonard makes a great contribution to painting. The Venetians and Rubens had already succeeded in breaking away from literal rendition and producing a transfigured, pictorial version of nature, whose beauty came less from nature itself than from the language of colors and strokes into which it was translated. Fragonard ventured further in this direction. He employs painting as a sort of alchemy: he transmutes substance; he volatilizes whatever is solid and motionless; he causes leafy branches to soar into the air as if they were tumultuous whirls of smoke; he compels them to surge and tumble like stormy waves; he stirs everything up like a fluid,

Fragment of the frieze of the Parthenon, representing the procession of the Athenian maidens who have woven the veil of Athene. Carved between 442 and 438 B.C. under Phidias' direction, it marks a rare moment in Greek art in which nobility and naturalness are fresh achievements rather than a tradition. 6'10" long, 2'½" high.

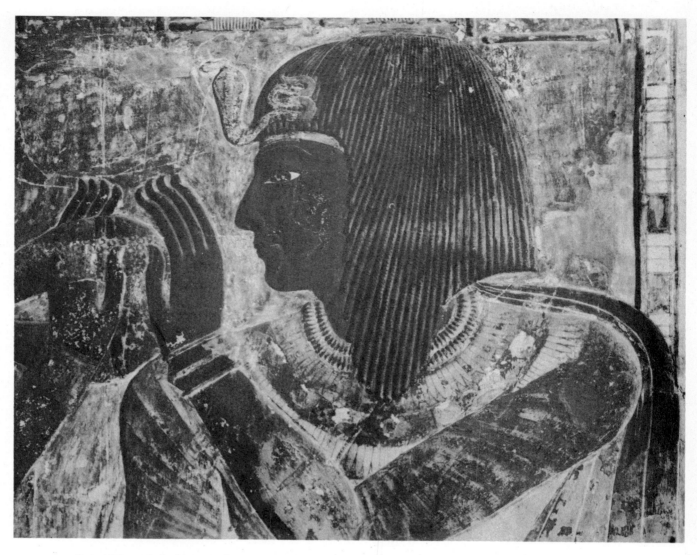

Painted bas-relief of King Sethosis I (1313-1292 B.C., XIXth dynasty) and the goddess Hathor. 89½″ high, 41½″ wide. The king receives from Hathor a necklace, which is the emblem of the goddess and the carrier of a protective fluid transmitted from the goddess to the king by contact.

or like jets of smoke. He extends the magic discovered by Rubens and Rembrandt; he vitalizes the universe.

What became of French realism during this interlude? Counterpoised to the refinements of the aristocracy, the bourgeosie, full of disapproval of their excesses, maintained the honorable and sober tradition of truth and seriousness.

Chardin, let us not forget, was Boucher's contemporary. In his work the scene changes. Chardin preserved the solid and discreet virtues of the middle class side by side with the luxury of elegant society. He brought to life the realism in which feeling, and therefore poetry, plays as great a part as observation. "One paints with the heart," he said. And for him it was enough to assemble on a table a few pieces of fruit, some game, a glass

of water, or a rustic pot, or to observe a woman returning from market (plate 74), or teaching her children to say grace. Such scenes under his hand glowed with the wholesome splendor of the family hearth and with tenderness for people and things. If the word goodness has any meaning in connection with painting, this is the quality with which Chardin illumines his pictures. Let it not be supposed, however, that in so doing he deviates from what is nowadays called "pure painting." On the contrary, never were textures, colors, and lights so satisfying in themselves, or blended in more delectable harmonies.

This, unfortunately, cannot be said of Greuze, who in the next generation—that of Fragonard—sustained the bourgeois inspiration. Yet he also loved to glorify the graces of the eighteenth cen-

tury. He was soon led, however, like Hogarth in England, to tell us stories for our edification, "to compete," as his friend Diderot wrote, "with dramatic poetry in moving and in instructing us, in amending our faults and inviting us to virtue." Painting became literature, and bad literature at that.

Thus French painting of the eighteenth century took two main paths: the aristocracy, at its apogee, gave sparkle to all the graces and seductive charms; its rival, the bourgeoisie, which was soon to triumph with the Revolution, took its stand against frivolity and favored realism.

In portraiture, however, these two opposing tendencies could be combined. Two rivals, Quentin de La Tour and Perronneau, reflect in their oppositeness the aristocracy and the bourgeoisie. Quentin employed the fragile and elegant technique of pastel—as for example in his striking portrait of *Madame de Pompadour* (plate 76)—so well suited to catch the animation of a woman's face, sparkling with wit and lit up with a smile. But he was just as good at painting soldiers or philosophers, for he knew how to probe into souls. "I delve into the natures of the sitters themselves," he said, "and I bring them onto the canvas in their entirety." Perronneau, for his part, lacks this verve; but his art is more tender, more attentive, with perhaps less complacency if also with less brilliance. In his study of the face of a woman—in his portrait of *Madame de Sorquainville* (plate 77), for example—he discovers exquisite delicacies; yet he can also express the gravity and conscientiousness of his male sitters. He was primarily concerned with serious attention and precision. Such were the main preoccupations of these painters until Madame Vigée-Lebrun succeeded in combining a still more attentive and colder realism with the ultimate evocation of the delicate, feminine smile of a society that was about to disappear.

The eighteenth century, now disdainful of elegances, demanded from the painter increasing probity, later to develop into severity. The worship of nature, which at this time was being preached by Jean-Jacques Rousseau, was to result in an eagerness to submit the landscape to stricter scrutiny. More and more the fantasies of Fragonard were replaced by an exactitude that took the Dutch school as its model. Fragonard himself had already taken an interest in this school—in Ruisdael, for example—to the point of sometimes seek-

ing inspiration from it. His friend, Hubert Robert, with whom he visited Italy, developed the study of nature in nimble and evocative drawings in red chalk, some of which might be mistaken for Fragonard's work. Hubert Robert's paintings of ruins reflected the new interest in antiquity stimulated by the excavations at Pompeii; and though his paintings still sparkle with the fluent and frothy technique of the eighteenth century, some

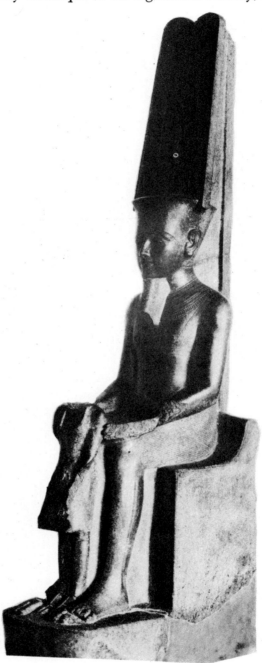

The god Amon protecting King Toutankhamon. Grey granite, Egypt, end of the XVIIIth dynasty, about 1200 B.C. 87″ high. It is supposed that the mutilation of the king's figure was due to his successor Horemheb, who wished to prevent the divine protection of Toutankhamon by breaking the contact between the god and the former king.

93

of his canvases were harbingers of Romanticism.

Western art could now represent and interpret form, substance, and movement, in strict obedience to the will of the painter. Its remaining task was to capture the hitherto uncapturable, that aspect of the exterior world which had been too insubstantial to be caught by the pictorial resources of earlier artists: light and its shifting nuances. At the end of the eighteenth century, Hubert Robert, among others, applied himself to this task. One can already glimpse on the horizon the advent of Impressionism.

The French Revolution inaugurated a new world. The rupture was complete on all levels;

the whole structure of society was modified. French art was once again to renew itself.

We have seen how the rise of the bourgeoisie brought about the establishment of new tastes which inclined toward realism and set a ban upon fantasy. In its reaction against the aristocracy, art became serious, grave, severe both in form and in basic conception. It fulfilled a moral function; its business was to glorify virtue; it interdicted grace and charm, and glorified energy and grandeur.

The France of the Revolution felt powerful affinities with the stern virtues of republican Rome. Painting turned irresistibly to the example

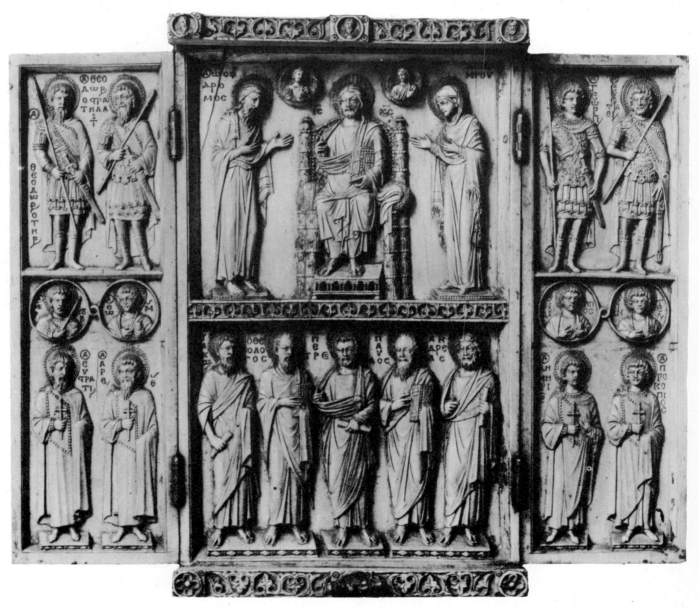

The Harbaville Triptych. A Byzantine ivory carving of the tenth or eleventh century, representing Christ enthroned between Mary and John the Evangelist; in the little disks on the upper border are Jeremiah, Elijah, and Isaiah; below stand James, John, Peter, Paul, and Andrew. On the side leaves are saints of the Greek church, including four in military dress. By such ivories the classical Greek formula was transmitted to the European mainland. Central panel, 6½″ high, side leaves 4½″ high.

of ancient classicism, recently brought into new prominence by the excavations at Pompeii and Herculaneum. It devoted itself to the imitation of this example with so much zeal that it fell into the danger that inevitably threatens all classicism, the danger of drying up into academicism.

The man who established himself, with universal consent, as the regent of the arts, the Le Brun of the Republic, was Jacques Louis David. After having made his first bow under the aegis of Boucher, David was converted by the revelations of his stay in Italy, and from then on swore only by the antique, especially its sculptures. From these he borrowed poses, and he came under the influence of their sharp outlines and clear-cut masses. He transposed these characteristics into the field of painting, and he added to them a coloring that was little more than a surface accompaniment to line and volume. Sensuousness of technique disappeared before his precise and implacable rendering. His themes, which were taken from legends extolling sacrifice, expressed the same harsh strength.

In his portraits, however, and in immense Napoleonic scenes like the *Coronation,* David, no longer concerned with doctrines, retained only his desire for absolute truth. In this he surpassed himself; he tolerated no adroitness which would enable him to gloss over a difficulty or to dazzle instead of convince. Rediscovering that sense of psychology which always gave French portraiture its profundity, he climbed to the summit of his art and succeeded in producing unforgettable likenesses. When confronted by a woman sitter — Madame Récamier, for example—and even in his scenes of antiquity, as in his *Battle of the Romans and Sabines* (plate 79), he even rediscovered that exquisite feeling of grace which was believed to have been abolished.

David governed the French school with an iron hand. A whole generation of painters—men like Guérin, Gérard, and Girodet—carried on his impetus. Only one isolated painter, Prud'hon, escaped the dessication of theories; coming at the end of the eighteenth century, Prud'hon was an echo of what Watteau had been at its commencement. A passionate admirer of Correggio, he loved to cast upon flesh a splendor of suave whiteness beneath a lunar and sweet brilliance emerging from deep shadow. It was thus that he

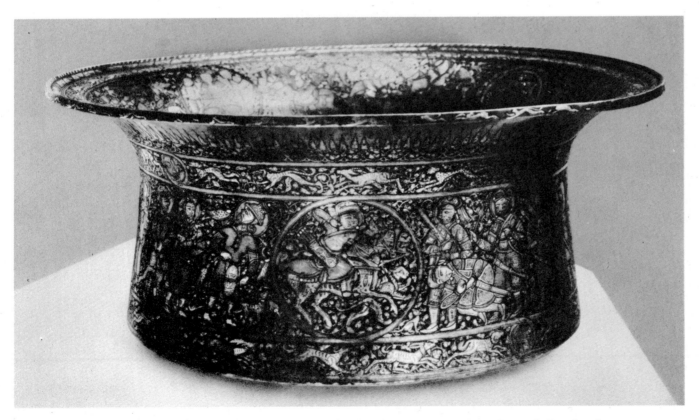

Copper basin incrusted with gold and silver, called the *Baptistery of Saint Louis.* It was believed to have been brought from the East by the crusading king, Louis IX, and was used for the royal infants since the seventeenth century. Scenes of hunting and feasting decorate the surface. The artist, Mohammed Ibn el-Zain, has inscribed his name. Probably Mameluk work from Syria or Egypt, fourteenth century. 9" high.

Polychrome faience plate. This extravagant design of sea-life is attributed to the French ceramist Bernard Palissy (1510?-1590), famous for his daring experiments and curiosity. 24″ long.

presented his *Empress Josephine* (plate 80). Heedless of his epoch, he was a poet, expressing in song his dreamy and melancholy soul. He carried over from the closing century all that had to be preserved in order to permit the birth of romanticism. Amidst the disciplines of his time—those both of the Revolution and of the Empire—he was an individualist. As such, he was the harbinger of the nineteenth century.

The French Revolution did not, in fact, merely put an end to a society exhausted by its own refinement; it founded a new society, based upon the Declaration of the Rights of Man. Man's new status encouraged all the creations of the mind, and first to blossom was art. Here we find revealed the essential characteristic of the nineteenth century, and, in particular, of Romanticism.

Another essential characteristic was an insatiable ardor for life, feeling, thought, or action. It was exemplified by Napoleon, an extraordinary

personification of the individual who starts from nothing and succeeds in everything, even in dominating the world. By the sheer force of his intelligence and energy, Napoleon introduced the theme of the superman. He whipped up the imagination of the nineteenth century with his epic, astounding adventure, an adventure which was to feed the dreams of several generations. Thus the Revolution, by creating the individual conscious of himself and fired with immeasurable ambition, laid the foundations of Romanticism.

David had already forsaken the heroes of antiquity in order to celebrate modern heroes in powerfully inspired canvases like the *Coronation*, already mentioned, almost equal in size to Veronese's *Wedding at Cana*. His favorite pupil, Gros—who was to become the leader of the Classical school when David was exiled after the fall of the Emperor—hastened the birth of Romanticism by inspiring painting with the fire of the epic, the

96

(Continued on Page 147)

51. EL GRECO [*1541-1614*] *Portrait of Covarrubias* · Spanish School
Painted about 1600 · Oil on canvas, 26¾″ x 22½″ · Commentary on page 166

52. ZURBARAN [1598-1664?] *The Funeral of Saint Bonaventure* · Spanish School
Painted 1629 · Oil on canvas, 98¾″ x 86⅝″ · Commentary on page 167

53. RIBERA [*1591?-1652*] *The Clubfoot* · Spanish School
Painted 1652 · Oil on canvas, 64⅜″ x 36¼″ · Commentary on page 167

54. VELASQUEZ [*1599-1660*] *Portrait of Queen Mariana* · Spanish School
Painted 1652-1653 · Oil on canvas, 83⅛″ x 49⅝″ · Commentary on page 167

55. GOYA [*1746-1828*] *Woman in Grey* · Spanish School

Painted about 1805 · Oil on canvas, 40½″ x 32⅝″ · Commentary on page 167

56. DÜRER [1471-1528] *Self-Portrait* · German School

Painted 1493 · Tempera and oil on parchment, 22¼″ x 17½″ · Commentary on page 163

57. HOLBEIN [*1497?-1543*] *Anne of Cleves* · German School

Painted 1539 · Tempera and oil on parchment, 25⅜″ x 18⅞″ · Commentary on page 168

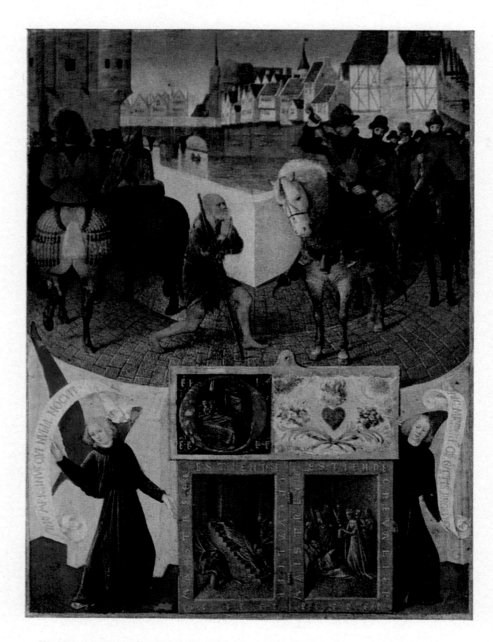

58. FOUQUET [*1420?-1480*] *Saint Martin and the Beggar* · French School
Painted about 1455 · Tempera on vellum, 6¼″ x 4⅝″ · Commentary on page 168

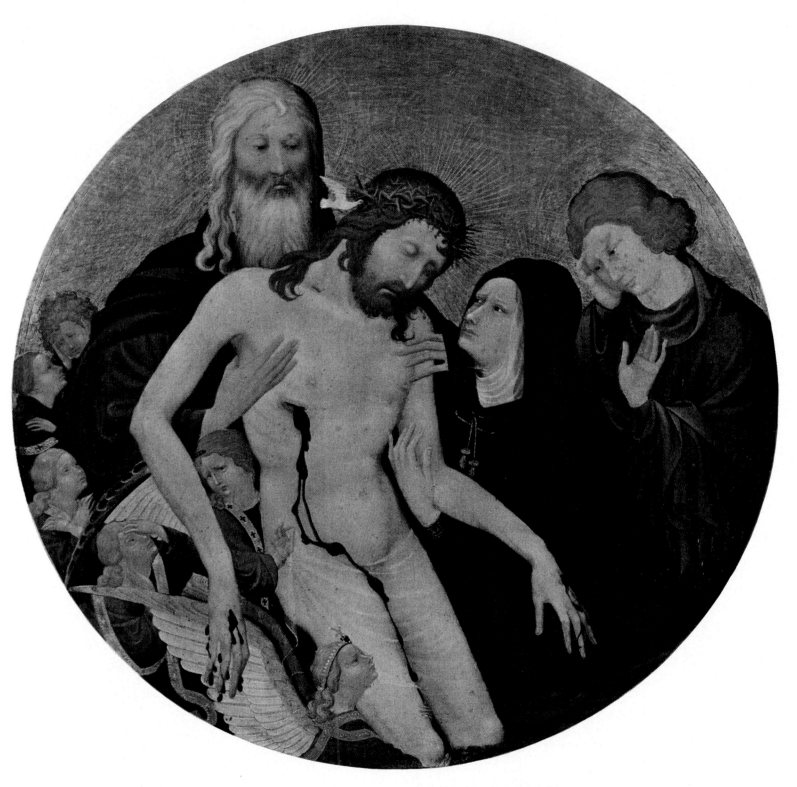

59. MALOUEL (?) [*end of 14th Century*] *Pietà* · School of Paris

Painted about 1400 · Tempera on panel, Diameter 25¼″ · Commentary on page 168

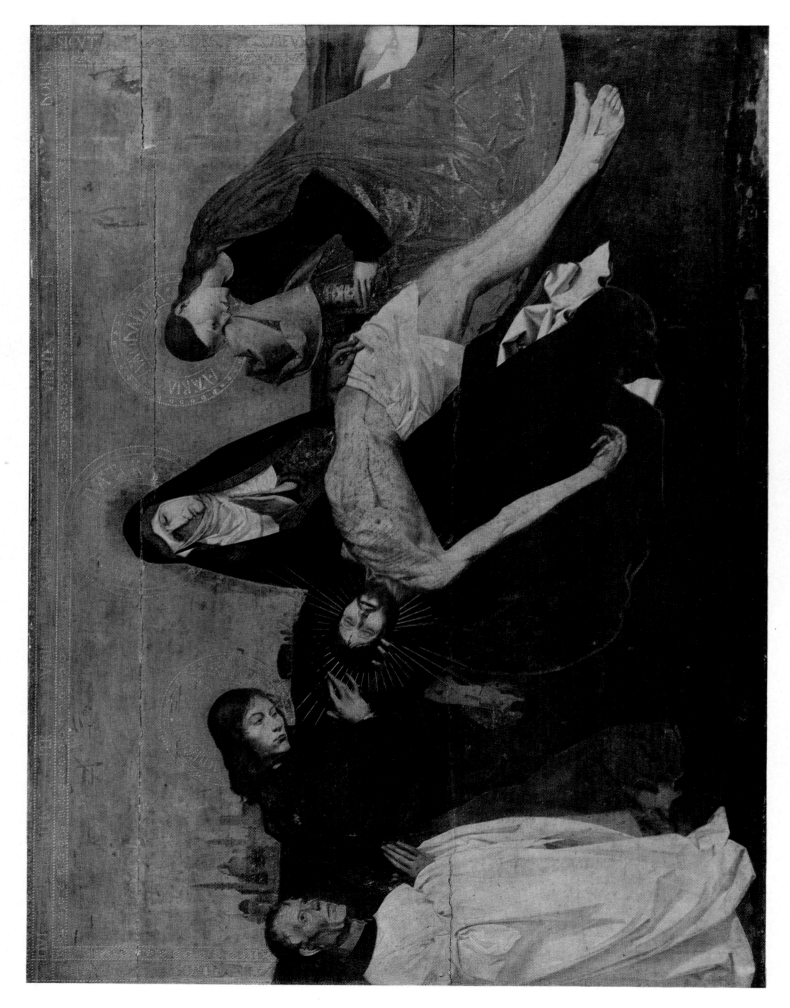

60. UNKNOWN PAINTER *Villeneuve-les-Avignon Pietà* · School of Avignon · Painted about 1460 · Tempera on panel, 63¾" x 85⅝" · Commentary on page 168

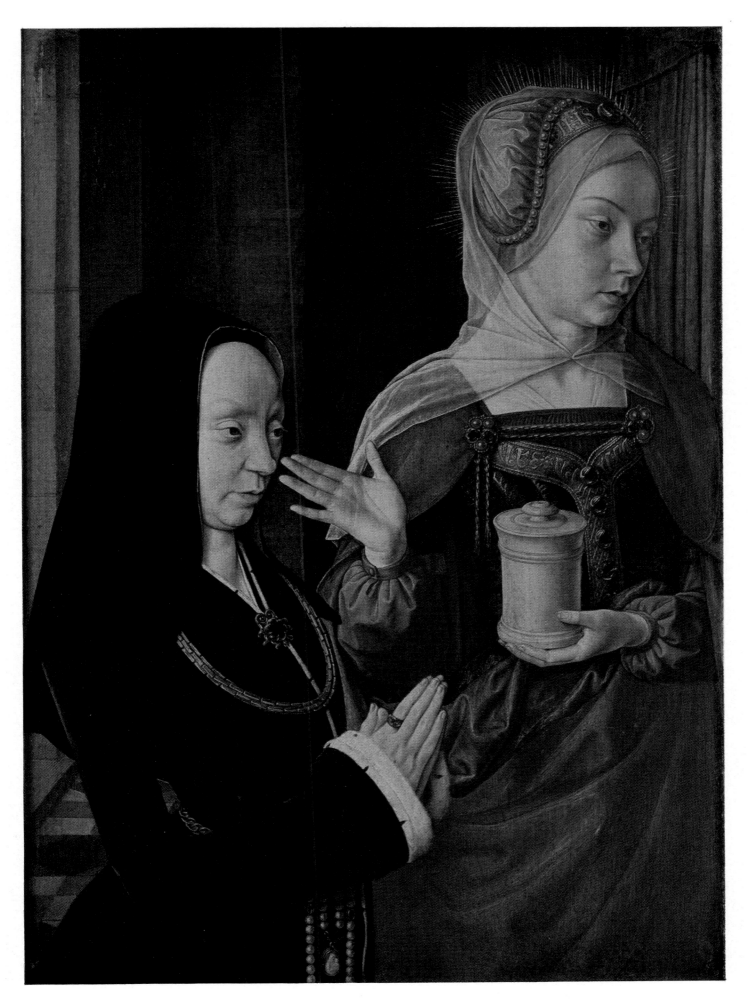

61. MASTER OF MOULINS [*end of 15th Century*] *Saint Mary Magdalen and a Donor* · French School
Painted about 1495 · Tempera and oil on panel, 20⅞″ x 15¾″ · Commentary on page 169

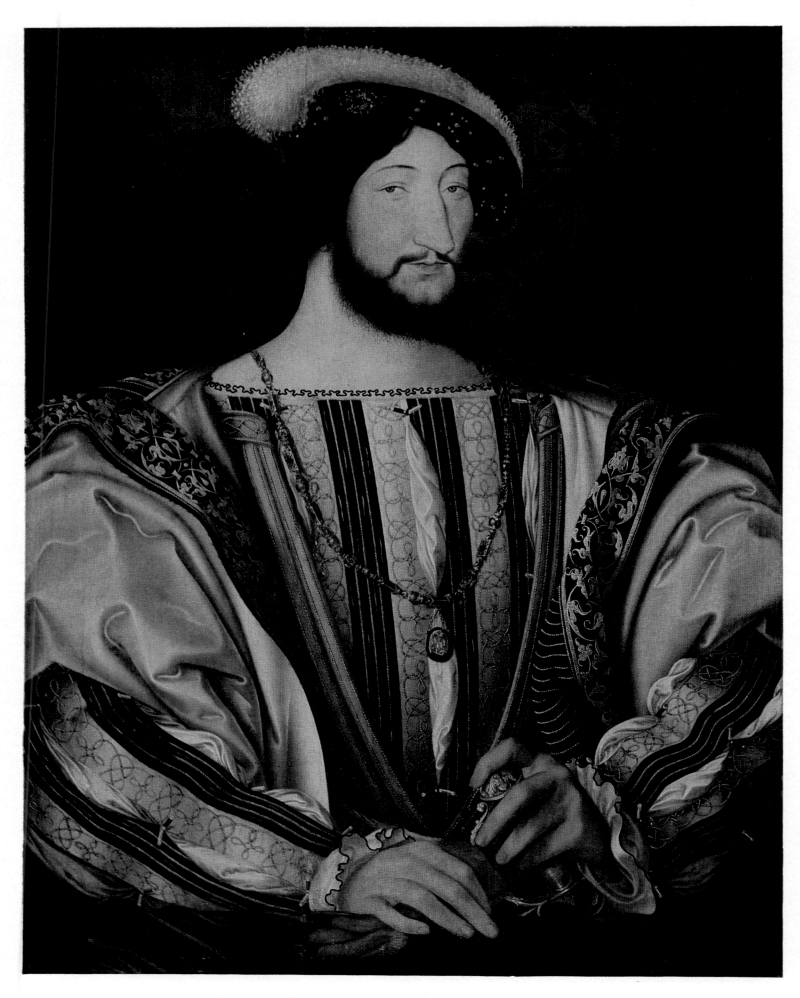

62. JEAN CLOUET [1485?-1540?] *Portrait of Francis I* · French School

Painted about 1524 · Tempera and oil on panel, 37¾″ x 29⅛″ · Commentary on page 169

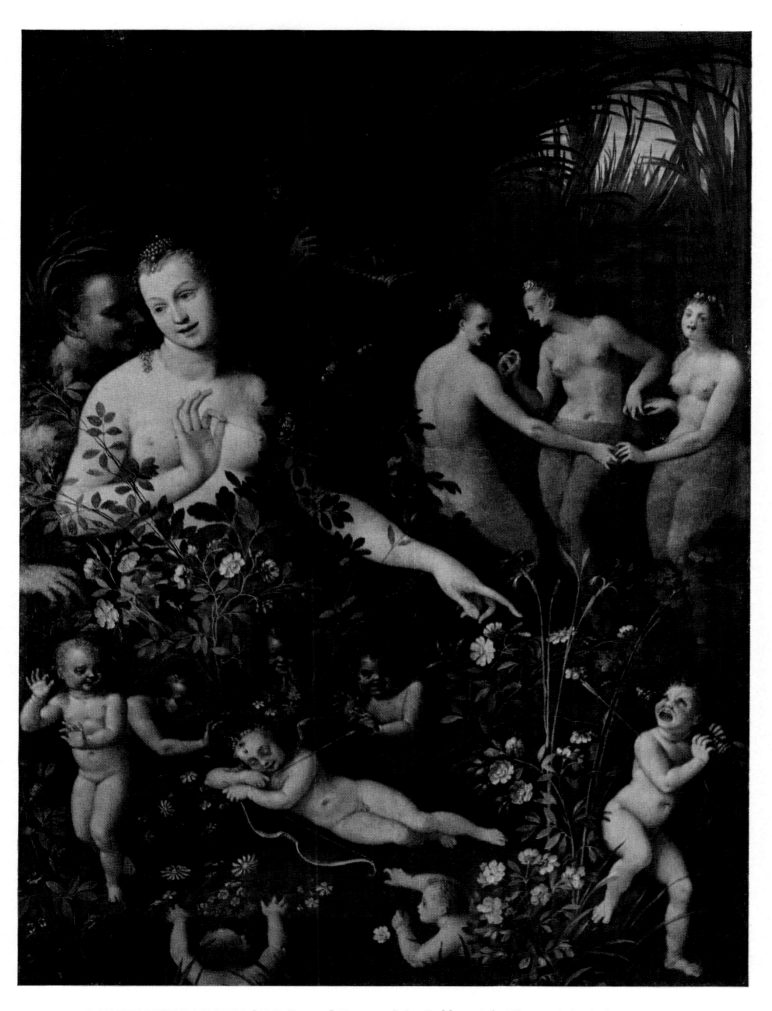

63. UNKNOWN PAINTER [*16th Century*] *Venus and the Goddess of the Waters* · School of Fontainebleau
Painted about 1560 · Oil on panel, 51⅜″ x 38″ · Commentary on page 169

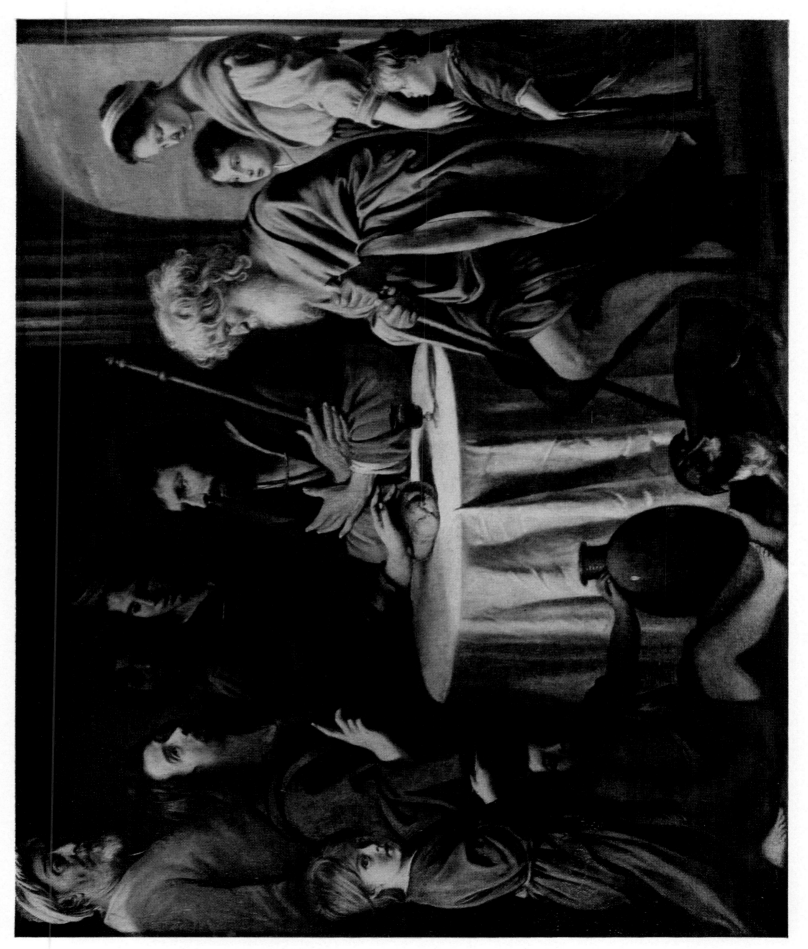

64. LOUIS LE NAIN [1593?-1648] *The Pilgrims at Emmaus* · French School · Painted about 1635 · Oil on canvas, 29⅛″ x 35⅞″ · Commentary on page 169

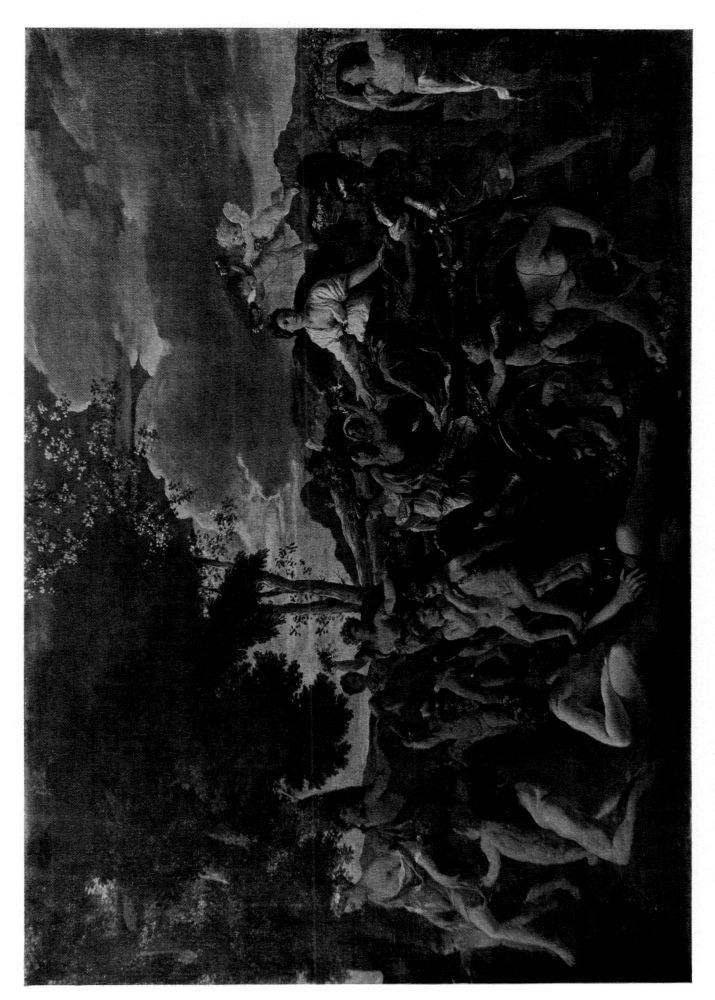

65. POUSSIN [1594-1665] *The Triumph of Flora* · French School · Painted about 1630 · Oil on canvas, 65" x 94⅞" · Commentary on page 170

66. CLAUDE LORRAIN [1600-1682] *A Seaport at Sunset* · French School · Painted about 1639 · Oil on canvas, 40½″ x 53½″ · Commentary on page 170

67. LE BRUN [1619-1690] *Equestrian Portrait of Chancellor Séguier* · French School · Painted 1660 · Oil on canvas, 116⅜" x 137¾" · Commentary on page 170

68. GEORGES DE LA TOUR [1593-1652] *Saint Joseph the Carpenter* · French School
Painted about 1645 · Oil on canvas, 53⅛″ x 39⅜″ · Commentary on page 170

69. DE CHAMPAIGNE [1602-1674] *Portrait of Arnauld d'Andilly* · French School

Painted 1650 · Oil on canvas, 35⅞″ x 28⅜″ · Commentary on page 171

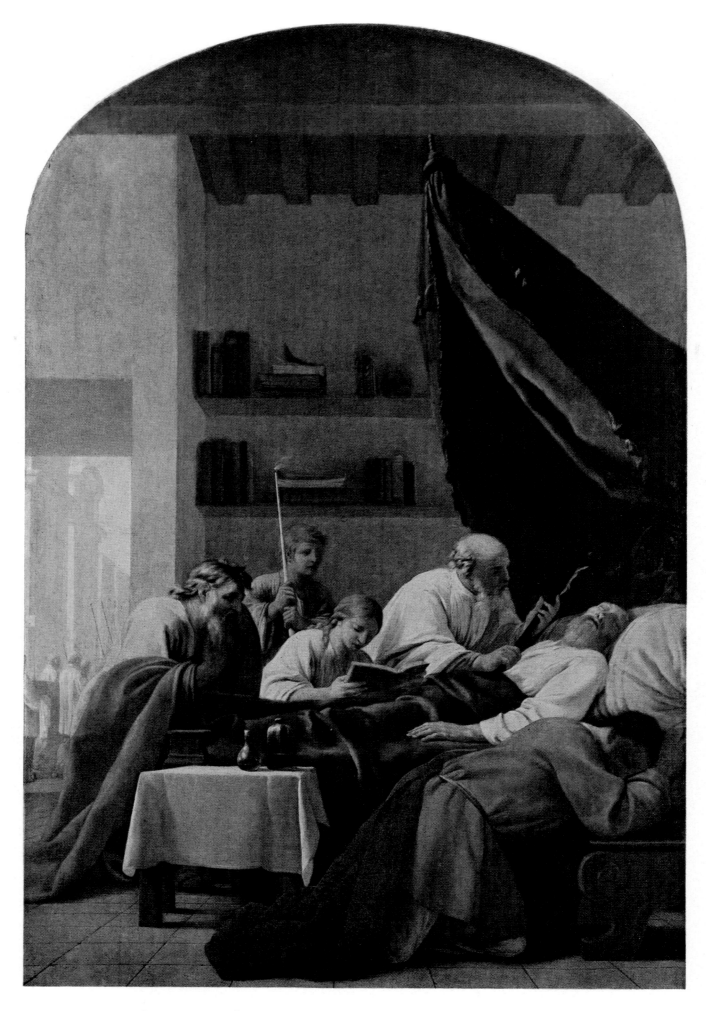

70. LE SUEUR [*1617-1655*] *The Death of Raymond Diocrés* · French School
Painted about 1646 · Oil on canvas, 76″ x 51⅛″ · Commentary on page 171

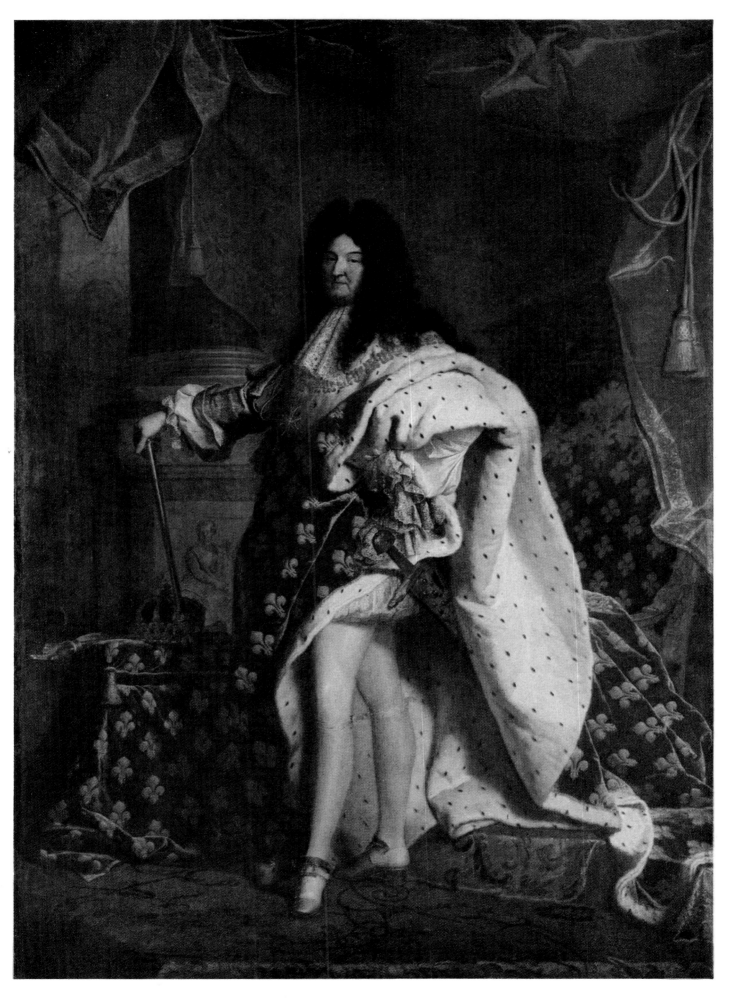

71. RIGAUD [*1659-1743*] *Portrait of Louis XIV* · French School

Painted 1701 · Oil on canvas, 109⅞″ x 74¾″ · Commentary on page 171

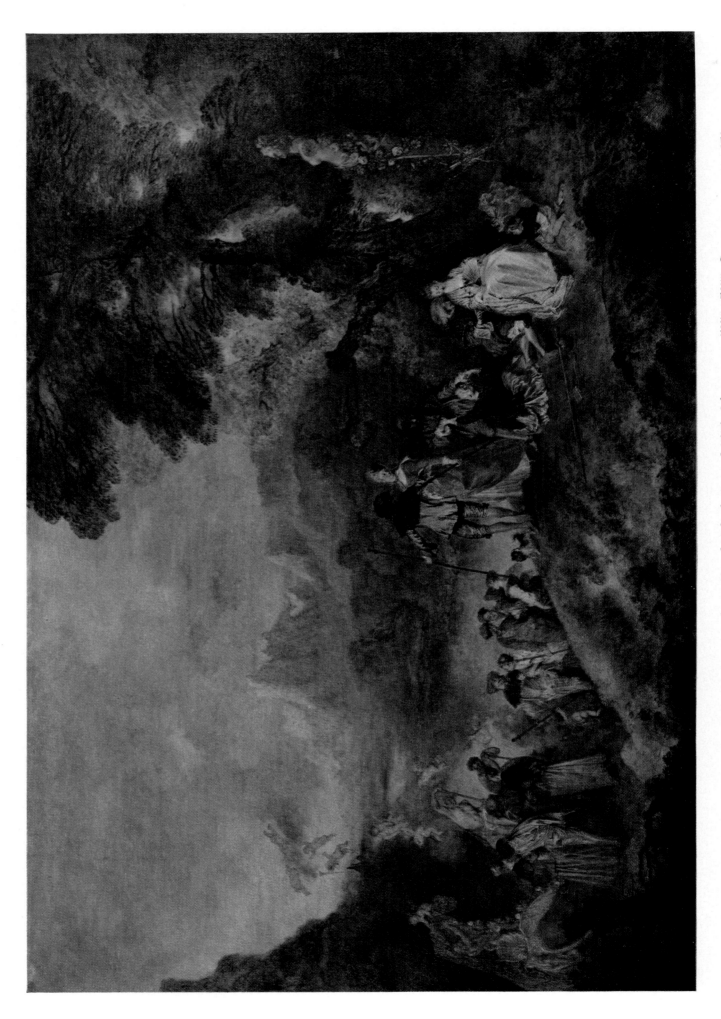

72. WATTEAU [1684-1721] *Embarkation for Cythera* · French School · Painted 1717 · Oil on canvas, 50¾" x 76⅜" · Commentary on page 171

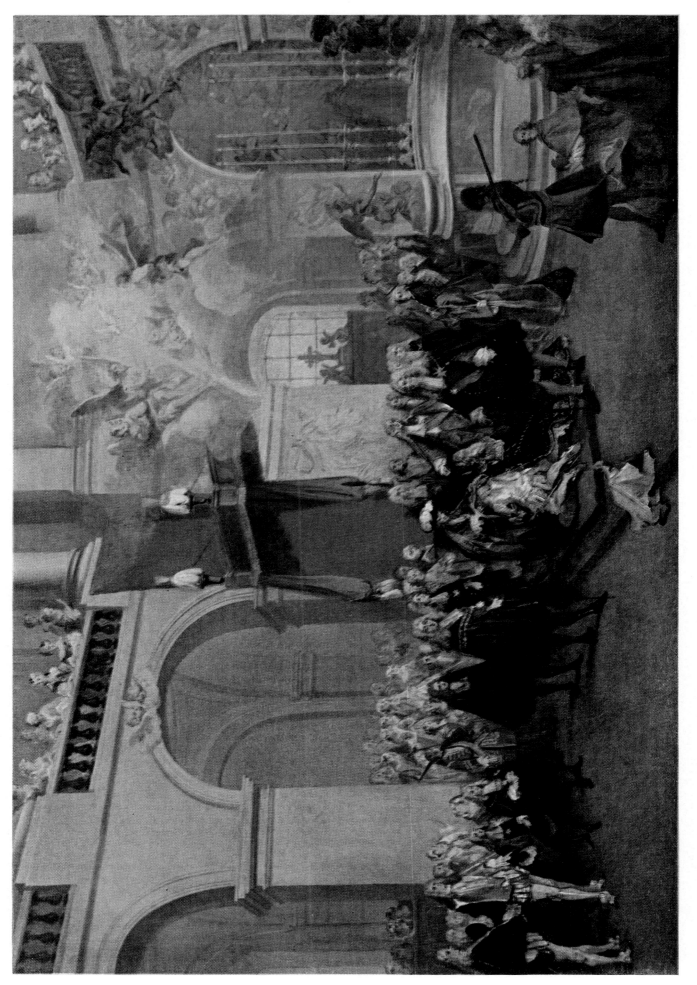

73. LANCRET [1690-1743] *Reception of the Order of the Holy Spirit* · French School · Painted 1724 · Oil on canvas, 21⅝″ x 31⅞″ · Commentary on page 172

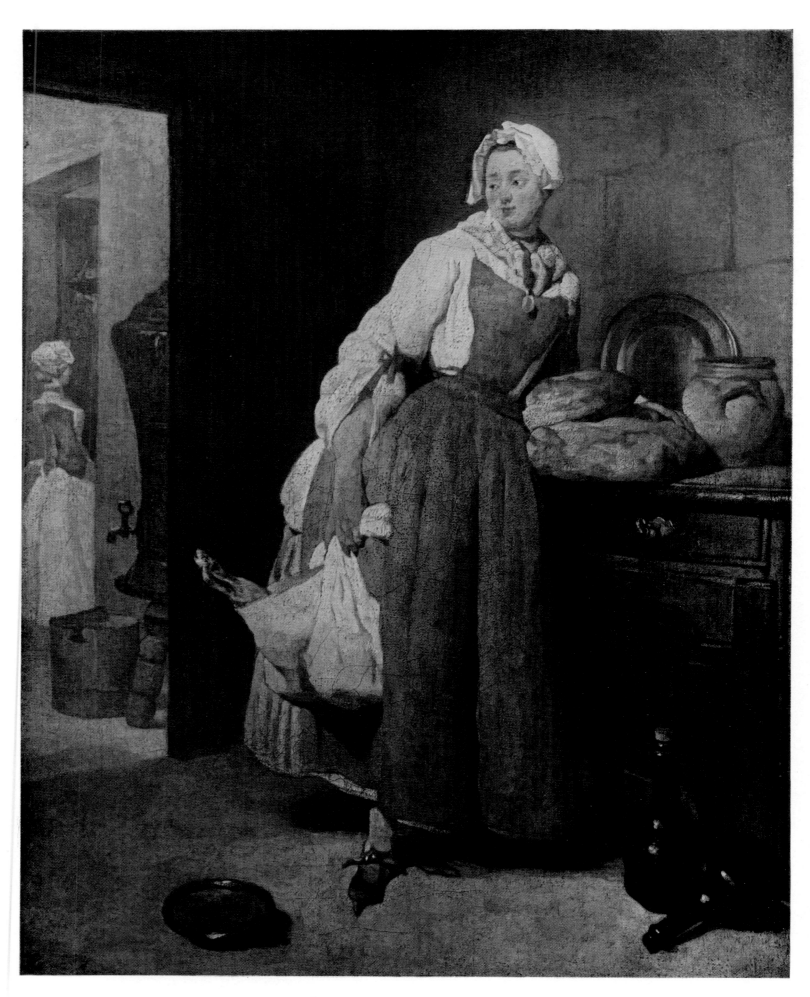

74. CHARDIN [*1699-1779*] *Back from the Market* · French School

Painted 1739 · Oil on canvas, 18⅛″ x 14⅝″ · Commentary on page 172

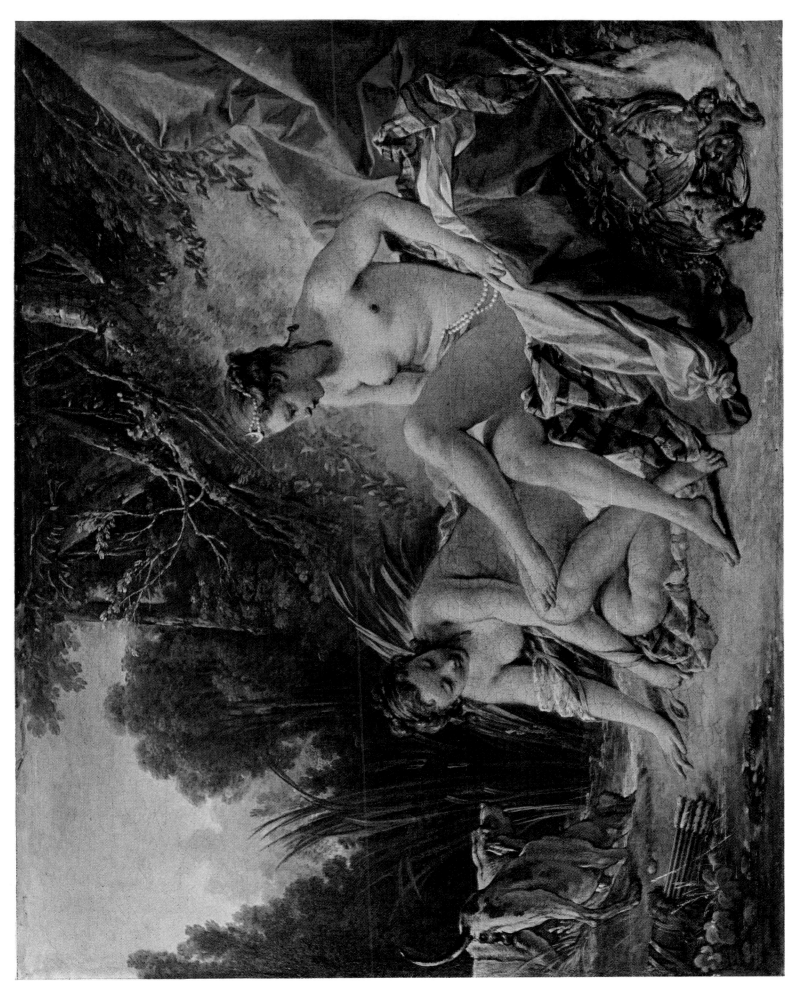

75. BOUCHER [1703-1770] *The Bath of Diana* · French School · Painted 1742 · Oil on canvas, 22½″ x 28¾″ · Commentary on page 172

76. QUENTIN DE LA TOUR *[1704-1788] Portrait of Madame de Pompadour* · French School

Painted 1755 · Pastel on paper, 68⅞″ x 50⅜″ · Commentary on page 172

77. PERRONNEAU [*1715-1783*] *Portrait of Madame de Sorquainville* · French School

Painted 1749 · Oil on canvas, 39⅜″ x 33½″ · Commentary on page 173

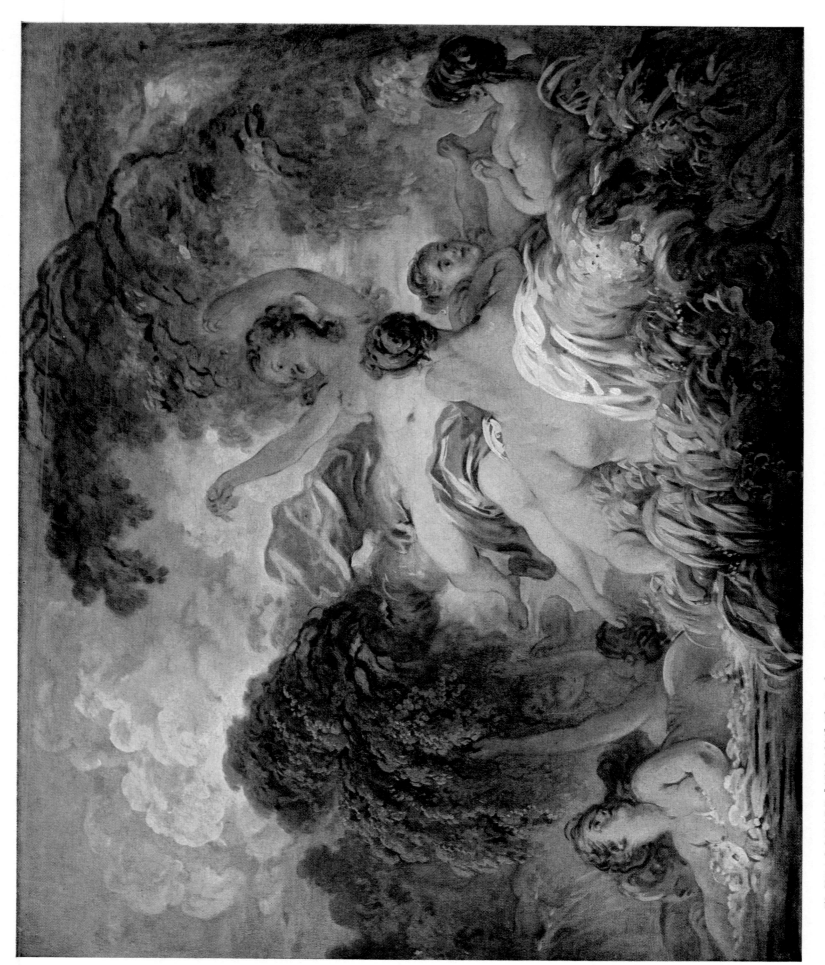

78. FRAGONARD [1732-1806] *The Bathers* · French School · Painted second third 18th Century · Oil on canvas, 25½″ x 31½″ · Commentary on page 173

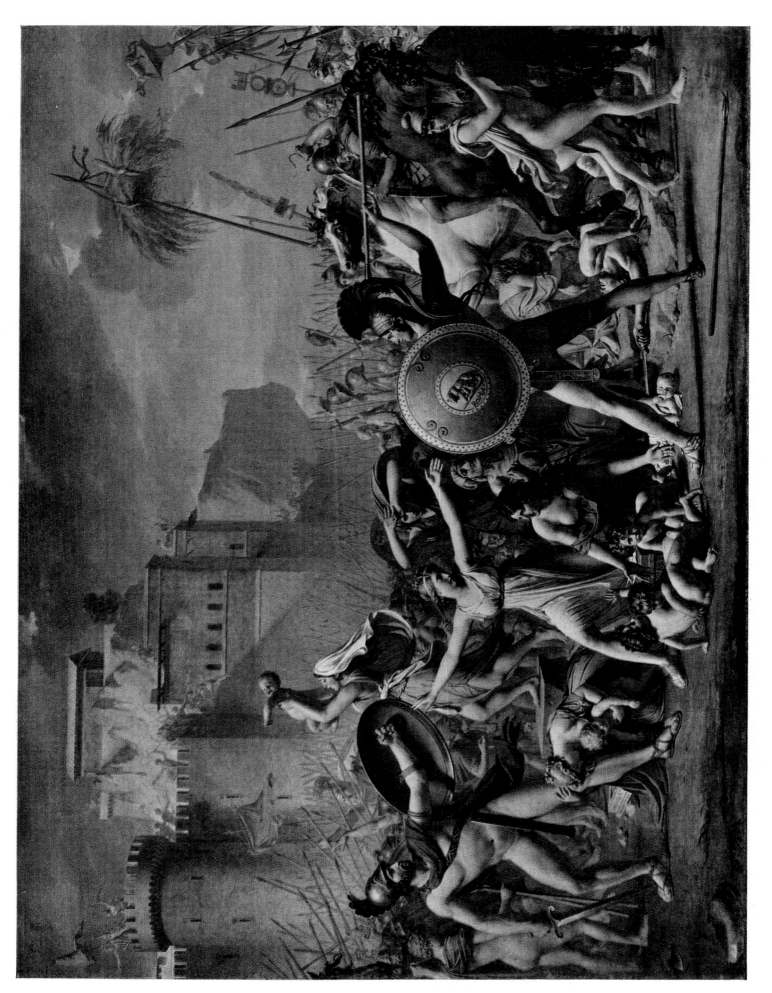

79. DAVID [1748-1824] *The Battle of the Romans and Sabines* • French School • Painted 1799 • Oil on canvas, 152″ x 204¾″ • Commentary on page 173

80. PRUD'HON [*1758-1823*] *Portrait of the Empress Josephine* · French School

Painted 1805 · Oil on canvas, 96⅛″ x 70½″ · Commentary on page 173

81. INGRES [1780-1867] *Odalisque* · French School · Painted 1814 · Oil on canvas, 33⅞" x 63⅜" · Commentary on page 173

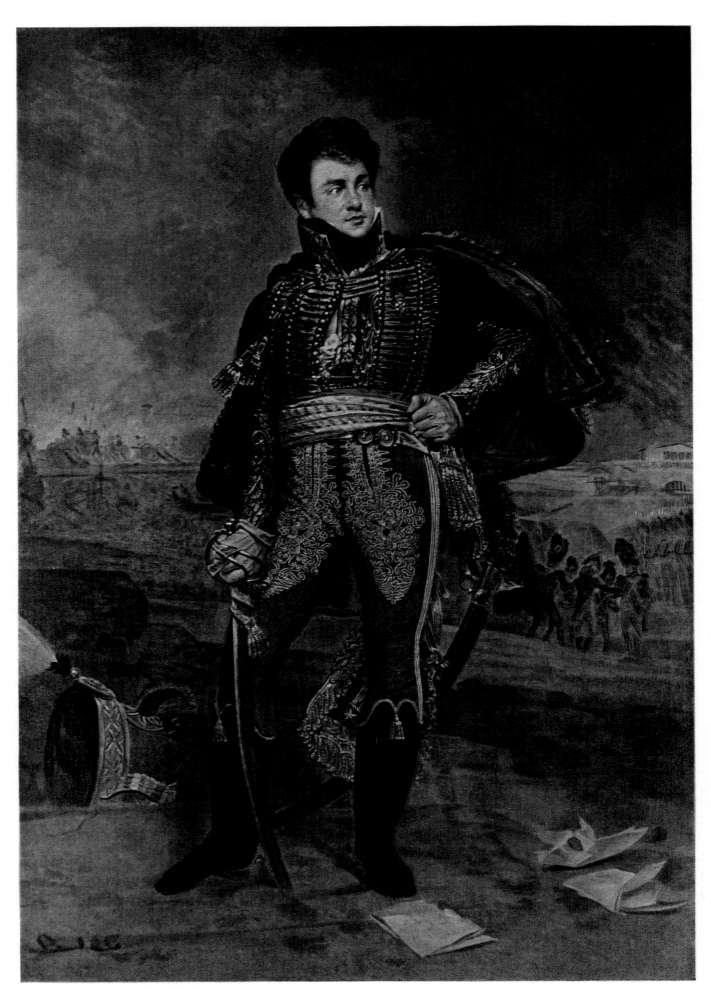

82. GROS [*1771-1835*] *Portrait of Count Fournier-Sarlovèze* · French School

Painted 1812 · Oil on canvas, 96⅞″ x 68⅛″ · Commentary on page 174

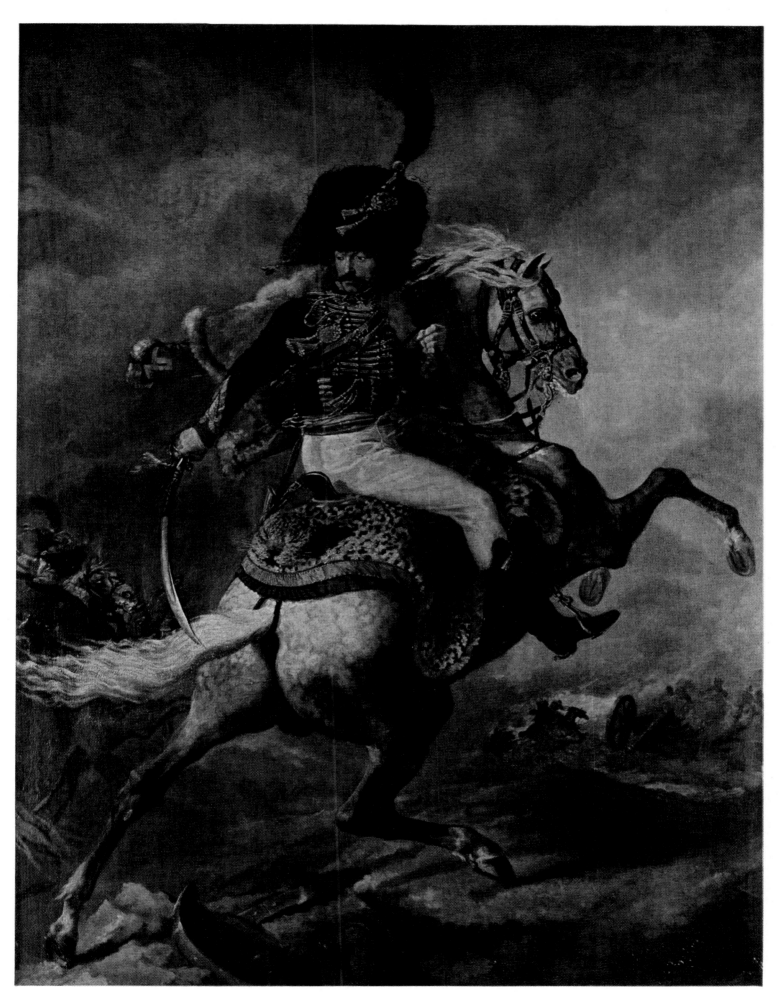

83. GÉRICAULT [1791-1824] *Officer of the Chasseurs of the Guard* · French School

Painted 1812 · Oil on canvas, 115″ x 76⅜″ · Commentary on page 174

84. DELACROIX [1798-1863] *Liberty Leading the People* · French School · Painted 1830 · Oil on canvas, 102⅜″ x 128″ · Commentary on page 174

85. THÉODORE ROUSSEAU [1812-1867] *Oak Trees* · French School · Painted 1852 · Oil on canvas, 25¼″ x 39⅜″ · Commentary on page 174

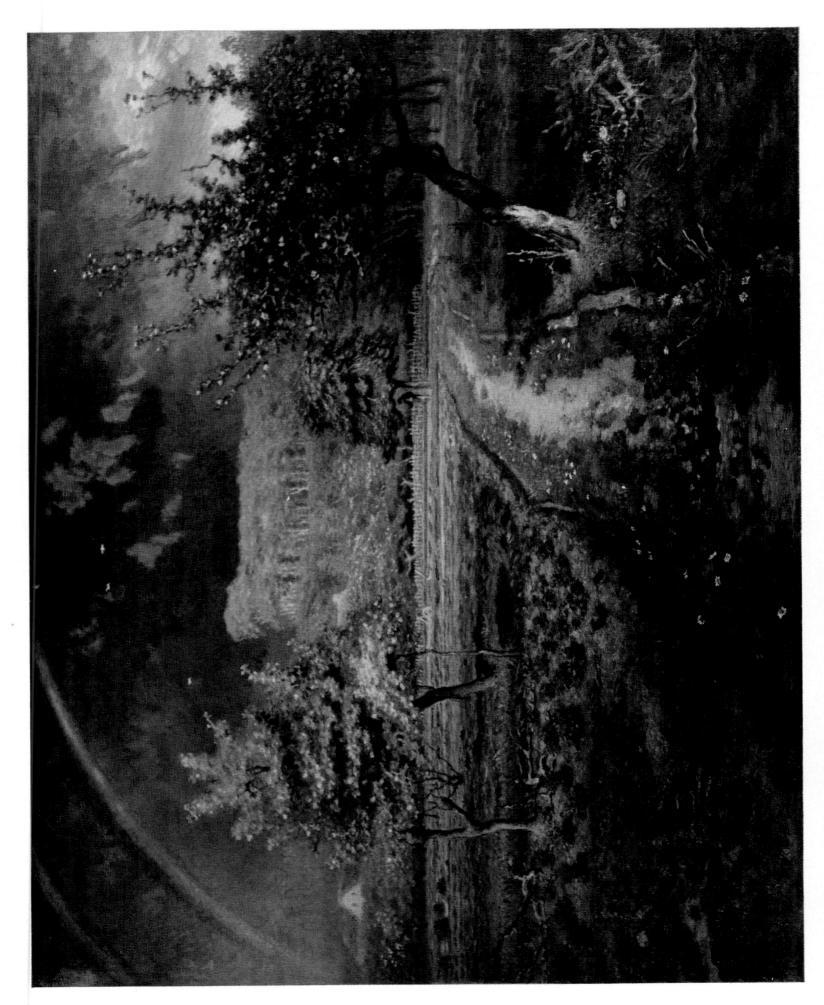

86. MILLET [1814-1875] *Springtime* · French School · Painted 1873 · Oil on canvas, 33½″ x 43¼″ · Commentary on page 175

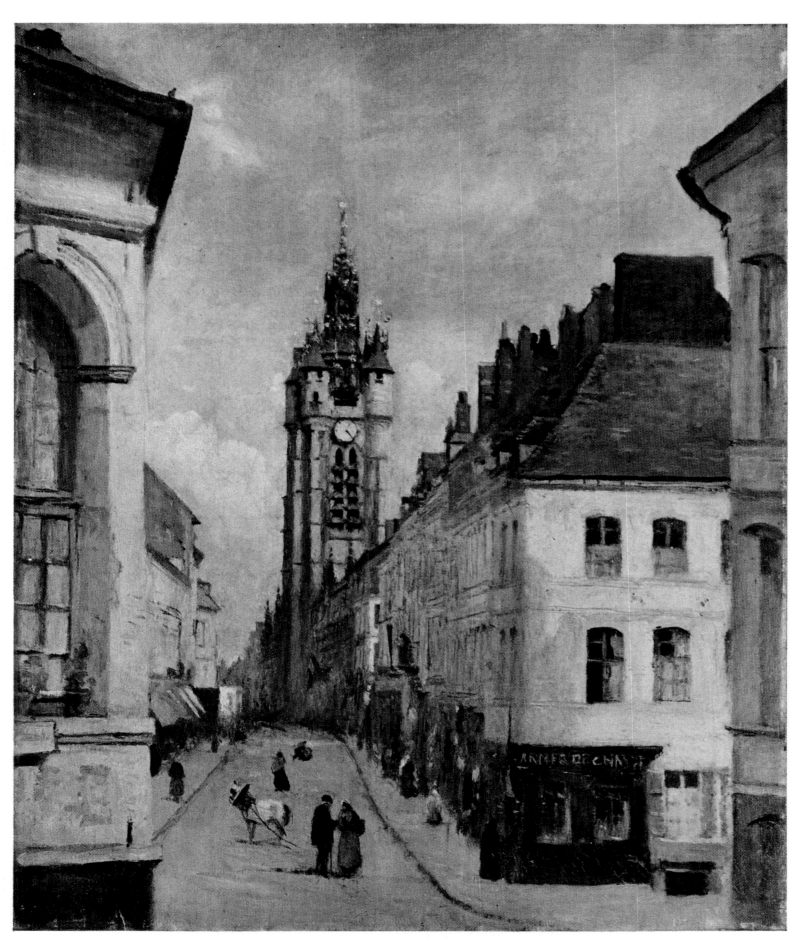

87. COROT [*1796-1875*] *Belfry of Douai* · French School

Painted 1871 · Oil on canvas, 18½″ x 15⅜″ · Commentary on page 175

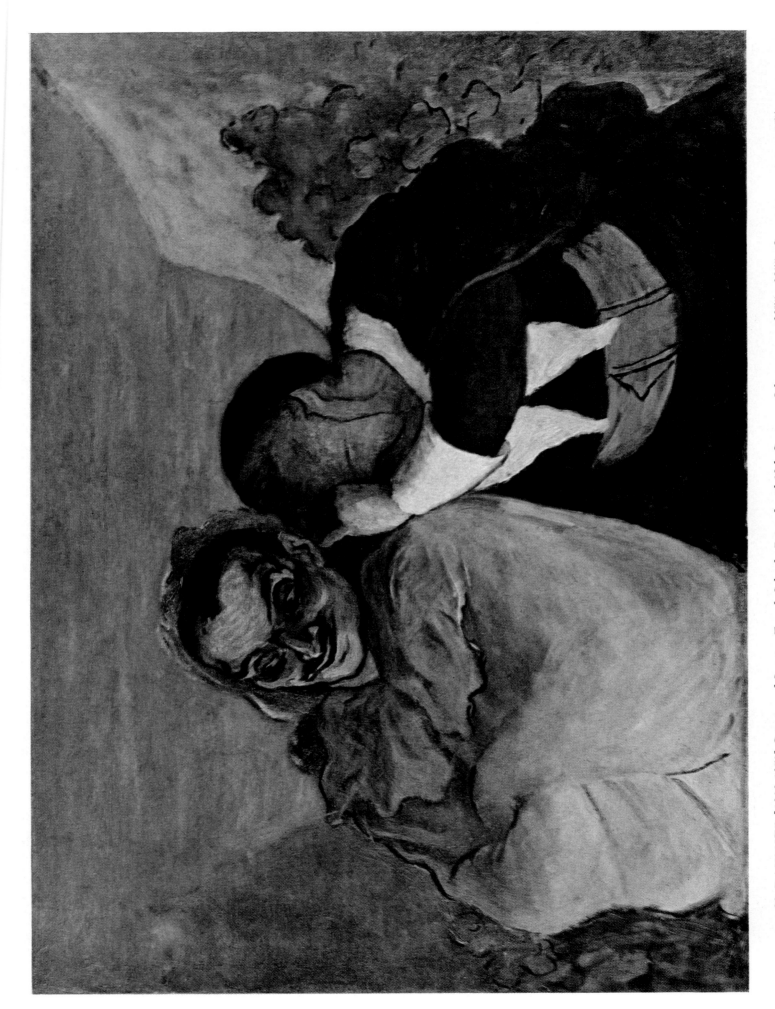

88. DAUMIER [1808-1879] *Crispin and Scapin* · French School · Painted mid-19th Century · Oil on canvas, 23⅜″ x 32½″ · Commentary on page 175

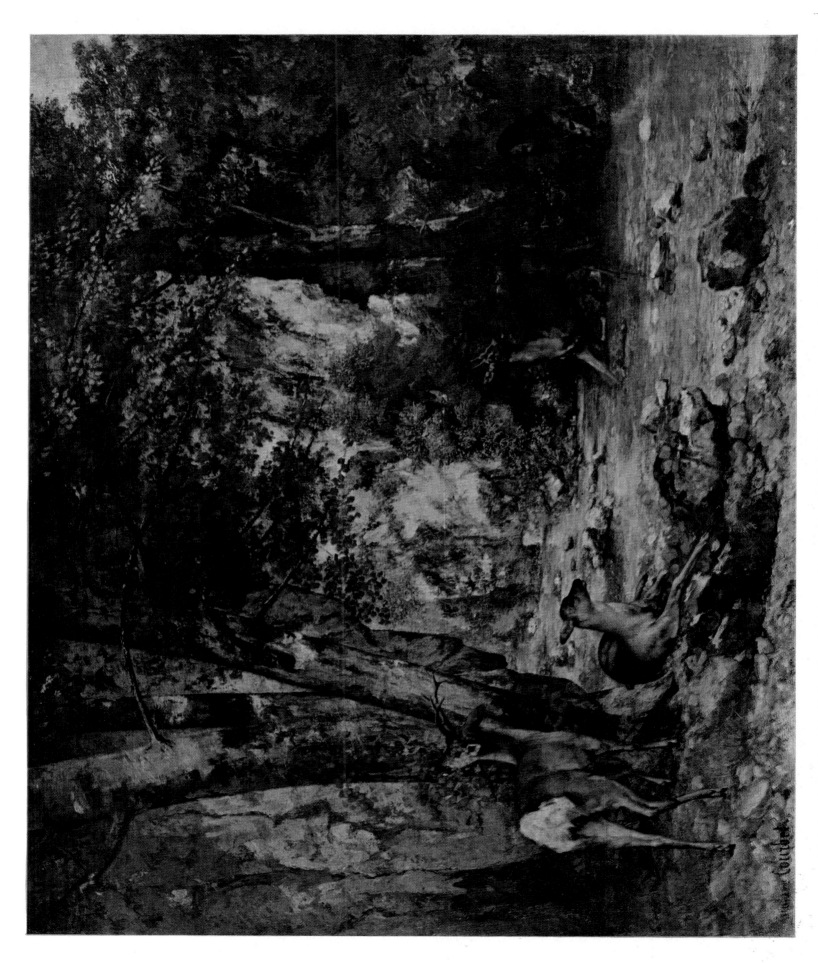

89. COURBET *[1819-1877] Roe-Deer in a Forest* · French School · Painted 1866 · Oil on canvas, 68⅞″ x 81½″ · Commentary on page 175

90. MANET [1832-1883] *Luncheon on the Grass* · French School · Painted 1863 · Oil on canvas, 84½" x 106¼" · Commentary on page 176

91. MONET [1840-1926] *Field of Poppies* · French School · Painted 1873 · Oil on canvas, 19⅝″ x 25⅝″ · Commentary on page 176

92. CÉZANNE [1839-1906] *Bay of L'Estaque* · French School · Painted 1883 · Oil on canvas, 22⅞″ x 28⅞″ · Commentary on page 176

93. SISLEY [1839-1899] *Flood at Port-Marly* · French School · Painted 1876 · Oil on canvas, 23⅜″ x 31⅛″ · Commentary on page 176

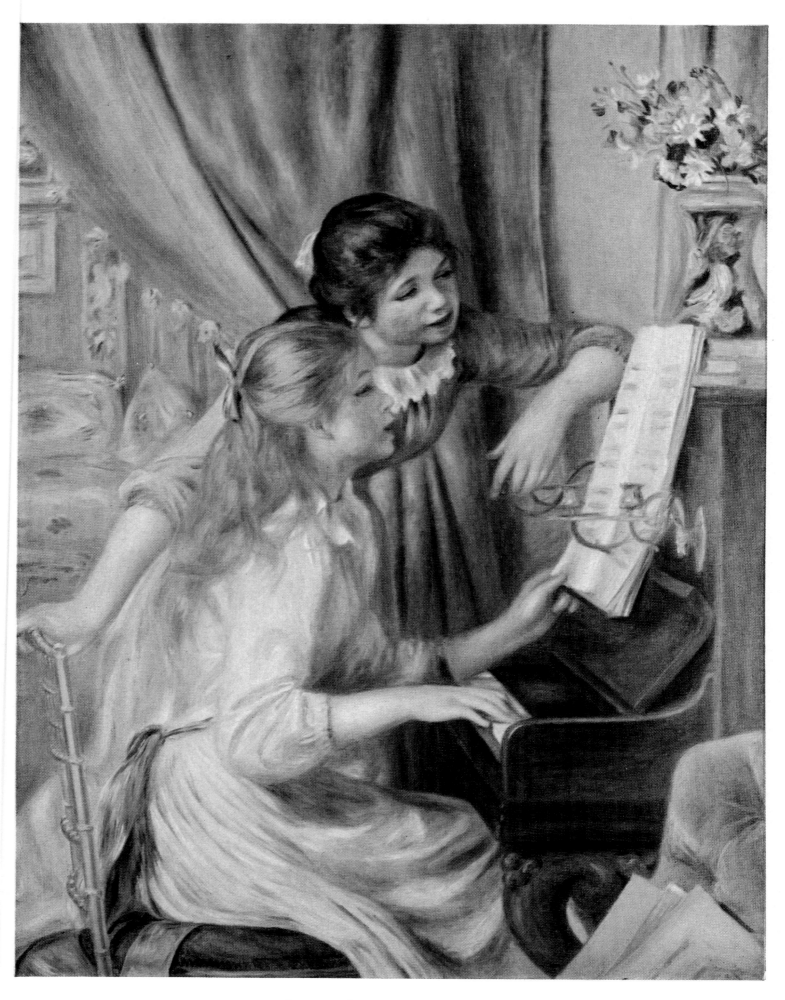

94. RENOIR [*1841-1919*] *Two Girls at the Piano* · French School

Painted 1893 · Oil on canvas, 27¼″ x 23¼″ · Commentary on page 177

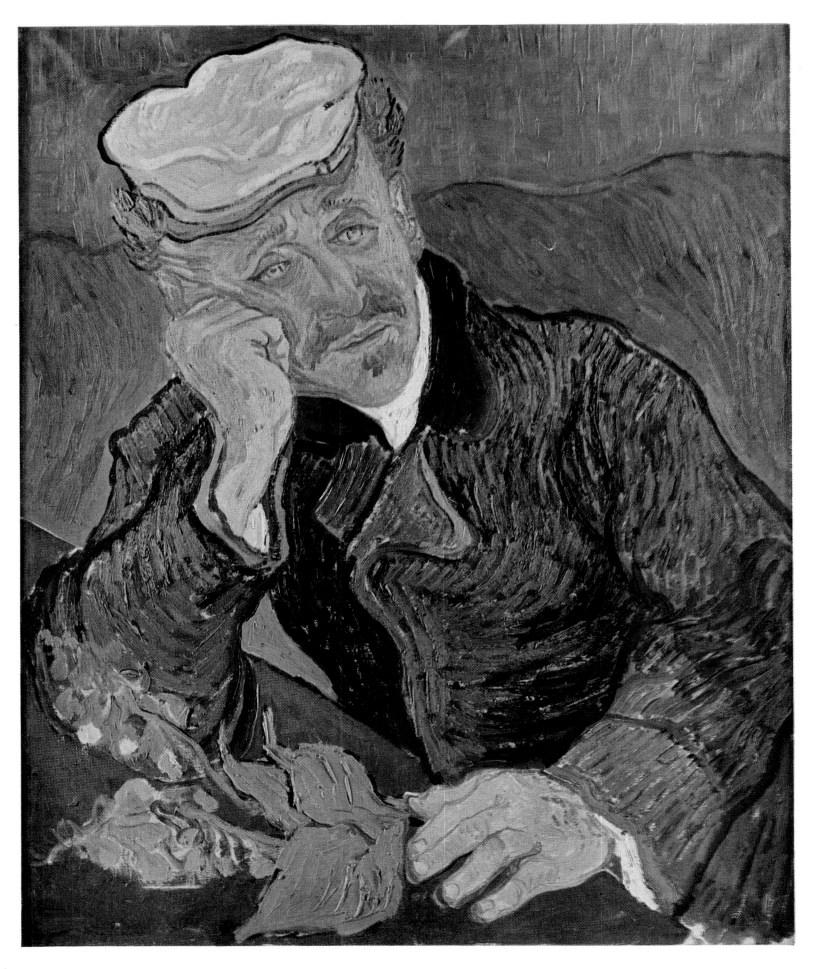

95. VAN GOGH [1853-1890] *Dr. Gachet* · French School

Painted 1890 · Oil on canvas, 26¾″ x 22½″ · Commentary on page 177

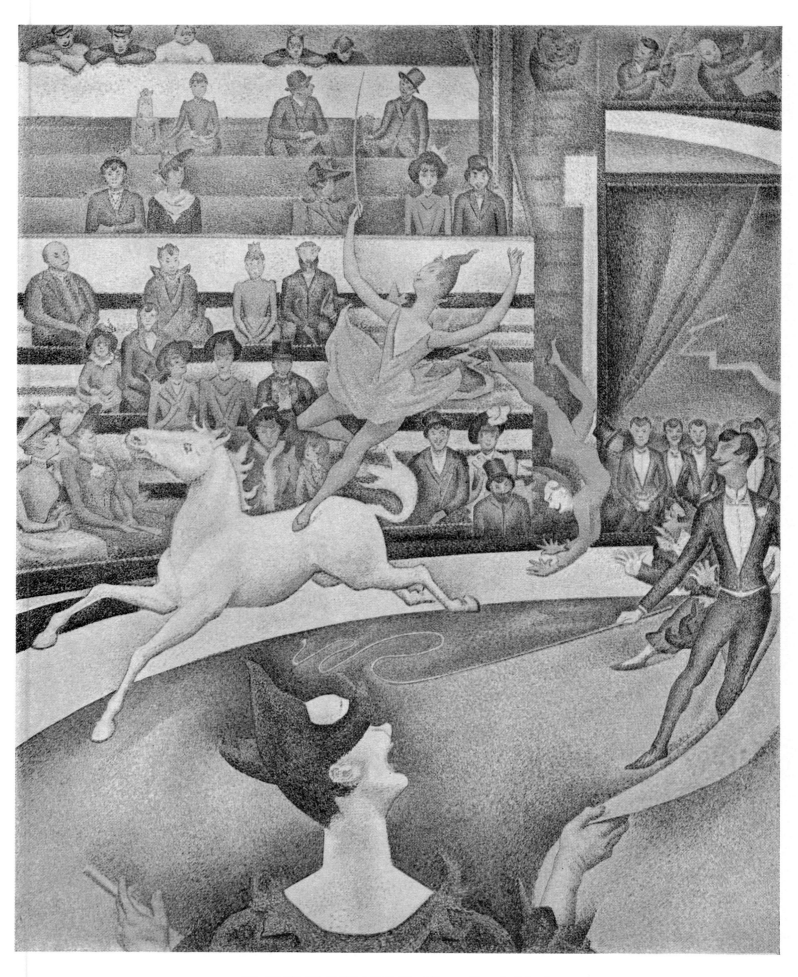

96. SEURAT [*1859-1891*] *The Circus* · French School

Painted 1891 · Oil on canvas, 70⅞" x 58¼" · Commentary on page 177

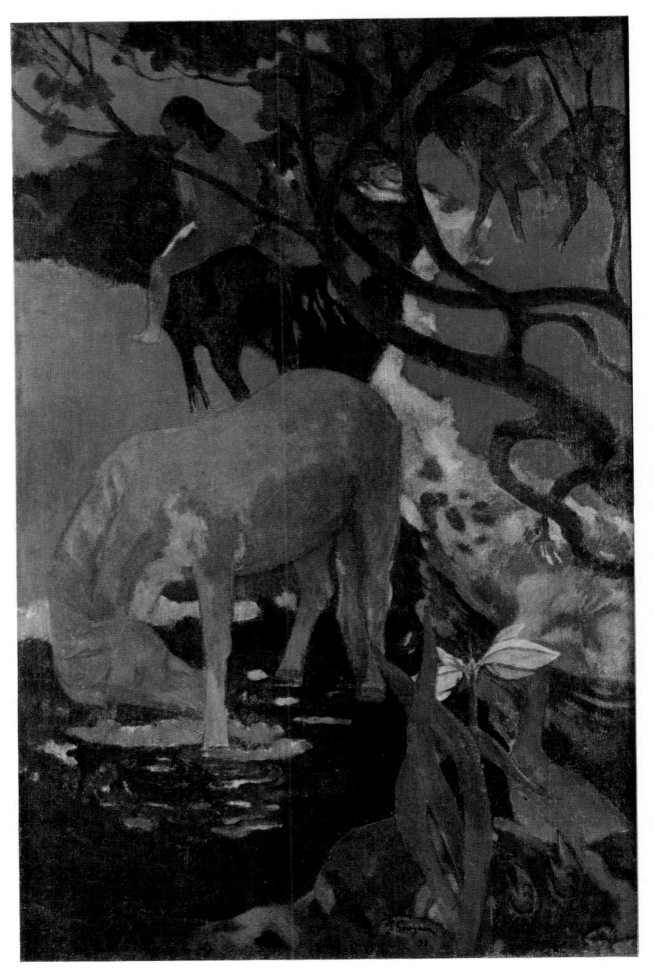

97. GAUGUIN [*1848-1903*] *The White Horse* · French School

Painted 1898 · Oil on canvas, 55½″ x 35⅞″ · Commentary on page 177

98. DEGAS [1834-1917] *Dancing Class at the Opera* · French School · Painted 1872 · Oil on canvas, 12⅞" x 18⅛" · Commentary on page 178

99. TOULOUSE-LAUTREC (1864-1901) *Portrait of Paul Leclercq* · French School · Painted 1897 · Oil on cardboard, 21¼″ x 25¼″ · Commentary on page 178

100. HENRI ROUSSEAU (1844-1910) *War* · French School · Painted 1894 · Oil on canvas, 44½″ x 76″ · Commentary on page 178

(Continued from page 96)

fire that blazes in the silhouette of his *Fournier-Sarlovèze* (plate 82). To celebrate Napoleon's victories and expeditions, Gros, too, painted immense canvases in which, carried away by the intensity of his subject, he throws aside classical discipline, hurls in cavalry charges, and makes his colors stand out as brilliantly as battle flags. Without intending to do so, Gros, who regarded himself as a champion of tradition, gave his own definite impetus to Romanticism, the revolution that was about to discard him.

Géricault, in turn, swore only by Gros: but he is endowed with a power and energy reminiscent of Michelangelo. He hurls upon his canvas horsemen in frantic career, like his cavalry officer (plate 83), or panting in the smoke of battle. He, too, dares to paint enormous canvases, the largest of which is the *Raft of Medusa* with its shipwrecked sailors whose magnificent bodies combine the severity of Classicism with the irrepressible movement of Romanticism. In him we find not only all the fruits of Romanticism but also the solidity of the realistic school that was to come after it.

There is no more striking sight than the great halls at the Louvre which have been hung only with those gigantic canvases which, from David to Courbet, testify to an ease and grandeur of which only the Italian Renaissance could offer an equally constant example. Between the virile and massive strength of these paintings and the frivolous graces of the eighteenth century there could be no stronger contrast.

After Géricault, Delacroix, his friend and his junior by several years, dominated the nineteenth century. Nervous and feverish, afire with an imagination almost unknown in French art, Delacroix occupies a position which public opinion is still slow in recognizing. He is one of the loftiest geniuses of the French school, a man of the same stature as Poussin. He dominates Romanticism by his ability to make of a picture an instrument by which the soul expresses, as if by means of music, its tensions, passions, and torments. In his work there is no longer any question of respecting the rigid rules of form and design; all these are swept away in the rhythm of inspiration. In his colors, especially, he invents tonalities and harmonies as evocative and unexpectedly haunting as the piano nocturnes of his friend Chopin. His art erupts into the century like the fiery symbolic figure

brandishing her brilliant flag in his *Liberty Leading the People* (plate 84).

Yet for all his flamboyance and power Delacroix was justly entitled to claim that he was also a Classical painter. He can be so designated by virtue of the balance he preserves between the impetus of his senses and the lucidity and discipline of his intelligence. He is the culmination of that great trend by which painting was to reveal the seemingly most inexpressible secrets of the individual soul. To gain freedom of execution it could scorn enslavement to literal reality and allow itself the freedom and range of music.

One man took his stand against Delacroix and condemned his innovations. Considering himself of the line of Raphael, Ingres fought to preserve

A wardrobe of the period of Louis XIV, by André-Charles Broulle, furniture maker to the king. The severe lines of the piece are in contrast to the rich ornamentation. Made of oak, it is covered with tortoise shell and ormolu inlay which is chased with fine tracery. Fishing, hunting, and farming motifs are on the doors.

the classical tradition. Less virile than David, whose pupil he was, capable of refinements and of a subtlety within flexibility, especially conspicuous in his prodigious drawings, Ingres was the painter of the nineteenth-century bourgeoisie. In his double program, realism was to be achieved through idealism: realism by means of a probity that scrupulously refrains from "cheating" in the presence of what the eyes behold, in order to capture it with the skill of a Flemish primitive; idealism that seeks to subject art to the laws of beauty, in order to extract from reality its purest harmonies. Here once again we have the aims of the classical Renaissance.

Like David, Ingres' art was weakened when he obeyed his principles and his desire for an "ancient" beauty; but in portraiture he was incomparable. He had the same honesty as his master, but he added to it something more voluptuous, which tells us that the austere "virtue" of the Revolution was by now being softened by a re-acquired luxury. In his *Odalisque* (plate 81), for example, Ingres achieves a feeling of classical purity mixed with studied elegance. "He is a Chinaman lost in Athens," the sculptor Préault said jokingly.

By the middle of the century French painting was torn between two trends. The reaction that had been born with David was becoming more and more closely confined within lifeless rules that reduced it to mere conventionalism. Opposing this was an individualistic tendency, passionate and romantic in vision and openly flouting everything to which the public had become accustomed.

Meanwhile, however, remote from conflicts and theories, one man, a contemporary of Ingres and Delacroix, was instinctively maintaining the most ancient tradition of French art: poetic realism, truth steeped in emotion and inspired by love of nature. This painter was Corot. A descendant of the eighteenth-century landscape painters, he too was obsessed by the subtleties of light. At the same time he was steeped in traditional culture. Like Poussin he adored Italy; like Poussin, again, he felt that a landscape was enriched by mythological presences. He liked to imagine Homer standing by the road he was painting, or to catch a glimpse of nymphs dancing through the veils of the morning mist. He set upon his canvas what he saw and what he dreamed: his vision, which

was prodigiously keen and observant of the subtlest values of light; and also, like Chardin, his heart.

Without any intention of being a revolutionary, Corot led painting toward an entirely new future. He restored to it the simplicity of the primitives, obscured by so many conflicting doctrines; yet at the same time, when confronted by nature—when contemplating the *Belfry of Douai* (plate 87)—he was aware of the last stage that Western painting still had to pass through in order to achieve its conquest of reality: the mastery of light, the element which was by definition the most impossible to master, the most impossible to transpose onto canvas.

The realism to which Corot gave new life was encouraged toward the middle of the century by two revelations of extraordinary importance. The first of these was in science. Its unprecedented successes and the limitless opportunities it offered

Door of a burial chamber. Palestine, Roman epoch. This limestone door is symbolically decorated with the candelabrum at upper-left, rose-shaped designs, and at the bottom, an arched niche with columns and a conch. It is richly varied yet unified in effect, ornamental as well as sanctifying. 35¼″ high.

for man to multiply his power through the strictly objective study of positive reality gave impetus to similar ideas in art.

The other revelation was of a social character. Industrial progress, by increasing the working class, revealed a new and growing force, the people. This force had asserted itself in the revolution of 1848, and art could not fail to be affected by the repercussions. Realism, to which art was already returning, was to incline toward the most humble and simple truths, in a movement analogous to Caravaggio's on the threshold of the seventeenth century. From realism, painters were ready to make a rapid transition to naturalism.

The taste for nature, studied in solitude with absolute honesty of method, was revealed in the Barbizon school, dominated by the lofty figure of Théodore Rousseau. The last gleams of Romanticism, which now had had its day, gave this scrupulous and passionate landscape painter, inspired by the example of the Dutch, a note of melancholy. A pantheist, he felt the presence of God everywhere: in the proliferation of grass and dust, in his titantic *Oak Trees* (plate 85), and in the horizons fleeing out of sight. Thus he remained more a disciple of Romanticism than a forerunner of Impressionism.

Rousseau's friend, Jean François Millet, shared his feeling for nature. In some of his landscapes—his *Springtime* (plate 86)—he reveals a massive and serenely lyrical truthfulness. But in Millet's work, a growing interest in the people is evident. Primarily concerned with peasants, he lovingly recorded the hereditary nobility of their simplest gestures. His *Angelus* and his *Gleaners* are today regarded with excessive scorn, as if in compensation for the no less exaggerated praise that was once bestowed upon them.

Daumier, involved through his lithographs in the political and social conflicts of his day, turned more deliberately to the people. Like Millet, he has an amplitude of stroke that transforms reality and imprints on it an urgency, a dumb violence that, again like Millet's, is traversed by an inner thrill of lyricism. Both these painters remind us that Romanticism was not yet extinct, and that they, too, owed something to it. But already the blaze of individualism, the passionate confession of passion, was beginning to lose its meaning for them. Daumier, especially, was no longer interested in the peculiarities of the individual. What

A Greek amphora of the end of the fifth century B.C., found at Milo. Of great terseness and animation, the drawing, executed in red terra cotta against a black background, depicts a battle between gods and giants. The Greeks devised many types of containers for highly specialized uses; the amphora was designed to hold oil or wine. 32″ high.

he saw were types, collective characters: the actor and the lawyer, Crispin and Scapin (plate 88), the art collector, or sometimes crowds. The zest that induced him to set his powerful and wilful stamp upon nature was no longer of a subjective, personal character; it expressed his self-abandonment to the popular life-force borne by him.

The hostility that Daumier displayed toward the triumphant middle classes became, in Courbet, active and aggressive. Furthermore, Courbet did not abandon himself to this warfare solely by instinct. He frequented the company of theorists of

Socialism, and assimilated—with varying degrees of success, it may be said — their doctrines as applied to painting. The result was an art in which realism violently took shape under its double aspect. On the one hand, he attained total objectivity, the obligation to paint only what one saw, as one saw it; and, on the other hand, resolute study of the subjects closest to truth—that is to say, of the people and their simple life. To a rustic burial or the painting of *Roe-Deer in a Forest* (plate 89), Courbet devoted canvases of a size which at one time had been reserved for what were held to be more noble subjects. His work marked the birth of naturalism.

Courbet, a master painter, was capable of obtaining new effects from the pigment which he applied, making it as smooth as enamel or brushing it on in corrugated streaks. He seems to combine the vision of Caravaggio with the execution of Velasquez. Never has the conception of painting been more a slave to reality; but never has its technique been more independent in order to pursue the painter's own researches.

It was at this point that naturalism began to give way to Impressionism. Edouard Manet, an admirer of Courbet, strove to develop even further the possibility of simultaneously "representing" something while extracting a new savor and beauty from the bold play of paint, stroke and color. Even more than Courbet, Manet paid a tribute of admiration to the Spaniards, and especially to Velasquez, for their exactitude of effect and boldness of method. His first paintings—his *Luncheon on the Grass* (plate 90), for example—proclaim the Spanish influence.

Less encumbered than Courbet by ideas and social programs, Manet helped to free painting from all extraneous concerns. He painted in order to paint, in order to paint well. He took an increasing interest in the experiments of those young artists who were founding Impressionism, and he extended such generous patronage to them that he was soon recognized as their chief.

Under the banner of the realism that had decisively triumphed in this second half of the century, Impressionism accentuated the tendency to turn painting inward upon itself. What, by definition, was a painter? A hand capable of reproducing upon canvas what the eye perceived. The realists had already enjoined the artist to paint nothing but what he saw; theories that idealized

reality or transformed it were to be discarded. The Impressionists felt that realism did not live up to this program; under the pretext of painting what he saw, the realist was actually only describing forms by their outlines, masses by their relief, surfaces by their color. But all of these elements—forms, masses, colored surfaces—were isolated by the mind which recognized and defined them. The eye, for its part, did not know so much; it preceived only light, mere patches of color devoid of meaning until the brain intervened.

For the Impressionists it therefore seemed to be an immense advantage to turn back to the raw material of vision. The intervention of the intellect, no matter how spontaneous, could only interpret and denature that vision. However accurate a picture might be, it was always inferior to real light. By compelling himself to record side by side on his canvas all the sensations of color his eye received, the artist would reawaken those same sensations in the person who looked at the painting. With this object the Impressionist applied touches of color which seen from a distance would reconstitute his original perception. Jarred by the novelty of these paintings, the public cried scandal; but at least painting had finally succeeded in mastering light just as, four centuries before, it had succeeded, by means of perspective, in mastering the illusion of depth. Such was the program and the achievement to which the Louvre recently devoted an entire museum, the Jeu de Paume, in which one can follow step by step the development of Impressionism and of the movements contemporary with it.

Very few of the Impressionists, however, carried out their program in all its aspects. The man who came closest to doing so was Claude Monet, the recognized center of the group. Interested only in landscape, and there only in its lighting, he came to disregard the identity of a given object —a poplar, a mill, or even Rouen Cathedral—to such a degree that it appeared different to him at each different time of day. He multiplied and diversified his image, thus inaugurating what has been called the "series" style of painting. Becoming more and more powerfully lyrical as he grew older, Monet lost himself in the impalpable clouds of light and the fugitive reflections which dance upon the waters of his pool of waterlilies.

Pissarro, who retained a secret attachment to Millet, gave his landscapes a more rural character

Wooden boat (tomb furniture). Egypt, Middle Empire, 28″ long. This model of a pleasure boat was probably designed to give the deceased the illusion of a voyage on the Nile. Crouching in the cabin with curtain raised to admit the breezes of the river, he inhales the perfume of a flower; his servants kneel before him.

and often enlivened them with figures of peasants. Sisley, an Englishman, devoted himself to the pursuit of the soft nuances of light (plate 93).

"Impressionist" is a designation which includes a number of painters who actually deviated from theory. Some of them regarded Impressionism less as an isolation of sensations of light than as a keen, instantaneous observation of gesture. Manet, in fact, had elements of both, and these painters, the greatest of whom was Degas, were developing only one of the two possibilities he suggested.

The son of a prominent bourgeois family, Degas took only a subsidiary interest in nature and devoted much more of his attention to the life of Paris, the world of the ballet and the opera. A deep admirer of Ingres, he was reluctant to abandon drawing, of which he was clearly a very great master. Moreover, of the task that Impressionism had set for itself to capture the elusive and insubstantial, the role he reserved for himself had much more to do with action than with light. But gradually, as he grew older and his sight began to fail, he allowed himself to be seduced by color. In dazzling pastels, with powdery shades of electric intensity, he captured the mirage of his ballerinas with more mobility than ever.

Degas' work was carried on by an admirer, the sickly and short-lived Toulouse-Lautrec. Endowed, like his master, with a gift for incisive drawing, his characteristic is the crackling and leaping pictorial stroke; laid on in vivid arabesques, the color itself is compelled to seize the revealing detail in an attitude or a face, and even to develop it to the point of biting irony. This is evident in his *Portrait of Paul Leclercq* (plate 99).

Degas and Lautrec broke away from pure Impressionism mainly because they were attached to old values—such as draftsmanship — which they could not bring themselves to disown. But others of the adherents of the new school began to leave it because they felt its deficiencies. They were indebted to Impressionism, as were all subsequent schools, for having made them aware of the independence of their art. In the future that art was to insist on being only painting and not an instrument for presenting ideas or anecdotes. But they felt that painting as Impressionism defined it was still the slave of reality. Though it had freed painting from the conventions that were supposed to represent reality, Impressionism believed that its only function was to reproduce reality. Why not escape this final slavery? Modern art was to take this ultimate step.

But if the task of painting was not the faithful representation of nature, then what mission was left to it? To this urgent question the abstract school of the twentieth century was to reply that painting could, and even should, take the utmost advantage of the elements that compose it—that is, of lines and colors combined upon a surface.

Already, at the time when Impressionism seemed to have triumphed, the seed was sown for its future downfall. Certain of its disciples were beginning to use painting to interpret their sensibilities, whilst others were to use it to record the order proper to human thought.

Let us turn first to the exponents of sensibility: more and more they were to convert painting into an art of expression. Renoir, to start with, seething with ardor and uplifted by the same joyful lyricism as Rubens or Fragonard before him, realized what an astonishing image of life could be supplied by color, especially by the color that Impressionism had intensified with all the brilliance of light. He did not break away from reality, since the passion for life by which he was animated could never be satisfied or find expression except in its contemplation. But from reality he took exclusively those things that sing the praise of life, its sovereignty and its splendor: woman, her flesh in which blood pulses and on which brightness lingers; flowers, which are light's perfume; fruit assembled in still lifes; and landscape—the landscape of the Midi, saturated with sunshine, riotous with verdure. Taking his first inspiration from the spectacle of pleasure parties of young people enjoying their ease in suburban parks or boating, he began by uniting the Impressionism of light with that of his own acute observation of human beings. After that he pursued his dream of fleshly forms whose fullness and sanguine splendor he continually enhanced.

Van Gogh went further in the same direction. He, too, had been obsessed by life's intensity. But where Renoir had found only a blossoming splendor, van Gogh found battle and drama. Life, whose gigantic fermentation he perceived within him and around him, overwhelmed and crushed him. It was to leave him broken, to hurl him into the vortex of madness, to drive him to suicide. This tragic destiny van Gogh transposed into—or, rather, realized in—his painting. In it the world takes on the topsy-turvy, sometimes hallucinated appearance that it had in his nightmares. He himself emerges, breaking forth from his canvas like a shout, his gaze heavy with anguish and violence, against a background that writhes and surges, except when, as in his *Dr. Gachet* (plate 95), the phrenetic style of execution contradicts the apparent nonchalance of the subject.

But outside this torrent hurtling toward Fauv-

ism and Expressionism, there were men who perceived that painting could enable them to give realization to dreams of the spirit, to bestow upon outward appearances an order and harmony which reside in these appearances but can be made manifest only in painting. They were to construct lines and colors in accordance with the architectural laws and rhythms proper to their formal qualities. To make use of the distinction drawn by Nietzsche, they are the Apollonians, as opposed to the Dionysians, whom we have just encountered.

The first of these was Cézanne. He did not feel that the power of fervent observation and the intense luminosity of color revealed by Impressionism were at all incompatible with the idea of pure form. The prodigious undertaking which he launched, aimed at the conquest of the absolute, no less, and laid the foundation of all modern art. Repudiating every convention and artifice, he heeded nothing but his amazingly exact sensation of color in order to suggest the masses he was painting. Like a classical artist he conceived of these masses in their deepest simplicity and reduced them to elementary and eternal forms. With these forms he was master of the task of reconstructing the world as a beautiful edifice decked with the brilliance of light and color; he accomplished what he so well described as "putting Poussin into nature." His Mediterranean scenes—the Bay of L'Estaque (plate 92) or Mont Sainte-Victoire—disclose in their total truthfulness a structure of perfect balance.

After him, Seurat, whose career was cut short by an early death, embarked upon a related experiment to make a science of the analysis of pure tones. He separated colors as they are separated by a prism and then put them side by side on his canvas in regular, circular touches, thus giving them maximum visual intensity. Next, he turned this fidelity of the senses into a harmony by discovering the pure lines whose association and contrast would satisfy the deepest expectation of the mind. His unfinished *Circus* (plate 96) gives us a glimpse of this scrupulous elaboration.

Perhaps it was Gauguin who set himself the most challenging task: of unifying these new discoveries. Perhaps it was he who did most to free painting from the errors into which Impressionism might stray and to indicate the directions in which the new art would find its own truth. Reso-

lutely and without confusion Gauguin proclaimed the breach with obedience to nature. The purpose of painting was not to reproduce visible reality, but at the same time this reality was to suggest the materials of the painting. It suggested, in fact, lines and colors which the artist would develop freely on his canvas without bothering about realistic exactitude, or even about relief or volume. The artist's aim was to achieve the highest beauty of arabesque in his lines and of harmony in his colors.

We find a striking confirmation of the opportunity such a program provided in the spontaneous effort of a "primitive," the Douanier Rousseau. With an infallible simplicity he sought truth in a vision of the real which was modified by the cadences of thought and nurtured by authentic emotion. His *War* (plate 100) rediscovers the secret of the great fifteenth-century Italians, of a Paolo Uccello (plate 8).

To make more certain that he was reaching the purest springs of art, remote from all convention, Gauguin left Europe, traveling each time a greater distance, first into the Atlantic, then into the Pa-

cific. But in the Marquesas Islands, where he died, he was able to discover his truth, to paint canvases like *The White Horse* (plate 97). He was to reveal to the Western world, overwhelmed and paralyzed by a too-heavy and too-glorious past, that it still had immense possibilities of self-renewal. It could replenish itself if it would transcend itself and consider anew even the most elementary problems, if it would regard the treasure-house of its past not as a fixed and definitive achievement, but as a stage in human development.

This is one of the many lessons the Louvre has to offer us. All that our predecessors have thought, felt, and won does not free us from the obligation to think, feel, and win in our turn. Knowledge of the past is not a weakness, a surrender to age. The Louvre, an immense treasure-house, exists to sharpen and multiply our aims. By concentrating our experience upon the loftiest triumphs of the mind and the sensibility, it teaches the artists of our generation to find their own orientation with new assurance. The Louvre stands at the center from which paths radiate toward as yet unknown territories, to be explored by future generations.

Bronze equestrian statue of Giovanni Francesco de Gonzaga, Marquis of Mantua. By Sperandio, late fifteenth century. A small version of the heroic equestrian statues of the Renaissance, which revive a Roman type. Vigorous and beautiful in craftsmanship, such small bronzes are now highly prized by collectors. 13″ high.

Commentary

COVER

CORNEILLE DE LYON [*1500?–1574?*]

Portrait of Clement Marot

DUTCH BY BIRTH, Corneille settled in Lyon, one of the intellectual and artistic capitals of sixteenth-century France. Although his Dutch origin is evidenced by the minute realism of his painting, the absence of preliminary drawing, and his use of color, Corneille is a painter on whom the French tradition has definitely left its mark. This is particularly noticeable in the care he takes to give the utmost expressiveness to the faces of his sitters, usually painted against a light green or blue background.

It may have been in Lyon, where nearly all the great humanists and poets visited, that Corneille made the acquaintance of the poet Marot and painted his portrait. It is also possible, however, that this portrait was copied from a drawing or engraving which served as frontispiece to one of Marot's numerous volumes.

A famous poet of the time of Francis I, Marot led an adventurer's life. High-spirited, impulsive, malicious, imprudent, he was befriended by both Francis I and his sister Margaret, Queen of Navarre. He provoked the hatred of the clergy and the Sorbonne by his anti-clerical epigrams, his friendship with Calvin, and his sympathy with reform. His translation of the psalms was immediately adopted by the Huguenots and he was obliged to flee to Geneva. When Calvinist constraint became too severe he moved to Turin, where he died.

FRONTISPIECE

QUENTIN MATSYS [*1465?–1530*]

The Moneylender and His Wife

IN HIS FREE AND LEISURELY ART, Matsys illustrates the transition from fifteenth-century realism, which had religious undertones, to the secular realism of the next century. A new interest in man and his surroundings, in which everything had a material and empirical existence, triumphed in the Netherlands as it had in Italy.

The subject of the moneylender in his shop, which was regarded as an opportunity to paint still life with jewelry, was originally a religious theme, referring to Saint Eloi, the goldsmith. Matsys has abandoned any religious pretext: he paints the moneylender as he must have seen him in Antwerp, surrounded by goldpieces and jewelry. These objects he paints solely for their own material beauty, studying the qualities of light as reflected from the mirror, the glass, and the stones.

In its luminous atmosphere and beautiful painting of textures this panel reminds us of van Eyck (plate 27). But in its vivid

reporting of gestures, in the diversity of the still-life objects, the painting anticipates the two great achievements of the sixteenth and seventeenth centuries: the depiction of life and of movement.

PLATE 3

CIMABUE [*1240?–1302?*]

The Madonna of the Angels

CIMABUE WAS ONE OF THE FIRST ARTISTS to emerge from the collective anonymity of the Middle Ages. He soon became a legendary figure, and today it is almost impossible to determine what is fact, and what fable, in Vasari's sixteenth-century biography. Indeed, some later critics even doubted the existence of this artist, whom tradition calls Giotto's master.

The only work definitely attributed to Cimabue is a mosaic executed in 1301-02 for the apse of the Duomo in Pisa. In this cosmopolitan city, with its maritime attachments to the Near-East, Cimabue must have felt the full impact of the flat, stylized art of Byzantium. But the importance of form was revealed to him by the sculpture of the Pisan school, and later, in Rome, by the classical works which he saw there.

The Louvre's *Madonna of the Angels* is now regarded as a rather late work by Cimabue. The details—the scroll which conveys the Infant's blessing, the drapery, attitudes, and angels' wings—still follow Byzantine iconographical traditions. But the new spirit of the fourteenth century is heralded in the flowing lines of the drawing, the modeling, and in the beauty of the symmetrical composition, imposing in the simplicity of its step-like movement which rises from the bottom of the throne and culminates in the Madonna's head.

PLATE 4

GIOTTO [*1266?–1337*]

Saint Francis Receiving the Stigmata

LEGEND HAS IT THAT GIOTTO, son of Tuscan peasants, was discovered by Cimabue, who found the boy drawing while tending his parents' flocks. In any event, it is probable that Giotto was the pupil of this renowned painter, soon surpassing his master. Dante, their contemporary, wrote: "Cimabue thought to lord it over painting's field; and now the cry is Giotto's, and his name eclipsed."

Giotto's style was formed at the time when Central Italian painting was freeing itself from Byzantine formalism and turning to the precepts of Roman sculpture; the teachings of Saint Francis stimulated a love of nature and observation of reality. He painted the holy stories with daring pictorial invention and

dramatic effect; and in a number of great frescoes, he celebrated the life of Saint Francis, creating at the same time a whole Franciscan iconography.

Panel paintings by Giotto are rare, making this picture the more precious to us. (It should be noted, however, that certain historians regard this as a school-piece.) We see Saint Francis among the rocks of Verna, where he has gone into retreat; he receives the stigmata during a vision of Christ wearing the six wings of a seraph. The predella below the central panel represents other scenes from the life of the Saint. At the left, Pope Innocent III has a dream which symbolizes the monk's efforts to bolster the Church of Christ; in the middle scene, the Pope, convinced, gives the Saint permission to found his Order; and at the right, Saint Francis teaches the birds to love God.

PLATE 5

SIMONE MARTINI [1285?–1344]

Christ Carrying the Cross

THE EARLY WORK OF THIS SIENESE PAINTER is markedly Byzantine, softened, however, by a Gothic grace which he admired in the ivories, miniatures, and sculptures brought from France. Later, after working in Naples, Simone's style became more realistic, delighting in picturesque detail. Summoned to Avignon in 1339 by Pope Benedict XII, he made the acquaintance of the poet Petrarch, for whom he decorated the opening page of a Virgil. Here, until his death in 1344, Simone continued to develop that alliance between French and Sienese styles which was characteristic of his exquisite final work.

The precious little *Christ Carrying the Cross*—its fresh coloring and use of gold reminiscent of miniature painting—was painted during those Avignon years, presumably one of the six panels of a polyptych which was eventually sold and dispersed at Dijon in 1826.

Soldiers, executioners, and pharisees drag the condemned Christ toward Calvary, accompanied by the Holy Women and Saint John, desolate in their grief. The Magdalen, her face twisted in anguish, raises her arms in a great tragic gesture, while the Virgin is menaced by a centurion who refuses to let her join Simon of Cyrene in helping to carry the cross. The exaggerated gestures of despair create an impression of movement and animation which accentuates the figure of the suffering Christ.

PLATE 6

FRA ANGELICO [1387–1455]

The Coronation of the Virgin

IN FRA ANGELICO'S PAINTING the mystical purity and emotion of the artist created an almost perfect expression of the serenity of faith. This Dominican monk, who became prior of his convent, was beatified after his death.

The Louvre's panel is from the church of the Convent of San Marco in Florence. To the music of an angelic concert, Christ, seated on a Gothic throne, places the crown of glory on the head of a young and slender Virgin, while saints, prophets, and apostles kneel in adoration. The exquisite harmony of the colors as fresh as when they were painted, the minute attention to detail and ornament, and the presence of the saints' halos, recall Gothic miniature painting. But the perspective, the interest in volume, the carefully thought-out composition with its double curve leading to Christ and His Mother isolated in their glory, are already the work of a Renaissance master, and show the influence of idealist and Platonic thought.

In the center panel of the fine predella we see the entombed Christ with the Virgin and Saint John. The other panels show episodes in the life of Saint Dominic. Proceeding from the left: Innocent III sees the Saint in a dream, supporting the Church of the Lateran (Giotto's, plate 4, is a Franciscan variant); the Saint receives the staff and book from Saints Peter and Paul; he raises a Cardinal's nephew from the dead; his books are thrown in the fire by the heretical Albigenses but do not burn; the Dominicans are ministered to by angels; and last, the death of the Saint.

PLATE 7

PISANELLO [1395?–1455?]

A Princess of the Este Family

HIS TALENT AS A MEDALLIST and decorator brought Pisanello a stream of commissions from princely patrons throughout Italy, though he retained his home in his mother's native city of Verona. His courtly style, with its taste for narrative detail expressed with refined elegance, was deeply imbued with the ideals of the international Gothic tradition, which, originating in France, dominated western and central Europe in the late fourteenth and early fifteenth centuries.

The flowers and butterflies painted in bright colors against the dark verdure of this portrait rival the work of medieval manuscript illuminators. Against this background Pisanello has sensitively traced the sinuous arabesque of bust, neck, and face, exercising the same virtuosity and precision as when chiseling the fine, exact lines of his portraits on medals.

The identity of this charming young princess, gowned and coifed in what is clearly the latest fashion, is unknown. But the similarity between the flower vase embroidered on her sleeve and a like motif on Pisanello's medal of Lionello d'Este justifies the supposition that she was a princess of the Este family of Ferrara.

PLATE 8

UCCELLO [1397–1475]

The Battle of San Romano

FRIEND OF MANY LEADING ARTISTS and scholars of the early Renaissance, Uccello devoted intensive study to the geometry of forms and the new science of perspective. His striking equestrian figure of the condottiere John Hawkwood in the Cathedral of Florence is a *tour de force* of optical illusion through perspective. Although sometimes confining himself to monochrome in order to concentrate more strictly on problems of form and volume, Uccello was also interested in color. From

his experience in designing stained glass he retained a feeling for dark, warm tones that is rare in Florentine painting.

His search for effects of volume, knowledge of perspective, and use of simplified geometric forms to produce decorative patterns, are well exemplified in *The Battle of San Romano*. It is one of a series of three battle scenes of equal size painted for the Medici to commemorate a victory of the Florentines over the Sienese in 1432. In the center, brandishing his sword, the condottiere Micheleto Attendolo da Cottignola leads the assault of the second line of knights; the first line, with lances down, is already attacking. The placing of crests, banners, the long shafts of vertical and diagonal lances, and the movement of the horses, produce an almost cinematographic effect of life and movement.

The predilection of the present-day aesthetic for abstract composition has led to a new appreciation of Uccello's intellectual, mathematical style.

PLATE 9

BALDOVINETTI [1425–1499]

Virgin and Child

CONTRASTED WITH A PANORAMA rich in picturesque details, the pyramid-like silhouette of the Virgin in adoration has a massive grandeur. This painting has been universally admired even though its authorship long remained in doubt. Today, by analogy with his known works, such as the frescoes of the Portuguese Chapel in the church of San Miniato at Florence, it is generally agreed to be by Alessio Baldovinetti.

Born probably in Florence, Baldovinetti was a pupil and collaborator of Fra Angelico. He also, together with Piero della Francesca, worked under Domenico Veneziano and acquired from him a taste for enamel-like colors and vast, deeply recessed landscape vistas. The technical experiments that Baldovinetti made in mixing oil and tempera has caused much of his painting in fresco to be ruined by flaking away.

In this picture, highly characteristic of the work of the second generation of Florentine artists of the fifteenth century, the purity and subtlety of line and the graceful modeling are accompanied by a knowing use of light to unify the diverse elements of the composition. While this *Virgin and Child* is sincerely religious in feeling, its subordination of sentiment to an ideal of formal elegance already foreshadows the spirit of the High Renaissance.

PLATE 10

ANTONELLO DA MESSINA [1430?–1479]

A Condottiere

WE DO NOT KNOW precisely how the Sicilian-born Antonello da Messina came into contact with Flemish painting and became the first Italian to master the technique of oil painting, perfected by the van Eycks and previously unknown in the South. After a period at the court of René d'Anjou at Naples, Antonello went to Venice in 1475. He taught the artists of that city the Flemish techniques; Giovanni Bellini particularly

was struck by the new possibilities offered by oil painting: thick impastos and superimposed transparent films of paint could produce infinite variations of tone. Antonello thus encouraged that richness of color which was later to become the glory of Venetian painting.

Perhaps it was also due to Flemish influence that Antonello became a leading portrait painter.

The *Condottiere* is typical of Antonello's close scrutiny of expressive physiological and psychological traits, and of his method of posing a sitter against a dark background gazing forward but with head and shoulders turned towards the left. This unknown subject's fierce energy and air of command, his searching glance and cruelly contemptuous expression, accentuated by the gash across his upper lip, have led to the supposition that he was one of the freebooting captains so well known to Renaissance Italy, as harsh to others as to themselves, not caring who their enemies were.

PLATE 11

GIOVANNI BELLINI [1430?–1516]

Portrait of a Man

TRAINED IN THE STUDIO of his father Jacopo, who had worked at Florence and Rome, Giovanni Bellini continued his father's efforts to liberate Venetian painting from the medieval Byzantine traditions which had kept the city of the Doges outside the new artistic currents emanating from Tuscany. Two events were crucial to his development. The first took place in 1453, when Andrea Mantegna became his brother-in-law and transmitted to Bellini the learned and monumental classicism which he himself had assimilated, in part directly from antique models, in part from Donatello. Bellini's paintings of this period show a growing mastery of modeling, perspective, and composition added to his primary interest in light. The second event, in 1475, was the introduction to Venice of the Flemish technique of oil painting by Antonello da Messina (plate 10). Adopting the new technique, Giovanni Bellini in such works as the great altarpiece for the Church of the Frari attained a luminosity, delicacy of modeling, and richness of color which his famous pupils, Giorgione and Titian, were to bring to perfection.

The *Portrait of a Man* is one of a group of similar busts Bellini painted around 1475. Like Antonello, he poses his model quite simply, ignoring decorative accessories and concentrating on the essentials of physical appearance and psychology. But while Antonello's sitters are inexorably linked to the spectator by their imperious frontal gaze, those of Bellini preserve an enigmatic character through the faraway look he has given to their eyes.

PLATE 12

MANTEGNA [1431?–1506]

Calvary

THE RENAISSANCE HUMANISTS' PASSION for antiquity is reflected throughout the work of the celebrated and influential North

Italian artist, Mantegna, whose master Squarcione, an artist of little talent but an excellent instructor, made his pupils copy classical sculpture. Even his early fresco work in Eremitani Chapel at Padua—largely destroyed in the last war—shows Mantegna's characteristic preoccupation with archeological detail and the perfection of his drawing. Through his connection with the Venetians (he was a son-in-law of the great painter Jacopo Bellini) Mantegna became a colorist as well. Under the protection of the Gonzagas, he settled in Mantua in 1468 and worked there for Isabella d'Este.

The beauty and simplicity of form in this *Calvary* recall classical bas-reliefs, while the drama inherent in its theme is intensified by the scientific logic of its composition. Subtle diagonals formed by the hilly slope of Jerusalem at the left, and the wall of rock at the right, meet in the center, leaving in striking isolation the figure of the dead Christ and the silhouette of the cross. The stiff outlines of the attendant figures repeat the upright of the cross; its horizontal bar is paralleled by the little white clouds which seem to have turned to the same stone as the prismatic blocks of the rocky landscape. The poetical intention of the artist is disclosed in the frozen, mineral universe; the horror of the scene in this inhuman world becomes so harsh and tragic as to be almost insupportable.

PLATE 13

BOTTICELLI [1444?–1510]

A Lady and Four Allegorical Figures

ORIGINALLY TRAINED AS A GOLDSMITH, Botticelli in the grace and elegance of his early works reveals the influence of his first master in painting, Fra Filippo Lippi. Somewhat later he acquired from the painter-sculptor-goldsmiths Verrocchio and Antonio Pollaiuolo his fine, nervous precision of line.

A Lady and Four Allegorical Figures is one of a pair of frescoes discovered in 1873 in the Villa Lemmi, a few miles out of Florence. Dr. Lemmi, noticing traces of painting under the whitewash in one of the rooms, exposed these frescoes. From 1459 to 1591 the house had belonged to the Tornabuoni family, and we know that Botticelli (and Ghirlandaio) had decorated the Palazzo Tornabuoni about 1485, shortly after his return from Rome. Though the exact subject of his painting has not been determined, it probably represents a young woman of the Tornabuoni family receiving gifts from the four Cardinal Virtues. Whatever its theme, the poised and rhythmic grace of the figures and the visual poetry of the draperies and gestures are completely characteristic of Botticelli.

Painter of gracious, charming, and slightly melancholy Madonnas, Botticelli was also capable in his portraits of refining a likeness so as to concentrate on its essential character. Above all, however, under the influence of the learned Florentine humanists who surrounded Lorenzo and Giulio de' Medici in the third quarter of the fifteenth century, he was the exquisite poet of pagan antiquity. His *Allegory of Spring* and *Birth of Venus* are delicate, imaginative visions of a golden age where mythical beings dance in flower-filled gardens. Towards the end of his life, however, he was converted by the preaching of Savonarola and thereafter painted only religious subjects of fervent pathos and emotion.

PLATE 14

GHIRLANDAIO [1449–1494]

An Old Man and His Grandson

PUPIL OF BALDOVINETTI and master of Michelangelo, Ghirlandaio was perhaps the most typical if not the most original artist of the fifteenth century in Florence. Little gifted with imagination, but a master of picturesque charm, he can lay claim to harmonious drawing, orderly composition and fresh, agreeable color. A keen observer of picturesque details, he often transformed his religious paintings, such as the frescoes for Santa Trinità and the choir of Santa Maria Novella, into scenes of daily life peopled with well-known Florentine personages.

Ghirlandaio's charm, sensitivity, and restrained realism are all apparent in this double portrait. The disfigured face of the unknown old man is transformed by the kindly smile he directs towards the young boy, who returns his grandfather's glance with confident affection. The area of light from the open window is skillfully used to give depth to the composition, and to balance the oblique line formed by the two figures.

PLATE 15

LEONARDO DA VINCI [1452–1519]

Mona Lisa

LEONARDO is probably history's prime example of a universal genius. The dazzling creative intellect of this accomplished humanist made him not only an outstanding artist and aesthetician, but also a philosopher, mathematician, astronomer, geologist, inventor in dynamics and ballistics, engineer, and architect. His notebooks and manuscripts are among the most important sources we have for the study of sixteenth-century learning and philosophy.

Leonardo was born at Vinci, near Florence, and as a young man he entered the studio of the painter-sculptor Verrocchio under the patronage of Lorenzo de Medicis. In 1483 he went to Milan, to the court of Ludovico il Moro, who commissioned paintings from him, and engineering and architectural works as well. Upon the invasion of Milan by the French army Leonardo went to Venice and Florence. Summoned by Francis I, he stayed at the French court to the end of his life.

There is perhaps no painting in the world more celebrated than Leonardo's *Mona Lisa*, his most perfect and characteristic work. It is also the finest product of the proud and ambitious spirit of the Renaissance, which aimed at the re-creation, in art, of the world according to intellectual laws. This is an ideal which reconciles art and science, and enabled Leonardo to write this Promethean formula: "How easily do we make ourselves universal!" The portrait, on which Leonardo worked four years, is sometimes called *La Gioconda* because according to tradition it represents the wife of the Florentine Francesco di Zanobi del Giocondo.

The Louvre is the richest of all galleries in paintings by Leonardo; there one may study the small *Annunciation* of his youth and the development of his famous *sfumato* style in *Saint John the Baptist, Saint Anne, The Virgin of the Rocks,* and above all, in the *Mona Lisa.*

PLATE 16

GIORGIONE [1477?–1510]

Pastoral Concert

BATHED IN THE GLOW OF SUNSET, two couples engage in conversation and music-making, while a shepherd drives his flock homeward through the Venetian countryside. The real subject of this *Concert Champetre*, however, is the beauty of the female body and the beauty of nature in the lingering golden light. The overtone of gentle melancholy tells us that the music will soon fade, the moment pass; already shadows claim the faces. The awakening of the spectator's sensibility through scenes of evocative charm that elude precise interpretation is the special gift of Giorgione, a capricious, independent artist whose individualism makes him in a sense the first of the moderns.

Little is known of his life. He was born at Castelfranco near Venice, trained in the studio of Giovanni Bellini and died while still in his early thirties. But the few paintings that he produced in his short life (many known to us only through copies, and others of disputed attribution) exerted a great influence on the artists of his generation. Giorgione's lyrical imagination and his innovations in light and color enabled his friend and disciple Titian, and later, Tintoretto and Veronese, to attain harmonies unparalleled in Western art.

PLATE 17

TITIAN [1477?–1576]

The Entombment

IN THE WHOLE HISTORY of Western painting it is Titian, perhaps, who has exerted the greatest influence. Not only his fellow Venetians, but many artists of various schools and periods owe much to him. Velasquez, Rubens, Rembrandt, van Dyck, Poussin, Watteau, Fragonard, and Gainsborough, down to painters as late as Delacroix and the Impressionists, may all be said to have learned from Titian's technical inventiveness, passionate brush strokes, and zest for light and color.

Trained in the studio of the Bellinis at Venice, Titian was profoundly influenced by his colleague and master Giorgione, with whom he collaborated on the lost frescoes for the facade of the Fondaco dei Tedeschi. Titian was quick to master Giorgione's discovery of atmospheric perspective, using color not merely decoratively but as a constructive means, as though the very being of his pictures arose from the radiance of color itself.

Throughout his long life Titian worked on commissions for a succession of illustrious patrons—the Doges of Venice, the Emperors Charles V and Philip II, Pope Paul II, Alfonso d'Este of Ferrara, the Duke of Urbino, and Federigo Gonzaga of Mantua.

About 1525 he painted for Federigo this *Entombment* — a tragic dirge resounding with cries of sorrow and rebellion. It is believed that in the figure of Joseph of Arimathea, who supports the feet of the dead Christ, the artist represented himself, just as he did when more than thirty years later he painted for

the king of Spain another version of the same theme, now in the Prado.

PLATE 18

RAPHAEL [1483–1520]

La Belle Jardinière

RAPHAEL SANZIO was born in Urbino. His father, also a painter, died when he was eleven. At sixteen he was apprenticed to Perugino, whose delicacy of composition and decorative sense had a great effect upon him. From 1506-08 Raphael lived in Florence where the theories of Leonardo and Michelangelo helped to form his mature style with its facility of draftsmanship and supreme mastery of composition. In 1508 Julius II called him to Rome to decorate the *Stanze* in the Vatican. His frescoes of the *Disputa* and *The School of Athens* rivaled Michelangelo's ceiling of the Sistine Chapel. His color, under the influence of Venetian painting or of newly discovered Roman murals, became increasingly rich. Overwhelmed with commissions and official responsibilities he died at thirty-seven, universally mourned for his goodness, the beauty of his character, and for his genius.

This Virgin and Child with Saint John, traditionally called *La Belle Jardinière,* is the finest version of a subject for which Raphael had, after his stay in Florence, a marked preference; it enabled him to give expression to his tender sensibility and religious feeling. The compositional pyramid formed by the figures of the Virgin and the two children stands out against the horizontal line of the landscape. The formal harmony, however, is only one of the delights of this masterpiece. The pose of the Child leaning against the Virgin, his arms forming a continuous line with hers, while he glances up at her confidingly, contributes a perfect note of sincere sentiment.

PLATE 19

CARAVAGGIO [1562?–1609]

Portrait of Alof de Wignacourt

WHEN CARAVAGGIO WAS BORN, Italian painting, after a period of enormous productivity, was going through the crisis of Mannerist refinement. Once an art form reaches its perfection, further evolution can come only through virtuoso development of its principal characteristics; this is Mannerism. To this, Caravaggio reacted violently, and his realism had a lasting influence throughout Europe, even affecting such great seventeenth-century masters as Velasquez, Rubens, Rembrandt, and Vermeer. Trained in northern Italy, Caravaggio went to Rome where he soon acquired notoriety and powerful patrons who were frequently to shield him from the consequences of his escapades, which climaxed in a murder. Banished from the capital, Caravaggio worked in Naples, Sicily, and Malta, and having at last received his pardon he died on his way back to Rome. Many of his religious pictures caused scandal because for his sacred personages he used models from the lower classes, painting them naturalistically in their own everyday dress.

Alof de Wignacourt, Grand Master of the Knights of Malta,

was a nobleman from Picardy. This state portrait is in Caravaggio's final manner; the background is abolished, the palette restricted; powerful volumes and a sculptural synthesis produced through the handling of the light enhance the forceful and domineering character of the subject.

PLATE 20

CORREGGIO [1498–1534]

Jupiter and Antiope

AFTER RECEIVING INSTRUCTION from the aged Mantegna in Padua, Correggio, by assimilating the flowing draftsmanship of Ralphael and the intangibly delicate shading of Leonardo, developed a highly original style of extreme grace and softness. Perhaps after a trip to Rome, where he would have seen Michelangelo's Sistine ceiling, he undertook the decorations of the domes of San Giovanni Evangelista and of the Cathedral of Parma in which the illusionistic style initiated by Mantegna is blended with later conceptions of grandeur and monumentality. In his religious compositions he displays a tender and calm piety.

For Federigo Gonzaga, Duke of Mantua, Correggio painted several compositions of a mythological character, mostly having to do with the loves of Jupiter. In this one the king of the gods under the aspect of a satyr gazes at the reclining Antiope while Cupid nestles at her side. The blue drapery acts as a foil to the nymph's dazzling nakedness which seems to absorb all the light of the picture. Slight shadows caress the lovely foreshortened head and soften the contours of the body, subtly accentuating the sense of relaxation. The whole effect is that of a limp body which no longer has control over gesture—the very image of sleep. Correggio's ideal of feminine beauty, so gentle and irresistibly charming, was particularly admired in the eighteenth century.

PLATE 21

VERONESE [1528–1588]

Calvary

IN HIS NATIVE VERONA the artist was exposed to artistic influences from central Italy, and in Venice, where he settled in 1555, he became acquainted with the work of Giulio Romano and Parmigianino as well as with Titian's splendid color. As a result of a trip to Rome he seems to have acquired a taste for monumental compositions which led him to produce immense canvases such as The Marriage of Cana in the Louvre. In his later years landscape assumes a very important role in his paintings, a powerful means of expression, as in Tintoretto's art.

In this Calvary the vast leaden sky takes up half the area of the picture; to the left three crosses rise above the holy women who attend the swooning Virgin. The composition is boldly diagonal though a balance is consciously restored by the wonderful tall figure draped in yellow; the strange, doomsday light, fantastic and tragic as well, unifies the picture further with its sulphurous brilliance. A preparatory drawing in

the Fogg Museum in Cambridge, Massachusetts, suggests a date of around 1570 at least for the initial conception, though the picture itself has often been considered a late work.

PLATE 22

NICCOLO DELL'ABBATE [1509?–1571]

The Rape of Proserpine

THOUGH HE WAS a native of Modena, Niccolo dell'Abbate's work reveals a close study of Raphael and Michelangelo, and the influence of Correggio, who evolved a style of great refinement by subtly remolding the achievements of the great masters. Like others of the generation of painters born in the early sixteenth century immediately following the climax of the Renaissance, Niccolo dell'Abbate was a Mannerist. Singularly interested in landscape, he shows a special liking for great panoramas and fantastic architecture. In 1552 he was summoned by Primaticcio to work on the decorations for the Palace of Francis I in Fontainebleau. He remained in France till his death.

Pluto, god of the underworld, abducts Proserpine before the eyes of her terrified companions. On the hill to the right he is shown again in his chariot as he drives off with his bride. The tall elegance of the nymphs follows closely the figure style of Primaticcio, but the vast landscape in which strange structures are picked out by a slanting light is the product of a very personal invention.

PLATE 23

TINTORETTO [1518–1594]

Paradise

NICKNAMED AFTER HIS FATHER, who was a dyer in the city of Venice, Tintoretto entered Titian's studio but did not remain there long; he completed his training through the study of Michelangelo and became acquainted with Roman Mannerism through Pordenone. His mature work shows technical freedom and the most daring invention. His creative urge was so strong that, like Michelangelo, he needed great walls to decorate. Dramatic light, animated shadows, and expressive color serve to orchestrate his dynamic Wagnerian visions. Tintoretto is, with Michelangelo, the greatest painter of the Baroque; in his power of pictorial invention he perhaps surpasses any other artist in the history of painting.

This is a small sketch for the largest painting in the world (23 x 72 feet), the Paradise in the Ducal Palace in Venice. Tintoretto was already seventy when, as a result of the death of Veronese, he was entrusted with this immense undertaking. At the height of his religious fervor he conceived this work in superhuman terms. As the solar system revolves around the sun—a fact revealed by Copernicus in 1543—thus the universe of saints, prophets, and the blessed rotates in concentric orbits around Christ as he places the crown on the Virgin's head.

159

PLATE 24

ANNIBALE CARACCI [1560–1609]

Fishing

IN 1585 ANNIBALE with his cousin Ludovico and his brother Agostino opened an academy in Bologna, his birthplace. At this time, painting in Italy was spending itself in refinements upon the lessons of the great masters. The Caracci were professed eclectics yet their erudition and thorough knowledge of the art of the past did not result in servile imitation, but in the formation of a style which was to exert a healthy influence in both Italy and France.

No attempt is made to give this picture a religious or allegorical meaning as was still customary at this time. It is a simple landscape of a river flowing through the countryside outside Bologna. Like Caravaggio, the Caracci refreshed their art through the observation of nature, though with a preference for landscape, as is particularly evidenced by Annibale's drawings. *Fishing* and its counterpart *Hunting* were painted in Bologna before the artist attempted to make deliberate arrangements of his landscapes. Later, in Rome, the countryside with its ruins and clearly defined plains inspired him to more formal compositions which were to be carried to their greatest perfection by Poussin and Claude Lorrain.

PLATE 25

GUARDI [1712–1793]

The Doge Embarking on the Bucentaur

THOUGH REARED IN THE TRADITION of Titian and the later Venetians, Guardi soon came to admire the richly inventive, Baroque fantasy of the Genoese painter Magnasco. The religious themes of his early work were but a pretext, allowing Guardi to create a romantic and fairy-tale atmosphere, with unreal silhouettes seen against fanciful landscapes. He was also a pupil of the great landscape painter Canaletto. But his nervous sensibility, so unlike that of his master, impelled him to give free rein to his poetic imagination in his *Views of Venice* and *Caprices*; these were exquisite constructions based on drawings whose technique was the notation of light. He was above all a subtle analyst of light, the refinement of his vision, the lightness of his touch, the bright, silvery tones of his palette making him a precursor of Bonington, Corot, and the Impressionists.

This painting is one of twelve representations of Venetian festivals, done by Guardi probably in 1763. On Ascension Day it was the tradition for the Doge, head of the Venetian Republic, to be rowed out to sea in the famous state barge, the Bucentaur. In the presence of the city's nobility and foreign diplomats he would throw a ring into the Adriatic as a symbol of the marriage of the city and the sea. It was the most famous of all Venetian ceremonies, attracting large numbers of visitors to the city for merrymaking.

Guardi's finest qualities are seen in this lively canvas; the light which pervades the scene with its sparkle also streaks the forms to give them animation. Thanks to the verve and

elegance of his technique, he is the most scintillating chronicler of eighteenth-century Venice.

PLATE 26

GIAMBATTISTA TIEPOLO [1696–1770]

The Triumph of Religion

THE VENETIAN TIEPOLO is unquestionably the greatest decorative painter of the eighteenth century. Gifted with immense fantasy as well as amazing physical energy, his brilliant, capricious inventions adorn villas, palaces, and churches in Venice, Milan, Verona, Würzburg, and Madrid, giving a measure of his widespread popularity and fame. Tiepolo's artistic lineage can be traced back to the sixteenth-century Venetians Tintoretto and Veronese, though his pervasive, opalescent light, bright colors, and agitated line are characteristic of a later period, as well as the result of his own artistic temperament.

This sketch for a ceiling in the Grimaldi palace in Venice is a religious allegory: Faith, crowned with stars and trampling the dragon of heresy, glances down at a procession of believers. The whole scene receives the blessing of God, encircled by angels. There are more important easel paintings by Tiepolo in the Louvre, but this sketch was selected in order to give an idea of his illusionistic decorations in which the ceiling is supposedly broken out into the very sky, affording the beholder a glimpse of heavenly events in an ethereal, infinite space.

PLATE 27

JAN VAN EYCK [1390?–1441]

The Virgin and Chancellor Rolin

A NATIVE OF THE MEUSE COUNTRY, van Eyck was painter to the Count of Hainault and Philip the Good, Duke of Burgundy, who sent him on secret missions of state. At Ghent, before 1432, van Eyck completed the celebrated altarpiece of *The Adoration of the Lamb,* which, with its subtle use of the medium of oils, is one of the foundations of modern painting. Through its impastos, smooth or rough, and its transparent glazes, oil painting is a technique which enables the artist to imitate the subtlest play of light on objects.

The Virgin and Chancellor Rolin shows how van Eyck used this medium to carry realism to the point of extreme fidelity. He masters the visible world in all its aspects and shows its diversity in clear, precise forms. But van Eyck's art is more than truthful representation. The severe face of the donor of this panel, Nicolas Rolin, Chancellor of Burgundy, is vivid not only in the painting of its surface markings, but also in its psychological significance. The bottle-glass of the windows seems as precious as the jewels of the crown, and even the small garden and its flowers, the town, the mountains, have something of this clear, jewel-like character.

Through balance and rhythm, through geometrically precise perspective and clear spatial intervals, van Eyck imposes on reality an intellectual discipline which is no less ordered than that of Italian art.

PLATE 28

ROGIER VAN DER WEYDEN [1399?–1464]

The Annunciation

THIS PANEL WAS for a long time considered to be the work of an unknown fifteenth-century master. No picture by Rogier has been authenticated by either signature or direct documentary evidence. But there are two paintings in the Escorial, near Madrid, which are attributed to him by reliable traditions, and it is by comparison with these that a body of work, including this *Annunciation,* has been identified as his.

Van der Weyden's realism is not so relentless as van Eyck's (plate 27); his work, Gothic in refinement and more linear in style, is colored by naive emotion and medieval sensibility. A Latin striving for style through abstraction and elegance is one of the most marked characteristics of his painting. This tendency toward idealization was probably strengthened by his travels in Italy in 1450, during which he worked in Rome and Ferrara. There is a complementary aspect of his work: a nervous sensibility which shows itself even in the kind of detail he chooses to depict. Van Mander has justly said that he was a painter of "the soul's changes."

The *Annunciation,* which inspired Bouts and Memling (plate 29), is the central panel of a triptych which Rogier painted in his youth. There are other treatments of the same subject by him, but he was never again to achieve the elegance of this vision of the angel in his sumptuous robe, or of the fragile, resigned grace of the Virgin.

PLATE 29

MEMLING [1433?–1494]

The Mystic Marriage of Saint Catharine

BORN NEAR MAINZ, Memling visited Cologne in his youth and probably painted in Rogier van der Weyden's studio in Brussels before he acquired the privileges of a citizen of Bruges in 1465. Here he lived in prosperity for the rest of his life, accomplishing his greatest work, the shrine of Saint Ursula at Saint John's Hospital, a work reminiscent of manuscript illumination.

The most important influences on Memling's art were those of van der Weyden, Dirk Bouts, and Hugo van der Goes. He was an eclectic painter, profiting from the work of his predecessors; with his great facility he assimilated the innovations of others and brought Flemish technique to its highest point of accomplishment.

The *Mystic Marriage of Saint Catharine* is one panel of a diptych—the other half, representing a kneeling donor with saints, is also in the Louvre—and was painted about 1475. The Virgin, holding the Child, who is placing the mystic ring on Saint Catharine's finger, is seated in a verdant landscape before a hedge of roses, with Saints Agnes, Cecilia, Lucy, Margaret, and Barbara. This theme of a group of saints was a favorite one with Memling, and he repeats the same female type with evident pleasure: the full oval face, arched eyes slightly raised at the sides—an inscrutable and gracious type.

The beauty of color, the calm simplicity of the circular composition centering in the vertical figure of the Virgin and echoed by the semicircle of bushes in the background, make this charming work a perfect example of classical Flemish painting of the fifteenth century.

PLATE 30

GERARD DAVID [1450?–1523]

The Wedding at Cana

DAVID WAS ONE OF THE LAST of the traditional Flemish painters of the fifteenth century. Settling at Bruges, he was influenced by Memling (plate 29), at that time the city's most famous painter. David's predilection for rich, enamel-like colors and a hieratic rigidity of figures reveals his debt to van Eyck (plate 27), whose work he must have seen. Especially after Memling's death, David occupied an important position in Bruges, receiving civic commissions and being elected dean of the painters' Guild of Saint Luke.

Although it ostensibly represents a miracle, *The Wedding at Cana* seems really to be a celebration at a prosperous middle-class house in Bruges. A tapestry of various plants hangs in the background, and a marble colonnade opens on to a city square. The bride is at the center of the table; Christ and the Virgin sit to one side among the other guests, who show no surprise at the miracle of changing the water into wine.

The absence of movement in this picture is to be noted: each figure is fixed in its position and appears to be as little able to take part in the action as the donors, who kneel in prayer at right and left. This fixity is very characteristic of David's work.

PLATE 31

BRUEGEL [1525–1569]

The Beggars

BRUEGEL'S ORIGINALITY and perfection of technique make him the greatest Flemish painter of the sixteenth century. A man of broad culture, he traveled in Italy, and unlike most of his compatriots he did not return satisfied with a vision of man which was merely an imitation of the classical. In Italy he acquired a sense of style, a breadth of composition, and a purity of draftsmanship characterized by simplification and economy. After his return to Flanders he moved toward an art which was more and more concerned with man and his drama: he engraved a series of "Virtues" and "Vices," and his landscapes became backgrounds for peasants at their labors.

The Beggars belongs to the last period of Bruegel's work. Nature no longer dominates man as in his earlier work; man takes the leading part and is the hero, whether fighting for existence or shattered by fate. The misery of his *Beggars* is accentuated by the exquisite light of Spring which appears in the background, behind the little wood one sees through the gate. Bruegel's astonishing pictorial virtuosity makes this small panel appear much larger than it is.

It is possible that as in many of his late paintings there is

here a political allusion to the rebellion of the Low Countries against the domination of Spain: the fox brushes which adorn the costumes of these maimed beggars were used to ridicule the government of Philip II.

PLATE 32

RUBENS [1577–1640]

Country Fair

A UNIVERSAL GENIUS—scholar, diplomat, collector, as well as artist—Rubens has been described by Delacroix as "the Homer of painting." Trained in Flanders and Italy, he was appointed painter to the Archduke Albert and the Archduchess Isabella in 1609. He began to free himself from his dependence on Italian masters, affirming his own lyrical and Baroque style. Overwhelmed with commissions, he employed a great many apprentices in his atelier—van Dyck (plate 34) was one of his collaborators; but the conception of the picture is always Rubens' own.

Toward the end of his life Rubens composed immense landscapes in which he celebrated with an almost unbridled lyricism the generative forces of life in men and nature. His *Country Fair,* painted in the last period of his life, presents a traditionally Flemish scene of peasant joy and drunkenness. Twelve sketches now in the British Museum show how carefully Rubens planned this work.

It is more than a realistic description of a country scene; it approaches symbolism. The drunken passions of this bacchanal are fast playing out, as peaceful twilight begins to descend over the small calm stretch of country in the background. The implied symbolism seems to sum up Rubens' art: the exaltation of life and movement is always accompanied by philosophical and moral overtones.

PLATE 33

JORDAENS [1593–1678]

The Four Evangelists

WE KNOW LITTLE OF JORDAENS other than what touches on his art. Born in Antwerp, he was the pupil and son-in-law of Adam van Noort, one of Rubens' masters. Jordaens never visited Italy, but his early work was shaped by the current Italian influences: he passed through a Mannerist period, and later the chiaroscuro realism of Caravaggio (plate 19) matured his style. After 1631, when he fell under the influence of Rubens his work began to show a greater understanding of atmosphere, a surer approach to composition, and an almost unbridled vitality. But, like van Dyck, Jordaens never became a mere imitator of Rubens; he always exploited his own rich and individual talent. His robust realism seems drawn from the very springs of the Flemish tradition.

The Four Evangelists shows the growing suppleness of his style at the same time that it retains the directness of his Caravaggian period. Like Caravaggio, who had chosen models from the poor people of Rome and Naples, Jordaens has painted ordinary citizens of Antwerp, posing them in natural attitudes

to represent the four sacred writers. Through his powerful and lively technique, through the simplicity of the composition which communicates an intensity of religious feeling, Jordaens has given these humble figures a touching grandeur. In doing so he sums up all that is finest in his art.

PLATE 34

VAN DYCK [1599–1641]

Portrait of Charles I of England

REMARKABLY PRECOCIOUS, van Dyck was already a celebrity when, at about twenty, he became Rubens' chief collaborator. Even his early work displays the two qualities which made him so admirable a portrait painter: the precise individualization of his subjects, and the pictorial harmony of the elements of his compositions. A visit to Italy enriched his style; from the Venetians, especially Titian and Tintoretto, he learned to employ rare and exquisite colors. Conversely, he exercised a profound influence on the Genoese school during this journey.

Wherever he went, commissions and honors were showered upon him. In 1632 King Charles I invited van Dyck to England, where he remained as court painter in a luxurious and easygoing atmosphere. About three years later he painted this portrait, which is probably the summit of his art. His dazzling technique has captured the majesty, dignity, and authority of his subject, expressed in the attitude of the head, the firm gesture of the hand on the cane. At the same time, he conveys to us the individuality, the inborn elegance and subtle grace which made Charles the paragon of dandies. Van Dyck's genius, exemplified in this painting, was the inspiration of the great English portrait school of the eighteenth century.

How this picture came to France after the King's tragic death is not known. But it is an ironical coincidence that this portrait of a king who was to be beheaded should at one time have belonged to Louis XVI, who suffered the same fate.

PLATE 35

BROUWER [1605?–1638?]

The Smoker

IN THE EARLY PART of the seventeenth century the abuse of alcohol, formerly a costly medicine, had begun to spread; and civil and church authorities prohibited the use of tobacco, which was then smoked unmellowed and strong, often mixed with drugs producing brutal narcotic effects and sometimes addiction.

This picture by Brouwer—who lived a short, chaotic life, himself totally addicted to "tobacco" and gin, according to his biographer—is a vivid commentary. The smoker relishes the fumes from his pipe and clutches his bottle of gin; Brouwer has caught his subject's grimace with the precision of a caricaturist.

Although born in Flanders and attracted as a youth to the work of Bruegel (plate 31), Brouwer received his artistic training in Holland. He worked in the studio of Frans Hals (plate 41), whose influence is obvious in this *Smoker,* and

162

from whom he acquired his vigorous technique and the crackling brilliance of his brush strokes. He would not allow himself to be influenced by Rubens or van Dyck or Jordaens, but remained true to his inspiration and to the vernacular tradition that he inherited from Bruegel the Elder. He was a landscape painter of great versatility and modernity, exerting a strong influence on Flemish and Dutch artists. Rubens owned no less than sixteen of Brouwer's pictures.

PLATE 36

HIERONYMUS BOSCH [1450?–1516?]

The Ship of Fools

THIS UNIQUE GENIUS seems to have been able to develop his originality more freely because of his provincial upbringing. Bosch was born and lived at 's-Hertogenbosch (from which he derives his surname), a commercial center that stood somewhat apart from the great cities in which Flemish art was flourishing. His work is so modern in feeling that it is difficult to think of it as by an artist who is midway in time between Memling (plate 29), his elder, and Geertgen tot Sint Jans (plate 37), his junior.

Like Bruegel (plate 31), who admired his work, Bosch was less interested in the usual subjects of European painting than in satirical themes and familiar proverbs. *The Ship of Fools* was inspired by Sebastian Brant's book of that title (*Das Narrenschiff*), published at Basle in 1494. Later editions of the work, which was enormously popular, were decorated with engravings that may have served as the basis for Bosch's painting. The book recounts the voyage to the Isle of Folly, Narragonia, of men given to vice and sensual aberrations. The fervor and mysticism of the Middle Ages had been replaced by a moralizing attitude concerned with man and his behavior.

Strange, tormented spirit, Bosch mingles the allegories of his time with his own fantasies, abounding in diabolism and extravagant imagery, expressed in haunting symbols which modern psychoanalysis has readily turned to its own account.

PLATE 37

GEERTGEN TOT SINT JANS [1465?–1493]

The Resurrection of Lazarus

A NATIVE OF THE NORTHERN PROVINCES of the Netherlands, which later became Holland, Geertgen derives his surname from the Knights of the Brothers of Saint John, who housed him in their monastery during the latter part of his life. There are two works definitely ascribed to Geertgen in the Vienna Museum, *Julian the Apostate* and *The Deposition from the Cross*; and it is from close similarity to these works that it has been possible to attribute a few other paintings to this artist, among which the Louvre's *Resurrection of Lazarus* is of prime importance.

Before the separation of Flanders from Holland, the Netherlands had only one school of painting. Geertgen, however, shows distinctive regional characteristics which make him, after his master Albert van Ouwater, the originator of a Dutch

school. He discloses a grasp of landscape in which the scene is spread out in depth instead of appearing as on a backdrop. His figures are popular types with rustic faces. It is possible from Geertgen's work to see how the northern provinces, separated by local autonomy from the main European influences, would in the seventeenth century develop into a school of painting which is resolutely faithful in depicting nature and people.

PLATE 38

HOBBEMA [1638–1709]

The Watermill

HOBBEMA'S FIRST SIGNED WORK is dated 1658, when he was twenty years old; his last authentic work (with the one exception of the celebrated *Avenue Middelharnis*, dated 1689) was painted in 1669. Thus, though he lived past seventy, he practically abandoned painting after the age of thirty, when he was at the height of his power. From the time of his marriage and his appointment as customs inspector for the city of Amsterdam, he seems to have devoted himself entirely to family life and to his employment.

After long neglect, he became increasingly well-known from the end of the eighteenth century onward, and about 1850 his fame outshone that of Ruisdael (plate 44), whom he equaled in technical ability but who far surpassed him in poetic feeling.

Hobbema loved the details of his landscape: the broken ground covered with bushes, sunken roads, and trees with complicated branchings and thick foliage, houses, farms, and mills—all under skies covered with intricate clouds. Nature did not arouse powerful emotions in him, as it did in Ruisdael. But he does endow it with an imaginary and compelling existence which makes us wish to explore his roads, to enter his thickets, which step by step lead us farther into a picture where we seem to feel the humidity of the atmosphere and the stir of life.

This picture and *The Woman in Sunlight*, to which it was a pendant, were in a Belgian collection until 1817, after which they went to England. *The Watermill* came to the Louvre through a purchase by Napoleon III from the Baron de Witzleben.

PLATE 39

REMBRANDT [1606–1669]

Bathsheba

REMBRANDT'S PAINTING brought him early renown and wealth. But after the deaths of his wife, Saskia, and their delicate son, Titus, he withdrew more and more into himself as his powerful genius, perhaps the greatest in the whole history of art, matured. Foregoing the easy successes of his youth, Rembrandt was to know hardship and financial ruin for the rest of his life. He was ostracized by the Consistory for living with his servant, the gentle Hendrickje Stoffels, who first joined his household about 1649. After her death, Rembrandt passed the last

six years of his life absorbed in his own magnificent visions which he put on canvas with a technique both daring and rich in mystery.

It is Hendrickje whom he has painted as Bathsheba, the wife of Uriah, nude at her bath. Deep in thought, she holds a letter telling her of the passion of her sovereign, King David, who will take her away and kill her husband. Hendrickje's body is heavy and without grace, her features coarse and sad; but her devotion and the depth of her love have transformed her in Rembrandt's eyes.

At this time, Rembrandt discovered that light is never so radiant as when it emerges from shadow; he discovered also that the simplest beings can be raised to the sublime, provided that a man of good will, depth of feeling, and reflective spirit turns his gaze upon them and permeates them with his own splendor.

PLATE 40

VERMEER [1632–1675]

The Lacemaker

WE KNOW LITTLE OF VERMEER'S LIFE, which was passed entirely in the peaceful city of Delft, celebrated for its ceramics, its manufacture of luxurious objects, and its distinguished society. Vermeer was twice president of the artists' Guild of Saint Luke, but despite this proof of esteem, he seems to have lived in poverty, engulfed in debts; he was even obliged to give several paintings as security to his baker. A scrupulous craftsman, he produced very few works, of which only about thirty survive. He died young, and after long neglect he was saved from oblivion only at the end of the nineteenth century. Modern criticism ranks him amongst the most illustrious of painters, where he joins his compatriot, Rembrandt.

Yet Vermeer would seem to be Rembrandt's antithesis, by virtue of his dispassionateness, his serene, limpid technique. These qualities are striking in his *Lacemaker*, which may serve as a model of Vermeer's art. Probably painted at the height of his brief career, it shows how he transforms the reality of everyday life and humble subjects into a gentle and pervasive poetry. Through the wonderful rightness of his tones, broadly applied with flowing touches as perfect as they are economical, Vermeer gives the impression of exactness in this small canvas; yet it is the quintessence of his subject, its charm and its sweetness, that he distills from the visible world around him.

PLATE 41

HALS [1580?–1666]

La Bohémienne

PROBABLY BECAUSE OF RELIGIOUS PERSECUTION, Frans Hals's family moved from Flanders to Haarlem, where Hals lived, studied, and worked. The sparkling intensity of life and joy—despite hardship, debt, and physical failings—expressed in the execution of his paintings recalls his Flemish origins; and it is at first surprising that he should have been the pupil of Karel

van Mander, one of the most prominent of the Italianizing artists.

His *Bohémienne*, in its color and brilliance, its opposition of red and white, reveals the influence of Caravaggio on Hals's early career. Brought to Holland by Honthorst, the Caravaggian influence established the model for these half-length paintings of wild and vagabond types.

But Hals transformed his model through the rapid strokes of his unerring brushwork; entirely original is his feeling for vivid expression captured in the sidelong glance of the eyes and the mouth twisted with laughter. With Hals, painting lost its ancient immobility and seized upon the fleeting and the elusive.

PLATE 42

HEDA [1593?–1682?]

Still Life

VERY LITTLE IS KNOWN of Heda's life. A native of Haarlem, he painted his first known and dated picture in 1621 and ten years later he was admitted to the artists' Guild of Saint Luke. There are very few religious paintings or portraits from his hand; the larger and indeed more interesting part of his work consists of still life painting.

First created by the artists of the North, this form of painting had developed in a particular way by the beginning of the seventeenth century: instead of a profusion of objects in cascading and decorative arrangements, the painter now concentrated on the study of a few objects spread out on a table. A glass, a plate, fruit, fish—objects such as these were given a strange and almost living personality.

Heda's contribution to the art of the still life is a personal and very pure perception of volume and structure, and a technique of great subtlety. Against backgrounds well balanced in both vertical and horizontal planes are placed a few impermanent objects—cracked nuts and half-eaten cakes. Here we may see one of the major characteristics of the Dutch still life which, as the poet Paul Claudel has remarked, "is something disintegrating, something that is prey to time."

PLATE 43

POTTER [1625–1654]

The White Horse

POTTER'S REALISM is not merely a painter's virtuosity, and this is the secret of his greatness. He is wholly absorbed in his subject for its own sake; while he gives himself up to the minute rendering of the horse's dappled coat, he also increases the stature of the animal to create a heroic silhouette. The horizon, the vertical lines of the trees, the contrast in tone with the sky, and the small deer grouped around a pond—all these help to bring his central figure into greater prominence. The light is golden, in the manner of the Italianate artists, but it is always true, for Potter's eye never fails him.

His reputation stood highest a century ago, when the triumph of realism and the taste for nature created a fashion for

such painters as Troyon and Rosa Bonheur; but their pedestrian truthfulness now seems only to emphasize by contrast the keen and inspired observation of Potter.

PLATE 44

RUISDAEL [1628?–1682]

The Burst of Sunlight

RUISDAEL WAS BORN IN HAARLEM of a family of landscape painters. He studied with his father Isaak, and he was also influenced by the work of his uncle, Salomon Ruisdael. He began as a painter of the Dutch plain, with its immense cloudy skies; but after his travels in Holland and Germany his outlook began to change, and we find him painting landscapes which are romantic, often tragic, in feeling. He settled in Amsterdam in 1656, but, curiously enough, he was in France in 1676, taking the degree of doctor of medicine at the University of Caen.

It was during the last period of his life, when the note of melancholy reverie became more prominent, that he painted *The Burst of Sunlight*. Instead of the realistic exactitude of his early work there are here a broader brush stroke and a bold treatment of lighting which communicate his imaginative vision of a familiar scene.

Under the vast sky and the shifting patterns of clouds and light, a windmill, human dwellings, and a few isolated figures are scattered across the scene. Ruisdael combines these elements as if to emphasize the weakness of man before the blind forces of nature. The gleam of sunlight bursting through the shade serves as a unifying and almost supernatural note.

A recent cleaning of the picture, which had hitherto been gold with varnish, has shown us how the artist's scrupulous eye has preserved the cold grey light of the North.

PLATE 45

STEEN [1626?–1679]

Celebration in a Tavern

BORN AT LEYDEN, Steen was primarily interested in painting scenes of everyday life, thus escaping the austerity and overseriousness which were beginning to appear in the work of some of his contemporaries. Although he was one of the first members of the painters' Guild of Saint Luke in Leyden he seems to have had difficulty in supporting himself as a painter. The last ten years of his life were spent in Leyden where in 1672 he had taken over the management of an inn. This may be the setting for his *Celebration;* at any rate, the pictures displayed at the back of the room prove that the landlord was a lover of painting.

In this energetic and animated scene Steen continues the interest of the Northern painters in revels and popular celebrations. But while Steen's work lacks the Dionysiac, lyrical quality of the Rubens *Country Fair* (plate 32), it has a natural, healthy gaiety of its own, far removed from the coarseness toward which Flemish painting often tended. And although

Steen was a reporter of everyday life, he was a reporter without triviality. With his refined and easy technique he shows the *joie de vivre* of these simple country people eating, drinking, laughing, and dancing to the sound of a rustic band.

PLATE 46

TER BORCH [1617–1681]

The Gallant

MORE MARKEDLY than other painters of his generation, Ter Borch was influenced by the social change which was to turn Holland into a middle class society aiming at elegance and refinement. He traveled widely; in Spain he was received at court where he is supposed to have painted several portraits of Philip IV. Returning to Deventer, his birthplace, he lived in great honor as one of the dignitaries of the town.

Ter Borch is an index of a growing refinement in Dutch art. Only the heavily emphasized detail of the offer of money relates *The Gallant* to the tavern and guardroom scenes of early seventeenth-century Dutch genre painting. We are impressed by the somber and silent room, the luxurious chimney piece, and by the lady, so discreet and distinguished in appearance.

Far from the lusty Frans Hals (plate 41), whom he must have known in Haarlem, Ter Borch heralds the generation of Vermeer (plate 40), Pieter de Hooch, and Metsu, for whom he established both subject and treatment: conversation pieces or concerts, reserved and delicate in spirit, with the attention of the painter focused on the technical handling of furs and precious cloths.

PLATE 47

REYNOLDS [1723–1792]

Master Hare

PAINTER OF THE ENGLISH ARISTOCRACY, Reynolds enjoyed a career of almost uninterrupted success and popularity; the catalogue of his works includes 2400 portraits and 172 paintings on religious, mythological, allegorical, and Shakespearian themes.

The son of a clergyman, Reynolds studied in London and later went on to Italy where he was particularly impressed by the work of Michelangelo, Raphael, and Correggio; during a later trip to Flanders and Holland he admired the works of Rembrandt and Rubens. With his rival, Gainsborough, he was one of the founders of the Royal Academy, of which he was the first president. His *Discourses*, delivered as lectures at the Academy, had a considerable influence on the English painters.

Painted between 1788 and 1789, just before Reynolds became blind, *Master Hare* displays all of the painter's technical resources. The healthy, gracious freshness reminds one of Rubens; and it is in fact from Rubens, by way of van Dyck, that Reynolds learned to communicate the free and happy charm of childhood. But for Reynolds the child seems hardly to be an individual; he is painting childhood rather than a portrait of Master Hare, lifting a rebellious finger.

PLATE 48

CONSTABLE [1776–1837]

Helmingham Park

WHILE HIS FAMILY envisaged for him a conventional and rewarding career as a portrait painter, Constable remained true to his profound and reverent love of nature. Nor did he go far afield for his scenes; the Suffolk country or that around Hempstead was his inspiration. He seems to have felt no need for a journey to France, where he was admired by the young romantics who were tremendously affected by his work, especially after the Paris Salon of 1824, where his paintings were seen. The great Delacroix, for example, impressed by Constable's *Hay Wain*, immediately repainted sections of his own *Massacre of Scio*. The contemporary landscape painter Paul Huet wrote: "The discovery of Constable's work is an important event in the history of modern painting . . . the admiration of the younger school . . . was boundless."

Constable found joy in being "quite alone among the oaks and solitudes." He worked directly from nature, beginning with a drawing or watercolor which established the principal harmonies; on his return to the studio, he would finish the composition.

He loved to oppose light and shadow in his paintings, and in *Helmingham Park* he has contrasted the shadowy green recess by a brook with the summery blue of the sky, giving expression to the freshness and richness of the English countryside.

PLATE 49

BONINGTON [1802–1828]

View at Versailles

BONINGTON WAS A MASTER of watercolor and of the small painting, executed in light fluid tints which give them their bright and delicate tonality. "You are a king in your own field," his friend and admirer Delacroix said; and during his brief career Bonington equaled the achievements of Constable and Turner as landscape painters. Although he was English by birth, he was trained and worked in France, and he may be said to have rediscovered for French painting the art of landscape, proscribed and scorned by the followers of David in their admiration for the antique.

His *View at Versailles* has often, and mistakenly, been described as a sketch. Bonington never gave a detailed and smooth finish to his work; he painted rapidly from his impressions and Delacroix said that one could not "fail to admire the marvelous harmony of effects, and the facility of his execution." His contemporaries, accustomed to the austere and coldly executed compositions of David and his school, must have been astonished at the sketchy simplicity, and audacious mastery of Bonington's work.

The passers-by, in the *View at Versailles*, provide touches of color which bring out the tone values of the great expanse of sky, covered with storm clouds, and reflected in pools. The bronze statues which decorate the borders of the mirroring water sound their notes of black metal in this bright symphony.

PLATE 50

LAWRENCE [1769–1830]

Julius Angerstein and His Wife

SUCCESSOR to the generation of Reynolds and Gainsborough, Lawrence was the last of the great English portrait painters. Achieving fame in his early twenties he went on to a career of brilliant success. When Delacroix met him in London in 1825 Lawrence was one of the most famous artists of Europe, the painter of kings and even of the Pope, knighted and presiding over the Royal Academy.

Lawrence's *Julius Angerstein and His Wife* was exhibited at the Royal Academy in 1792. In this early work the strong influence of Reynolds is evident. The family portrait—two people, or parents and children seen against the background of a peaceful landscape—was a typical subject of late eighteenth-century English painting. Hogarth and Gainsborough excelled in it, and Lawrence continued the tradition. His subjects are of the middle class—Angerstein was a wealthy merchant and Lawrence's early patron—but he has given them a harmonious and natural grace by which this painting rivals the elegance of Gainsborough's paintings of the aristocracy.

PLATE 51

EL GRECO [1541–1614]

Portrait of Covarrubias

EL GRECO WAS BORN IN CRETE, which was then in the hands of the Venetians. He was never to forget his Greek and Byzantine antecedents. We know nothing about his artistic education nor when he went to Venice. A contemporary text calls him a follower of Titian; it is rather Tintoretto and especially Bassano who influenced him. In 1570 he went to Rome, where he came under the influence of Michelangelo. From Rome he went to Spain, the Spain of Saint John of the Cross and Saint Teresa of Avila, the great mystics of the Church. He settled in Toledo, where he became the friend of the city's poets and scholars, and found a spiritual climate refined and hungry for truth. The harmony between the mystical genius of El Greco and the city of Toledo explains the Metropolitan Museum's extraordinary *View of Toledo*, which is no longer a landscape but an almost supernatural vision. Greco's productivity was remarkable; he was a religious painter, a portrait painter, and a sculptor and architect as well. His art, so intensely spiritual, is almost without parallel in the history of art; he is, as Jean Cocteau has written, "a call, a prayer, a cry."

Covarrubias, son of the celebrated architect of the Emperor Charles V, was a friend of Greco. His portrait is strikingly modern in style and characteristic of those painted in Greco's last manner. Neglecting the beauty of diversified color, he uses blacks, greys, and whites, barely enlivened by a touch of red, to make even more expressive this mask of an old man on the edge of the grave. Greco's characteristic elongation is further exaggerated by the pointed beard and the hard white collar. The funereal harmony, the long falling lines of the composition, the soft eyes filled with sadness—these make of this portrait a dramatic representation of old age.

PLATE 52

ZURBARAN [1598–1664?]

The Funeral of Saint Bonaventure

FRIEND AND CONTEMPORARY of Velasquez, Zurbaran, in contrast to the brilliant court painter, is Spain's great painter of religious and popular subjects, the painter of monks in their ample and sculpturesque habits seen against the shadow of their cloisters. His simple art, distinguished by power and concentration, was technically restrained but grandly conceived, sometimes overpowering in its solemnity.

The Funeral of Saint Bonaventure is not only one of Zurbaran's finest works but it is also one of the most typical examples of Spanish art of the seventeenth century. The boldness of the composition with the great diagonal of the saint's white corpse, the beauty of the golds and reds, and the purity and sobriety of the modeling are all overshadowed by the harsh grandeur of the composition. The sad meditation of the Franciscans contrasts with the worldly aplomb of Pope Gregory X and the Emperor Palaeologus V, as they confront death. The greenish face of the corpse is the face of death itself, which always has fascinated the Spaniard and haunted him; it is also the face of the Spanish genius, which combines a cruel realism with a deep spirituality.

Saint Bonaventure, whose real name was Giovanni Fidanza (1221-1274) acquired his name from his miraculous cure by Saint Francis when he was a child, crying out *"O buona ventura!"* Cardinal, and General of the Franciscan order, he was also important as a theologian.

PLATE 53

RIBERA [1591?–1652]

The Clubfoot

A CLOSE FOLLOWER OF CARAVAGGIO, Ribera painted realistic and passionate pictures of old men, with faces coarsened and lined by toil and misery, and other street types. Even more than the Italian master, he was drawn to the portrayal of suffering and death, of scenes of martyrdom. But, like Velasquez, he turned the picaresque faces of his beggars and thieves into those of wise men and philosophers. And when he painted scenes of antiquity and figures of saints, Ribera, religious as well as realistic, gave them almost the sweetness of Correggio. He was also an engraver, a solitary example in seventeenth-century Spain.

His *Clubfoot* is a lowly equivalent of the monsters, dwarfs, and court buffoons who served as models for Velasquez at the same period. Carrying his rolled *capa*, with his crutch over his arms, this strange cripple stands proudly against a background of sky. An inscription, which he holds in his left hand, tells us that he was also dumb. His smile accentuates the cruelty of this portrait, one of the last and most bitter of Ribera's works.

The extreme realism and the violent and harsh expression of ugliness are neither exaggerated nor turned into caricature. Ugliness and misery, depicted with such simplicity and grandeur, with a fierce and wild dignity, here produce a deeply moving work of art.

PLATE 54

VELASQUEZ [1599–1660]

Portrait of Queen Mariana

PAINTER TO KING PHILIP IV of Spain, Velasquez in his later years depicted only the court, including even the buffoons and the king's dogs. Primarily a portrait painter, he is the greatest artist of the golden age of Spain. He is certainly the most brilliant of those painters who, through the originality and perfection of their technique, glorified the reality they saw. An inscription on Velasquez's statue dedicates it to "the painter of truth." Painter of truth, yes, but of a truth filled with poetry by the magic of the brush.

The *Portrait of Queen Mariana* has been called his finest painting of a woman, and it is one of the most typical examples of his sober and distinguished art. The somber harmony of black and white, set off by the gold and silver, is contrasted with an exquisite rose and a touch of vermilion. Velasquez has not flattered the plain features of his subject; he has skillfully transformed her by emphasizing her architectural headdress, her magnificent costume, and her beautiful and regal hand.

Mariana of Austria became the second wife of Philip IV in 1649, and about three years later Velasquez painted this portrait. At the request of the court of Vienna, Velasquez painted a copy of the portrait, but Philip refused to give up either version. Mariana's portrait came to the Louvre by exchange with the Prado, which owned both of the Velasquez originals.

PLATE 55

GOYA [1746–1828]

Woman in Grey

IF VELASQUEZ' PORTRAITURE is aloofly impartial, Goya, in his paintings, acts as judge. To the refined realism of Velasquez Goya added a psychological penetration. In some paintings, for example in his portrait of the *Family of Charles IV* in the Prado Museum, he even went to the limits of caricature.

We do not know the identity of his *Woman in Grey* with her fresh, rosy complexion. Though the Louvre owns two magnificent portraits of men by Goya, it does not possess a better example of his refined coloring than this harmonious picture in grey, livened with pale grey-green and rose painted over a harsh black. Goya, André Malraux has written, "idealizes through color." His flexible and swift technique is entirely modern in its ease; his brush, flicking across the canvas, gives to each touch a perfection and an audacity which remind us of Manet or Degas.

His deafness, the misfortunes of his country, and the war which after 1808 devastated Spain, later turned Goya away from portraiture toward painting which was dramatic, bitter, and often cruel, and etchings of unparalleled ferocity. He decorated his house in Madrid with strange and savage scenes where his art, more and more emancipated, develops an almost modern Expressionism. In 1824 he left Spain for France, where he died four years later.

He ranks with Greco and Velasquez as one of the most astonishing and original of the great Spanish painters.

PLATE 56

DURER [1471–1528]

Self-Portrait

DURER WAS A MAN OF BROAD TRAINING and interests, a true man of the Renaissance rather than simply a skillful Northern craftsman. Born at Nuremberg, he studied there and in Cologne at the studio of Martin Schongauer, where he learned copperplate engraving. His two trips to Italy brought him under the influence of the work of Mantegna and Bellini, which helped form his style. At the same time he pursued scientific studies of perspective and the proportions of the human body, and toward the end of his life he wrote three books: on perspective (1525), on the construction and fortification of cities (1527), and on proportion (1528). His work is enriched by the conflict between the analyzing, realistic Northern spirit, and the synthesizing, rational Latin spirit always in search of the fundamentals of art and aesthetics.

The *Self-Portrait* is the first of a series which Dürer was to do. He has taken great care over this representation of himself. Its precise realism, its acute, relentless linearity still preserve the essential mystery of the human face, making this portrait a striking expression of Germanic painting.

The artist holds a sprig of thistle in his hand, a plant which in Germany symbolized conjugal fidelity. From this detail some historians have drawn the conclusion that Dürer intended this painting for his betrothed, whom he married at Nuremberg in 1494.

PLATE 57

HOLBEIN [1497?–1543]

Anne of Cleves

IN 1526 HOLBEIN LEFT FOR ENGLAND, with letters of introduction from his friend Erasmus, the great humanist. Within a few years he became court painter to King Henry VIII, and after the death of Jane Seymour, whose portrait he had painted, he was sent abroad on the mission of finding a new wife for the King.

It was on this mission that he painted Anne of Cleves. Her portrait shows Holbein's art at its highest level. This is evident not only in such refinements as the jeweled details of the sumptuous robe and coiffure, but also in the psychological subtleties: the vague, empty look, the sullen, expressionless features, and the precision of attitude in the rigidly crossed hands. But he seems to have been interested primarily in the construction of the beautiful robe, so that the unlovely face of the Princess appears even more insignificant and unlovely than it was.

The King was captivated by Holbein's portrait, with its unflattering realism, but he was so disillusioned by the living model that he put up with her for only a few months and then divorced her. The portrait is proof that a great artist may create a masterpiece to order, even if this order confronts him with the most uninteresting subject. The influence of Holbein's genius on English painting was not to exhaust itself for a century.

PLATE 58

FOUQUET [1420?–1480?]

Saint Martin and the Beggar

OUR PICTURE IS ONE OF A SERIES which Fouquet executed for a Book of Hours commissioned by Etienne Chevalier, the treasurer of Charles VII. The subject is the familiar episode in the life of Saint Martin: the Saint divides his cloak with his sword in order to share it with a shivering beggar. Typically, Fouquet set this legend in an actual landscape, a view of Paris.

The self-conscious essays in perspective on the right side of the picture suggest the effects of Fouquet's travels in Italy about 1445. Characteristically French, however, is his skillful disposition of a dense crowd in a minute space, so that it becomes a dramatic element through its calm simplicity.

Fouquet broke away from the Gothic linearity and Mannerist elegance of the school of Paris. He was the earliest painter to record the famous subtle light peculiar to the Ile-de-France and he used this light, not mechanically, but to fuse his figures with his landscapes. By the sculptural grandeur of his forms, the austerity of his composition, and his deliberate use of light Fouquet transformed the miniature into a monumental art.

PLATE 59

MALOUEL(?) [end of 14th century]

Pietà

SAINT JOHN AND ANGELS mourn the dead Christ, who is supported by God the Father and the Virgin; the Dove of the Holy Ghost hovers overhead. This theme, according to Emile Mâle, was popular around the end of the fourteenth century and was probably inspired by a text of Saint Bonaventure.

This painting, in egg tempera on a gold ground, was undoubtedly executed about 1400 for the Dukes of Burgundy, whose arms appear on the back. It is attributed by some historians to Jean Malouel, a Flemish painter employed by the Dukes of Burgundy, whose *Martyrdom of Saint Denis* is markedly similar to the *Pietà*. At Dijon the Dukes of Burgundy had created a center of Franco-Flemish art of which the detail of the gold-wrought crown of one of the angels is characteristic.

Other historians, however, are impressed by the dominant Parisian character of the *Pietà* and deny the attribution to Malouel. Some elements which may indicate the school of Paris are the harmonious simplicity of the composition, balanced if somewhat stilted, the tender calm of the faces, the graceful purity of the drawing of Christ's body, and the beauty of the long, elegant hands.

PLATE 60

UNKNOWN PAINTER [15th century]

Villeneuve-les-Avignon Pietà

EVERYTHING ABOUT THIS MOVING WORK is lost in mystery. We do not know the name of the white-robed donor on the left or the identity of the city whose delicate minarets appear dis-

tantly against a gold background. What great artist had the power to create, in a style both monumental and sober, so harrowing an image of sorrow? The sublime mystery of the death of the Son of Man and the sorrowful love of those closest to him are transmitted with audacious simplicity: we are held by the great white sweep of Christ's body, toward which are pulled the symmetrical silhouettes of Saint John and the Magdalen, and by the strong vertical of the admirable figure of the Virgin who dominates the composition.

All that we know is that this panel was at the Charterhouse of Villeneuve-les-Avignon probably until the Revolution and that it was discovered at the time of the exhibition of "Primitives" in 1904. Though the *Pietà* can be dated about 1460 attempts to attribute it to any known master have been inconclusive. It is the most beautiful example of Provençal and Avignon painting whose linear style gives a harsh reality to forms and a poignant expression to faces. The solemn pathos of the scene and the intensity of expression make this painting one of the great achievements of French art.

PLATE 61

MASTER OF MOULINS [*end of 15th century*]

Saint Mary Magdalen and a Donor

BECAUSE OF VARIOUS SIMILARITIES, historians have agreed to link a certain number of unascribed paintings with a very beautiful triptych in the Cathedral at Moulins. These paintings are collectively attributed to an anonymous Master of Moulins who worked in the Bourbon country at the close of the fifteenth century.

The present painting shows an unidentified praying donor being presented by her patron, Saint Mary Magdalen; this follows the iconographical practice of the time. The painting was once part of a triptych, the other two panels of which are lost.

The realism with which the faces are depicted, as well as the coloring, suggests a Flemish influence, particularly that of Hugo van der Goes. Whoever he was, the Master of Moulins approached Fouquet in the breadth of his draftsmanship; like Fouquet he followed a course different from that of the school of Paris.

The rounded and gentle modeling, the graceful attitude of the Saint, the devout bearing of the donor, and the attention given to the faces—these are typical of French art at the end of the fifteenth century: an art of measure and balance, of attention to realistic detail which the artist must transcend in order to extract the inner poetry.

PLATE 62

JEAN CLOUET [*1485?–1540?*]

Portrait of Francis I

IN CLOUET'S PORTRAIT Francis I is not the handsome man that his admiring contemporaries described, but rather a refined and elegant person with maliciously ironical and intelligent eyes. We see him with his hand on his sword, a king of great majesty, the first knight of his kingdom. Here is the *grand seigneur*, both gallant warrior and patron of the arts and sciences. One of the builders of the Louvre, founder of the Collège de France and the school of Fontainebleau, brother of the learned Margaret of Navarre, friend and protector of Leonardo da Vinci, Francis was one of the brilliant figures of the Renaissance.

Clouet has expressed the brilliance and majesty of his royal patron in the penetrating look, in the refinement of the head placed on a strong massive neck, and in the elegance of the long, supple hands. The decorative effect of the sumptuous costume does not detract from the importance of the figure but on the contrary gives it a greater nobility.

This portrait remained at Fontainebleau until the eighteenth century when it was transferred to Versailles before coming to the Louvre.

PLATE 63

UNKNOWN PAINTER [*16th century*]

Venus and the Goddess of the Waters

IN 1531, AS PART OF HIS PROGRAM of subjecting French art to Italian influences, Francis I established il Rosso and Primaticcio—and later Niccolo dell'Abbate—at Fontainebleau; the resultant mixture of French and Italian elements effected a radical change in the French tradition.

Venus and the Goddess of the Waters is typical of the eclecticism, the preciousness and decorative subtlety of the school of Fontainebleau in its full flowering. The subject, probably inspired by an elaborate mythological poem, is difficult to identify with any certainty; but in the execution French and Italian elements may be distinguished. The stilted essay in elegant gesture, the elongated silhouettes, the delicate metallic colors—these suggest Italian Mannerism, a style which Primaticcio and his colleagues had brought to France. But there is a decorative precision in the painting of the flowers reminiscent of medieval illuminations; a fragile grace about the bodies; and a certain naivete in the composition, all of which remain essentially French. Even a Northern influence is evident in the realism, almost verging on caricature, with which the little cupids are drawn.

PLATE 64

LOUIS LE NAIN [*1593?–1648*]

The Pilgrims at Emmaus

THE WHOLE ART of Louis Le Nain is summed up in this scene: a simple village meal transformed into a miracle by the appearance of the Savior. Here are the subjects he loved: the various old men, the children at play; even the little dog is not out of place; and the wine and the bread on the table are sacred food. As the three men begin their sparse meal, the eyes of the two disciples suddenly open as their companion, who has the finely drawn face of an aristocrat, breaks his bread. Le Nain always discerned the passion latent in humble, everyday gestures. The slow movement, never vulgar, always reverent,

with which a peasant holds his glass of wine and breaks his bread touched his sensibility.

The composition is of the utmost simplicity, as is the arrangement of the serious dignified figures. The absence of any striving for effect reveals the inner purity of the painter's Christian devotion.

Louis Le Nain painted a number of pictures in collaboration with his two brothers. Although he was honored during his lifetime his reputation, like that of Georges de La Tour, fell a victim to the sectarian and academic taste of the age of Louis XIV. He was rescued from obscurity at the end of the eighteenth century, but it was not until recently that attempts were made to distinguish his work from that of his brothers.

PLATE 65

POUSSIN [1594–1665]

The Triumph of Flora

THE HIGHEST QUALITIES of French seventeenth-century art are epitomized in the work of Poussin who, paradoxically, spent the years of his mature artistry in Rome. Here, rather than in his native country, he must have sensed an atmosphere indispensable to his genius. His profoundly classical temperament—reasonable, calm, and balanced—was at ease among the monuments of antiquity; the pagan gods were the preferred subjects of his paintings.

The Triumph of Flora is characteristic of Poussin's early style, the rich brassy colors recalling Titian who, with Raphael, was a major formative influence. The drawing and modeling of the bodies, which resemble the noble forms of Greek sculpture, testify to the artist's learning and precision; often, as studies for paintings, he made clay figures which enabled him to define both anatomy and shadow.

Flora, the goddess of flowers and of regeneration, dominates the composition, advancing in a chariot drawn by cupids in the manner of an ancient triumphal procession. About her spreads a train of nymphs, symbols of beauty and youth, and a dancing and running crowd which expresses the joy of Spring. The composition, accented in the left half of the picture, proceeds in repeated parallel rhythms which balance one another, giving this work a unique perfection.

PLATE 66

CLAUDE LORRAIN [1600–1682]

A Seaport at Sunset

A NATIVE OF LORRAINE, as his name indicates, a Northerner by birth and environment, Claude settled in Rome in 1627. There he spent the rest of his life, painting his fantastic landscapes bathed in sunlight and haze—an unreal light, like nothing ever achieved in painting. With Ruisdael he is the greatest landscape painter of the seventeenth century.

The Seaport at Sunset is not a real port; that would not have interested Claude. Here all is poetic invention, a transformation of the actual. He cared only for the play of the golden light of sunset, when the sun, already almost invisible, still

dominates the dust-laden air, flooding the sky, and gilding the ships and buildings. The classical palaces, the colonnades, the porticoes by the strand—these are all an architecture of dreams; the ships are phantom, the figures in the foreground are actors out of a Chinese shadow-play. Even the light itself seems unreal.

The whole composition centers on the heavenly body that will die below the horizon. This aspiration to measureless distance adds the gravity of poetry to the pictorial enchantment and makes this picture one of Claude's purest achievements.

PLATE 67

LE BRUN [1619–1690]

Equestrian Portrait of Chancellor Séguier

LE BRUN WAS THE FAVORITE PAINTER of Louis XIV, the founder and first director of the Académie des Beaux Arts, and consequently the artistic dictator of the age of Louis XIV. Prolific and erudite, in his powerful and formal decorations of the Palace of Versailles he gave perfect expression to the grandiose aesthetic of the Sun-King.

The Equestrian Portrait of Chancellor Séguier was painted at the beginning of his official career, two years before he was appointed Painter to the King. Séguier, Le Brun's patron and Chancellor to Louis XIV, wore this magnificent costume when he rode in the train of the young Queen Maria Theresa at her solemn entry into Paris in 1660.

The simple processional arrangement, the realism of the portraiture, the beauty of the adolescent figures—all of these recall the quiet poetry of Le Nain and de La Tour. But in addition to this the painting is marked by a sense of grandeur, the quality for which Louis XIV so prized Le Brun, and which represents the moral and aesthetic ideal of the seventeenth century.

This masterpiece, forgotten among the belongings of the Chancellor's descendants until 1935, was purchased by the Louvre in 1942.

PLATE 68

GEORGES DE LA TOUR [1593–1652]

Saint Joseph the Carpenter

IT IS ONLY RECENTLY that the reputation of de La Tour has been restored. His paintings, at various times mysteriously attributed to Dutch and Spanish followers of Caravaggio, and even to Vermeer and Velasquez, have now been reassembled as the work of a single master. Once a favorite of Louis XIII, who asked that no other painting but de La Tour's Saint Sebastian be hung in his bedroom, he is now again considered one of the great painters of the seventeenth century.

Saint Joseph the Carpenter is one of the most beautiful and most moving of those night scenes which were considered de La Tour's glory in his own time. In contrast to the strong and realistically painted Joseph stands the exquisite figure of the Child, heightened by the candlelight. At first the grandeur of the gold and violet-tinged red, the simplification of volumes,

and the sculptural stylization appeal to the spectator. But soon the mystery of the shadows begins to convey a stirring of the spirit; the piece of wood Joseph is working seems to contain the shape of a cross.

One critic, P. Jamot, has admirably defined the secret of de La Tour's poetry: "although it is sometimes held in the hand of a little child, a candle has conquered the enormous night."

PLATE 69

DE CHAMPAIGNE [1602–1674]

Portrait of Arnauld d'Andilly

TRADITIONALLY the subject of this portrait is identified as Robert Arnauld d'Andilly, the elder brother of Antoine Arnauld, a leading theologian of the anti-Jesuit Jansenist movement and, with Pascal, one of the strongest supporters of the religious community at Port-Royal. Arnauld d'Andilly retired to Port-Royal where he worked on a translation of the *Confessions* of Saint Augustine and on other religious writings.

Like Jansenius, the moving spirit of the Port-Royal movement, Philippe de Champaigne was a Fleming by birth; and although he was not a Jansenist he was aware of the profoundly Christian spirit which animated the recluses at Port-Royal.

He had made portraits of several of his Jansenist friends and in them, as in his *Arnauld d'Andilly,* he invested his subjects with an austere dignity, a moral elevation, and a singularly severe beauty. De Champaigne does not omit a single wrinkle or a swelling vein; he even develops the illusion of Arnauld's hand extending beyond the picture frame; but together with this painterly virtuosity he possesses the secret of expressing in his subject's face the ardent impulses of the soul.

PLATE 70

LE SUEUR [1617–1655]

The Death of Raymond Diocrés

THIS CANVAS is one of a series of twenty-two scenes from the life of Saint Bruno of Cologne (1030?-1101), founder of the Carthusian order. Le Sueur was given the commission to execute this important religious cycle by the Charterhouse of Paris.

In his youth Saint Bruno had been much swayed by the sermons of Raymond Diocrés, a famous preacher. But Diocrés was an impostor and after his death, when he was being mourned as a saint, his body rose in its shroud and announced his soul's damnation to the terrified clerics.

Le Sueur communicates his fervor here with the utmost pictorial economy, which gives an impressive power to the anguish and astonishment on the individual faces. The composition is simple, dominated by the vertical of the bishop's figure and the horizontal of the figure of Diocrés; but the most intense drama centers in the eyes and hands of the individual actors.

Le Sueur was influenced by both Raphael and Caravaggio. Although he was inclined by temperament towards a not too rigid form of classicism, he took from the realistic style of Caravaggio what he needed to give greater force to his art.

PLATE 71

RIGAUD [1659–1743]

Portrait of Louis XIV

A PROTEGE OF LE BRUN, Rigaud became a fashionable portrait painter, overwhelmed by commissions. To execute these he employed apprentices whom he trained as specialists in painting the various accoutrements which adorn and set off his subjects.

Though Louis XIV was sixty-three when Rigaud painted his portrait, he was still the greatest king of Europe. Rigaud has painted him as the image of monarchy by divine right, the incarnation of kingship. Each detail takes on symbolic grandeur: the enormous marble column and the vast sweep of drapery it supports do not appear to dwarf the majestic and elegant figure of the Sun-King any more than the heavily embroidered mantle or the sacramental ornaments.

Although this picture is characteristic of the art of the *Grand Siècle*, it already shows the signs of a new development: there is a delight in the beauty of color, in the exact rendering of texture, and of the varied play of light. Here we have the germ of that pictorial sensualism which, in the eighteenth century, was to triumph over the academicism of Le Brun.

Though Louis commissioned the portrait as a gift for King Philip V of Spain he was so pleased with it that he retained it, and it hung in the throne room at Versailles.

PLATE 72

WATTEAU [1684–1721]

Embarkation for Cythera

WATTEAU WAS ABOVE ALL a poet and a magnificent draftsman. In his notebooks he sketched figures which he would later gather into groups and set in imaginary landscapes and scenes of gallantry; their exquisite color and delicate poetry continued to inspire artists throughout the eighteenth century.

A scene of fantasy and imagination, the *Embarkation for Cythera* is in essence a poetic transformation of an eternal theme. After hesitating at her lover's pleading, the girl agrees to follow him and then, while approaching the boat which will take them to Cythera, the mist-shrouded island of love, looks back on the land she is leaving.

The Académie des Beaux Arts had been so impressed by the genius of the young Watteau that they admitted him in 1712, but it was not until 1717, at the last possible moment, that he submitted his diploma work, this admirable masterpiece, composed with the fire of genius upon him. Some years later he wanted to repaint the picture at greater leisure and the second *Embarkation*, bought by the King of Prussia, may be more complete, more technically accomplished; but it has lost the grace of the earlier version, lost the impulse of youth, the hope for an inaccessible dream.

PLATE 73

LANCRET [1690–1743]

Reception of the Order of the Holy Spirit

A PUPIL OF WATTEAU, Lancret seems to have inherited his master's technique and his subjects, but little of his genius. Although his work is full of imaginary landscapes, gentle shadows, fantastic figures, shepherds, and Italian comedians, he has lost the poetry and the charm and retained little more than anecdote. But Lancret's elegant and scintillating art won him success and fame among his contemporaries. He was elected to the Academy in 1719.

This commemorative painting is an exception in the body of Lancret's work, and together with a companion piece was probably painted in the hope of a commission from the Gobelins factory to design tapestries; this commission, which he did not receive, would have won for him the coveted title of a history painter.

Unfinished though it is, and unappreciated by his contemporaries, this is one of the most pleasing of Lancret's works. The scene is set in the chapel of Versailles on June 3, 1724; the young King Louis XV presents the insignia of this famous Order to two kneeling novices as the court, shimmering in satins and velvets, looks on. The work has an extraordinary pictorial quality, brought out in a luminous harmony of ashen tints lightly touched with black. And in reporting the scene without pomp or grandiloquence, Lancret has created a vivid and impressive historical document.

PLATE 74

CHARDIN [1699–1779]

Back from the Market

CHARDIN'S PROPER PLACE is in that essentially French dynasty of painters that begins with Le Nain and ends with Corot, those artists who have been called painters of poetic reality. Chardin painted what he saw: familiar things, intimate scenes in peaceful household, all that was close to him. Although he was made an Academician in 1728 his work was not in the main current of his day. In contrast to Boucher, who painted for the court, Chardin was a bourgeois painter; "You can use colors," he said, "but you must paint with your sentiment."

When a subject pleased Chardin he would paint it many times with very little change, applying himself to the perfection of his rendering. This painting repeats the subject of an earlier one, now at Potsdam, painted in 1738. Chardin has looked with great sympathy at the slow, somewhat tired posture of the maid as she rests her arm on the sideboard; under his brush, the loaves of bread, the bottles, and the kitchen utensils acquire a massive importance.

In Chardin's painting we are most conscious today of qualities other than those of mere representation; and because of this he has been called the first of the moderns. Indeed, it is difficult to know what to admire more in his work: the solid, deliberate composition of still life which reminds one of

Cézanne, or the richness of pictorial substance which translates reflections with a luminosity that recalls Vermeer.

PLATE 75

BOUCHER [1703–1770]

The Bath of Diana

ACADEMICIAN AND PAINTER TO THE KING, Boucher worked primarily in the service of Madame de Pompadour, who even took drawing lessons from him. An artist of unrivaled facility, Boucher exercised his versatile talent on all subjects, but above all on portraits of women. He is the most inventive and refined of the French decorators and his work marks the high point of the Rococo style.

The Bath of Diana had an immediate success when it was exhibited in the Salon of 1742. Diana and one of her followers relax after the hunt; their dazzling and shimmering beauty is a harmony of pale gold playing against a background of blue. The dead game, the quivers, the thirsty hounds—all these are traditional attributes of the goddess. The painting satisfied the taste of a fastidious and sophisticated public, sensitive to the most subtle relations of color, a public with a liking for pictures which could be hung against the light wood paneling of even the smallest room.

The composition is based on two oblique lines, ascending from left to right; they are adroitly played against a balanced line which follows the bust and head of Diana and continues upward along the trunk of a tree. In this painting Boucher has rediscovered the tradition of grace and elegance which belonged to the school of Fontainebleau.

PLATE 76

QUENTIN DE LA TOUR [1704–1788]

Portrait of Madame de Pompadour

PROTECTED BY THE PORTRAITIST LARGILLIERE, Quentin de La Tour soon made a name for himself in Paris as a society painter, and was elected to the Academy at the age of thirty-three. He was eccentric, quick-witted and ironical, the friend of aristocrats, philosophers and scholars. Most of his portraits are in pastel, a medium he preferred for its swiftness and pliability. Thanks to it he was able to capture not only the likeness but the most fleeting expressions of his fashionable sitters.

When Madame de Pompadour asked to have her portrait done by Quentin, he haughtily replied: "Je ne vais pas peindre en ville," meaning that he expected his sitters to come to him. However, he finally consented to go out to Versailles, though he was incensed when Louis XV walked into the room, interrupting a sitting. In this portrait the artist set out to show that pastels could achieve the same effects as painting proper, and he succeeded in proving his point. The Marquise, now thirty-four, has lost some of the dazzling beauty that made her so famous in her youth; now she has acquired an almost regal grace and elegance. Clothed in sumptuous embroidered satin, she is shown surrounded by objects and attributes which mark her as an artist, a musician and a patroness of the arts—in

other words as a woman of culture, taste and sophistication, the perfect product of eighteenth-century enlightenment.

PLATE 77

PERRONNEAU [1715–1783]

Portrait of Madame de Sorquainville

ALTHOUGH HE BEGAN as an engraver, Perronneau found his vocation when he turned to portraiture. In his own time, his reputation was overshadowed by that of the pastelist Quentin de La Tour, but the greater sensitivity and sincerity of Perronneau's work have now come to be more justly appreciated.

Madame de Sorquainville is rather unusual in Perronneau's work, in that it is a three-quarter-length portrait; generally he confined himself to the head and the intensity of facial expression. The smile which he has rendered here is an eighteenth-century smile—one which is friendly, yet plays only on the lips; the eyes are serious, with a discreet touch of melancholy and tenderness, two sentiments which the century minimized or suppressed. The emotional subtlety of the portrait comes from its elegance and ease, and from the harmony of the blue-green and warm beige colors enlivened with black.

PLATE 78

FRAGONARD [1732–1806]

The Bathers

BECAUSE OF THE FREEDOM with which he handled his brush and pencil, and because of his facility, Fragonard, pupil of both Chardin and Boucher, has been considered superficial. But he was, in fact, the greatest lyrical painter of the age, inspired by a powerful love for all manifestations of life.

The subject of bathers, in its mythological or Biblical variants, offering an opportunity to paint nudes in a landscape, is an ancient one in painting. Fragonard handles this theme with his characteristic verve and high spirits. The passion and energy of the brush, the quick, nervous touches betray a kind of drunkenness, a fever of inspiration. He exults in the beauty of his models and in the light which transforms their skin and hair into a shimmering haze, and the trees and plants into indeterminate shapes as light as clouds. Even the water is changed into foam. Everything is volatile, nothing seems material, or to obey the laws of gravity.

Fragonard here transcends the ideal composure which his century cherished; he exults in that pantheistic lyricism which he shares with Rubens and Renoir.

PLATE 79

DAVID [1748–1824]

The Battle of the Romans and Sabines

LONG BEFORE the French Revolution, David was trained under the auspices of Boucher in the colorful, frivolous tradition of the French eighteenth century. However, in 1774 he received the *Prix de Rome* and an overwhelming admiration for the art of ancient Rome altered his ideals. He evolved a rigid, cold, virile style admirably attuned to his revolutionary beliefs. An intimate and admirer of Robespierre, he became a member of the Convention, narrowly escaping the guillotine on the 9th Thermidor. Under Napoleon, to whom he transferred his faith, he became the official painter of the Empire; after its fall, in discouragement, he emigrated to Brussels where he died.

This large canvas was painted in 1794 when David, having escaped the fate of his friend Robespierre, was still held in prison. His wife, a sincere royalist from whom he had become estranged, had recently come to visit him and he was deeply moved by this reunion. Woman plays the role of the conciliator in this painting which is meant as an exhortation to pardon and peace between enemy brothers. In the center of the composition the Sabine Hersilia, clothed symbolically in white, intervenes in the fight between Romulus and her father Tatius. Other Sabine women hurl themselves and their children between the struggling contenders. Recent restoration reveals that David successively altered and harmonized the muted colors of this enormous canvas with extreme care and deliberateness.

PLATE 80

PRUD'HON [1758–1823]

Portrait of the Empress Josephine

UPON HIS ARRIVAL in Rome at twenty-six Prud'hon, who had received his training in the French provinces, attached himself to the Neo-Classic sculptor Canova and came to know and love the works of Raphael, Leonardo and, above all, Correggio. On his return to Paris he executed decorations for the Chateau of Saint-Cloud, the Louvre, and for private mansions as well. He was held in high esteem at Napoleon's court, although his delicate, sensitive style was far removed from the official pronouncements of David. Within his own generation he was only a marginal artist, but the young Romantics, more psychologically aware, were quick to note the melancholy quality which he introduced into painting at about the same time that Chateaubriand was expressing it in literature.

The background of this portrait, executed in 1805, shows the park of Malmaison where the charming creole Empress was to seek refuge four years later, after her divorce from Napoleon. Susceptible to Josephine's charm, Prud'hon did not paint her as Empress but as an attractive woman, lovely, elegant, indolent—a woman who knows how to make herself loved. Prud'hon has heightened her graceful charm by hinting at a meditative sadness.

PLATE 81

INGRES [1780–1867]

Odalisque

INGRES, DAVID'S GREATEST PUPIL, lived in Rome for twenty years, ultimately becoming the director of the French Acad-

emy there. His classic style was mainly inspired by Raphael, although for his subject matter he often strayed into the medieval or exotic pastures of the Romantics. He was a flawless draftsman. Drawing, indeed, was the foundation of his painting: it was the purification, the culmination of his creative thought. Color was only an addition. It was this which made him the irreconcilable adversary of Delacroix, whose every brush stroke is glowing and intense with color.

This *Odalisque* clearly illustrates Ingres' devices. The oriental accessories, immaculately painted, only furnish an excuse for the title; actually the theme is the ever-recurrent one of Venus or the female nude which Ingres, rivaling the masters of the past, was to carry to new heights of abstract perfection. He was not interested in anatomy and was only concerned with line and purity of arabesque. He has changed the shape of the female body, softened and distilled it, re-creating it in an idealized form. In this way Ingres, the avowed classicist, is a precursor of modern abstraction, the forerunner of Modigliani and certain aspects of Picasso.

PLATE 82

GROS [1771–1835]

Portrait of Count Fournier-Sarlovèze

UPON THE ADVICE of his master David, Gros, who was suspected of royalist sympathies, left Paris for Italy in 1792. Relieved of the rigid yoke of his master he felt free to give himself up to his instinctive preference for Rubens and the Venetians. Through Josephine Beauharnais he was introduced to young General Bonaparte in Milan, and like David, he was swept along by the driving force of this latter-day Alexander, willingly becoming a glorifier of the new Empire. His art, full of energy and verve, attracted pupils and set the stage for the color and excitement of the Romantic school. But Gros, torn by the conflict between his classical training and his ardent temperament, became increasingly despondent, finally committing suicide at the age of sixty-four.

During the Napoleonic campaign in Spain in 1809, Count Fournier-Sarlovèze, then a brigadier in the dragoons, was holding the town of Lugo against the Galicians. An emissary came to him demanding surrender, but Sarlovèze tore up the note declaring that if ever the town were captured, his body would be found buried in its ruins. He is shown against a background of fire and battle, his sword planted defiantly in the ground, while the enemy's ultimatum flutters at his feet. A tense, dramatic being, proud and brave, living dangerously: this was the hero of the new day.

PLATE 83

GERICAULT [1791–1824]

Officer of the Chasseurs of the Guard

GERICAULT adored horses and sport, romantic poetry, music, and fashionable society. Although a dandy, he was also undeniably a serious and gifted painter. He admired Caravaggio, Rubens, and Rembrandt, and when he went to Italy he was overpowered by Michelangelo. What he learned from these masters found fruition in such masterpieces as the Louvre's huge canvas, *Raft of the Medusa,* and in the present painting.

The model for the *Officer* was actually the painter's friend, Lieutenant Dieudonné, but the general idea for the picture came to Géricault one day in 1812 when on his way to the fair at Saint-Cloud he saw a fine dapple-grey horse rearing. It is hard to say which is the more beautiful, the dynamic poise of the rider or the admirable spirit of the horse. Dominating the composition is the twisted figure, against a setting of tumult and clamor, concentrating its power for a blow.

When confronted by this revolutionary work by the young Géricault, the classicist David exclaimed in astonishment, "Where does it come from? I do not know that hand." David was witnessing the birth of romantic painting, for Géricault in this single canvas communicates the message of a new generation: passionate force, a zest for life and violence, exalted by the threat of death.

PLATE 84

DELACROIX [1798–1863]

Liberty Leading the People

A DISCIPLE OF GERICAULT and Bonington, a frequenter of the highest social and intellectual circles, Delacroix was a man of many talents and interests. He was quickly adopted as leader by the young painters who were banding together in opposition to the pupils of David; between Delacroix and Ingres, who became the standard-bearer of classicism in painting, a fierce enmity developed. Delacroix, strangely enough, also thought of himself as a "pure classicist" and he disliked being dubbed "the Victor Hugo of painting."

Delacroix was not actively interested in politics, but he was stirred by the ideal of freedom. The heroic figure of Liberty, brandishing the flag of the Revolution, leads the people of Paris, the bourgeois as well as the street urchin, over the barricades. Through the smoke of battle the towers of Notre Dame are visible to the right. Only a daring genius would attempt to combine the real with the allegorical in this way; by depicting the stiff and livid corpses under the flame-like figure of Liberty he creates an impassioned vision of men willing to die for her sake. The contrast between modern dress and classical nudes, between familiar scene and epic grandeur, creates the shock which Delacroix intended, the shock which "opens up the secret paths of the soul."

PLATE 85

THEODORE ROUSSEAU [1812–1867]

Oak Trees

SUCCESS CAME TO ROUSSEAU slowly even though his work was accepted by the Salon as early as 1832. In 1847 he decided to quit Paris and move to the village of Barbizon on the edge of the Forest of Fontainebleau. Other painters followed and thus the group known as the school of Barbizon came into being. A born landscape painter, Rousseau had for nature the reverence of a mystic; he elected to live a permanently solitary

existence in order to achieve a more direct contact with God's creation.

The vast trees of this canvas, in whose shadows cows are grazing, have an impressive solemnity. They are not mere accessories to a landscape; rather, they represent forces of nature. The animals, the shepherd, even the background fade away before the grandeur of these royal oaks. The composition follows the classic pyramidal arrangement with the axis only slightly off-center. Each part of the picture has its own subtle color values: the light in the background, soft and touched with gold, contrasts with that of the foreground in which the shadows of the oaks show in a bluish light. With his sensitive and reverent vision Rousseau has raised this realistic picture to the level of poetry.

PLATE 86

MILLET [*1814–1875*]

Springtime

MILLET IS BEST KNOWN for his two great canvases in the Louvre, *The Angelus* and *The Gleaners*, both glorifications of rural life. A peasant himself, with a marked talent for painting, he came to Paris where he supported himself with difficulty by doing portraits and decorative panels in the eighteenth-century tradition. One of his pictures was accepted by the Salon in 1840; this gave him hope. Leaving Paris for the country he turned his attention to depicting the aspect of life he knew best and felt most deeply: the life of the peasants in all its dignity. He saw them not coarsened and bowed down by hard work but ennobled by their simple, nearly biblical existence. Millet's sober and monumental vision harks back to the work of Louis Le Nain in the seventeenth century.

Encouraged by Théodore Rousseau, Millet settled in Barbizon with his large family. In 1867 his works were exhibited with considerable success, but he continued to live in unrelieved poverty. In his later years he painted several landscapes in which figures play a minor role. *Springtime* is one of a series on the four seasons; it symbolizes the hopefulness of Spring, the promise of fair weather as the sun breaks through the swollen storm clouds.

PLATE 87

COROT [*1796–1875*]

Belfry of Douai

IT WAS ONLY WITH DIFFICULTY that the young Corot persuaded his parents to allow him to take up painting rather than a commercial career. In Rome, instead of frequenting museums and copying classical works, the usual course of training for students, he devoted himself to studies from nature, constantly seeking new motifs and light effects. These he painted with a wonderful eye for subtle modulations of form and tone.

"Let our feeling alone be our guide . . . the beautiful in art is truth bathed in the impression we have received from looking at nature," he wrote in his notebook. This lyric emotion suffuses all his canvases, from the early portraits and nature studies that we prefer today, to the misty woodland scenes that he began to paint in the last third of his life, under the spell of Virgil's poetry. Although his previous painting had been almost ignored, the silvery landscapes that he produced with such tenderness and delicate skill from about the middle of the century on caught the public's fancy and won him wide popularity.

He painted the *Belfry of Douai* in May, 1871, from the window of a house where he was staying; his old friends the Robauts, fearful for his safety in Paris under the Commune, had taken him away from the capital. Though the artist was then seventy-five, he devoted some twenty sessions to this work, which in its mastery of light and bright color tells us that Impressionism is on its way.

PLATE 88

DAUMIER [*1808–1879*]

Crispin and Scapin

A BITING SATIRIST, Daumier made his reputation when quite young through his lithographs for the newspaper *La Caricature*. His savage ridicule of King Louis Philippe and the government brought him a six-month prison sentence; after his release and the suppression of the paper he turned his wit to attacks on the bourgeoisie and the law courts.

Entirely absorbed in his draftsmanship, he took up painting comparatively late in his career, using at first a few dark colors and modeling his figures through effects of light and shadow in a powerful and sculptural way. Towards his fortieth year his color range began to broaden, and in *Crispin and Scapin* the active blue, red, and white seem to quiver in the brightness of the footlights. Gas illumination was still a novelty, and like Degas and Toulouse-Lautrec, Daumier was fascinated by the new light effects it produced on the stage. His gift for characterization brings to life the dialogue between the two valets in Molière's play, *Les Fourberies De Scapin*. No written page could ever convey so pointedly the expression of those raised eyebrows, the crooked look and the smile of a cheat and swindler who folds his arms in triumph, satisfied with his low cunning. Daumier's art, like that of the theater itself, is both realistic and expressive to the point of symbolism.

PLATE 89

COURBET [*1819–1877*]

Roe-Deer in a Forest

COURBET'S FIRST MONUMENTAL CANVAS, the *Burial at Ornans*, was a deeply felt and noble representation of a homely scene in which every face was the face of a friend. It proved to be a battlecry. The critics of 1850 were outraged: the mourning, rustic figures were unbearably real, the whole treatment was too stark and shocking. A peasant himself, mostly self-taught except for the lessons he gleaned from Hals and Velasquez in the Louvre, Courbet persevered, obstinately painting only what he saw. Accepted and successful at last, after twenty years of uncompromising sincerity he was accused, in 1871,

of having too actively participated in the Commune. He was sentenced to exile and spent the last six years of his life on the shores of Lake Geneva.

This picture of deer was a great success when it was exhibited in the Salon of 1866. Even his enemies recognized the beauty of this work into which Courbet had put his whole understanding of nature and animal life. It seems to be through some private communion with nature that Courbet attains his unique power of suggesting the coolness of water, the texture of leaves and grass, the silky coats of the deer. It is entirely a work of instinct, which starts from the senses and arrives at poetry.

PLATE 90

MANET [1832–1883]

Luncheon on the Grass

ALTHOUGH BASED ON A COMPOSITION by Raphael and inspired by a desire to emulate the transparent atmosphere of Giorgione's *Pastoral Concert* (plate 16), Manet's large *Luncheon* provoked a scandal when it was exhibited in 1863 at the Salon des Refusés after having been rejected by the official Salon. The realism of the figures, sketched out of doors, was felt to be shocking and improper: recognizable are Manet's brother Eugène at the right; Ferdinand Leenhoff, a Dutch sculptor who became his brother-in-law, in the center; and, on the left, Manet's model Victorine Meurend, who in the same year posed for his famous *Olympia*.

Manet's unusual, nervous technique and pure colors were as distasteful to official circles as his realism and the modernity of his subjects; but these very qualities attracted the young realist painters of the day—Monet, Bazille, Renoir, Sisley, and Pissarro—the future leaders of Impressionism. This daring canvas exemplified what they were seeking: clear, bright painting from nature, giving the feeling of a real, luminous atmosphere into which actual persons have wandered.

Manet, though greatly admired by the Impressionists and adopted as their leader, never exhibited with them. He always remained slightly aloof, his distinguished personal style a reflection of his cultured, fashionable tastes and the independence of his temperament.

PLATE 91

MONET [1840–1926]

Field of Poppies

MONET WAS INITIATED into outdoor painting by the landscapist Boudin, whom he met at Le Havre. In Paris he became the friend of other artists—Pissarro, Renoir, Sisley, and Bazille—who were seeking, like himself, to solve the problem of rendering the sensation of light in painting. The early effect on his art of Manet's naturalism was succeeded by other influences when, during the war of 1870, Monet traveled abroad and discovered in Holland the work of Ruisdael, in England that of Constable and—still more important for him—of Turner. On his return to France, Monet became the leader of the group

which was to derive its name "Impressionist" from the title of one of his paintings, *Impression–Sunrise*.

Field of Poppies, executed at about the same period, shows Monet's relative lack of interest in human figures, and his primary concern with effects of atmosphere and shimmering light. The red flowers, vibrant stains, blaze out on the bleached grass which extends like a sea to the distant horizon with its silhouette of trees—the only firm line in the picture. Vast rolling fields with grass waving in the wind were among the Impressionists' favorite themes; Monet himself painted several compositions similar to this one.

In his later work Monet abandoned figures almost entirely and concentrated on single motifs: a mill, a cathedral, a haystack, poplars. These he painted in different lights according to the time of day, attempting to introduce the passage of time into a series of paintings in a manner unique in the history of art.

PLATE 92

CEZANNE [1839–1906]

Bay of L'Estaque

CEZANNE WAS BORN AT AIX, where he received his early training in art and where he was to spend the greater part of his life, finding inspiration in the Provence he loved so well. An admirer of such masters as Courbet, Delacroix, Michelangelo, and Tintoretto, he painted in his early period with dark colors thickly applied to the canvas in an agitated manner. Under the influence of the Impressionists, and especially of Pissarro, Cézanne's palette became purer and brighter, his touch lighter, and he began to apply broken tones to his canvases.

In contrast to the Impressionists, however, Cézanne believed that a painting must be a work of synthesis and solid construction. His bold determination to build up form and volume by exact modeling in color, and his study of planes in relation to space, made him the forerunner of Cubism and probably the most important single influence on twentieth-century painting.

Cézanne's precepts "to render perspective solely by means of color," and to use color to *represent* rather than to *reproduce* light, are successfully illustrated in his views of L'Estaque, a small port near Marseilles. In 1883 he wrote to his childhood friend, the novelist Zola: "At sunset, mounting the heights, you see before you the wonderful panorama of the Bay of Marseilles and the islands."

PLATE 93

SISLEY [1839–1899]

Flood at Port-Marly

BORN IN PARIS OF ENGLISH PARENTS, Sisley studied at the Gleyre studio, where he met Monet, Renoir, and Bazille. Although he first modeled his landscapes on those of the Barbizon school, his love of skies and water naturally attracted him to the greater freedom of Impressionist technique. He responded to light, vaporous, and delicate things like clouds and snow, and to shimmering colors—pale blues, pinks, or silvery greys. Al-

though never winning recognition or success in his lifetime, Sisley is now appreciated as the initiator of a style of mellow paintings that recapture the atmosphere of calm retreats in the Ile-de-France.

A village near St. Germain-en-Laye, inundated by the waters of the Seine in 1876, made a great impression on Sisley. In addition to the *Flood at Port-Marly*, he painted several other pictures of the scene. Characteristically, he did not conceive this subject in terms of a terrifying drama nor see in it, as the Romantics would have done, a tempestuous unleashing of great natural forces. Instead, Sisley portrayed a limpid, rain-washed sky above houses and trees reflected in the water. Without striving to interpret or to indulge in rhetoric, he has conveyed the strange isolation of a village entirely surrounded by water amid the beauty of indifferent elements.

PLATE 94

RENOIR [*1841–1919*]

Two Girls at the Piano

BORN AT LIMOGES, Renoir worked as a decorator of china before entering the École des Beaux-Arts in Paris. Together with Sisley, Bazille, and Monet, who were to become leaders of Impressionism, he used to paint outdoors in the Forest of Fontainebleau, which had earlier in the century been the favorite haunt of the Barbizon school painters. He was inspired by Courbet, but it was through Delacroix that he was led to his own researches in color. Striving to render the modulations of daylight falling on faces and figures, he developed a technique of painting with separate brush strokes of pure color.

In quest of more solid form, and following a trip to Italy, Renoir entered a period deeply influenced by the pure draftsmanship and hard color of Ingres. Still later his work is marked by a return to a bolder manner and to richer, more iridescent color, culminating in the lyricism of his landscapes of Provence and a series of wonderful nudes.

Unlike Sisley and Monet, Renoir always delighted in painting the human figure, and in the *Two Girls at the Piano* he shows his special mastery of subjects which show people in moments of gaiety or relaxation. It is one of a series of works on the same theme which Renoir painted in the last decade of the century after his Ingresque period. It was the first painting by the artist to be purchased by the state.

PLATE 95

VAN GOGH [*1853–1890*]

Dr. Gachet

ENCOURAGED to come to Paris by his brother Theo, an art dealer, van Gogh in 1866 made the acquaintance of the Impressionists, from whom he learnt the technique of divided color. Two years later, he went to Provence; there, dazzled by the Mediterranean light, he created in a frenzy of enthusiasm a series of beautiful canvases of impassioned lyricism. But under the stress of overstimulation and semi-starvation, his health and stability gave way. Periodic mental lapses, during which

he attacked his friend Gauguin and cut his own ear, led to his confinement in the asylum of St. Rémy, where he continued to paint.

Returning from Provence, van Gogh spent several months in the house of Dr. Gachet at Auvers near Paris. Despite the care and affection the doctor devoted to him, van Gogh finally committed suicide in despair at his inability to find a solution to his anguish.

Dr. Gachet, whom van Gogh represented several times, was interested in psychiatry; he was the author of a treatise on melancholy and had made a close study of the madness of the engraver Méryon. A water colorist himself, he was a lover of Impressionist painting and a friend of Cézanne. This powerful portrait of him, presented to the Louvre by his son, with its strident color, unstable composition, and designs that undulate like flames, seems a projection of van Gogh's own mental and spiritual suffering.

PLATE 96

SEURAT [*1859–1891*]

The Circus

SEURAT was conscious of the impasse which Impressionism had reached around 1880-1885: it could not convey more than the aspect of a fleeting moment. A picture, he felt, should be an idea, a conception, not an impression; it should present a synthesis, not an analysis. Classical by temperament, he submitted himself to the influences of Ingres, Puvis de Chavannes, Raphael, Holbein—and Delacroix. His precise, methodical mind led him to study optics and the physical properties of color.

Although he did not find the solution of pictorial problems in science, his style accorded with his theory that lines and colors should obey the laws of contrast and similarity, and he developed a strict method of painting, using little dots of pure color and cleverly modifying the distance between these dots in order to achieve his tones. This method, called Pointillism or Neo-Impressionism, won several adherents among his contemporaries; but today, though his work may seem cold, Seurat is admired for his pictorial form, the purity of his architectural conception of art, and his almost geometric rhythms.

The Circus is the last of the six great compositions which he achieved in his short life and it was still unfinished when he died at the age of thirty-one. Characteristic are the bold structural lines of the painting, the horizontal rigidity of the tiers of spectators which is contrasted with the curves of the circus ring and the performers. The frame of graduated blue lines was painted by Seurat in accordance with his conviction that the over-all effect of a painting was of supreme importance.

PLATE 97

GAUGUIN [*1848–1903*]

The White Horse

A BANK CLERK BY PROFESSION, a painter at first only by hobby, in 1883 Gauguin abandoned his wife, his children, and his job to devote his life to art. After a period of association with

the Impressionists, Gauguin joined the Symbolist painters and returned to the use of broad areas of simplified color. To seek direct contact with the primitive sources of nature, which he believed held secrets lost to over-civilized communities, he traveled widely: in Martinique he had his first introduction to primitive art and to the violent colors of the tropics; later he went to Tahiti and to the Marquesas Islands, where he died. "To me," he said, "Barbary means rejuvenation"; and although he failed to find amongst the primitive peoples of the South Seas the untainted paradise he sought, he succeeded in interpreting as no one else has the poetry and disquieting beauty of the tropics.

In *The White Horse* Gauguin tried to express the mystery of the exotic forests, of the natives at once hieratic and animal in appearance, whose religion and customs are incomprehensible to Europeans. This strange horse, whose white flanks are made grey-green by the light which filters through the luxuriant vegetation, slakes its thirst in a stream mottled with remarkable orange lights. With the poet Mallarmé, we marvel that it should be possible to "put so much mystery where there is so much brightness."

PLATE 98

DEGAS [1834–1917]

Dancing Class at the Opera

THE FINEST DRAFTSMAN OF HIS GENERATION, Degas received a classical training at the École des Beaux-Arts in Paris under a follower of Ingres; in Rome and Naples he studied the Italian primitives. But under the influence of other young painters and writers, he soon began to develop a more modern and original technique. He exhibited with the Impressionists in 1874 and later broke with them. During his last years, when he was almost totally blind, he worked in pastels and made models in clay of his favorite subjects—horses and dancers.

Degas' highstrung, sensitive temperament responded to the atmosphere of the ballet: the attitudes of the dancers, their diaphanous tulle costumes reflecting the light, and the brilliantly illuminated scenes. The *Dancing Class* is one of the earliest of the astonishing series of subjects he derived from the corridors, stage, or rehearsal rooms at the Paris Opera. With split-second accuracy he could capture fleeting postures and light effects. It was perhaps under the influence of photography that Degas dared to let the lower edge of his painting cut off the legs of the chair in the center—a truncation that must have appeared revolutionary in his day. From time to time his acute and caustic spirit amused itself by catching the inelegant expression or attitude of a ballerina in repose. As he wrote in one of his poems on the dance, "Queens are made by distance and by greasepaint."

PLATE 99

TOULOUSE-LAUTREC [1864–1901]

Portrait of Paul Leclercq

TOULOUSE-LAUTREC was a descendant of the illustrious Counts of Toulouse who held sway in Languedoc during the Middle Ages. When he was about fifteen his legs were broken in two successive accidents; his body became deformed, his torso being normal but his legs dwarfed. His frustrated love for swift, graceful movement found expression in his many paintings and drawings of horses, dancers, and acrobats. As a youth he was an admirer of the equestrian painter John Lewis Brown, and his first works were some fine studies of horsemen, which already show his striking grasp of effects of movement. Under the influence of Degas and of Japanese prints, he developed a fluid, simple line which he used with dazzling effect. He tried to interpret the bitter poetry of what Baudelaire called "modernity," frequently finding themes sympathetic to his mood in music halls and night cafés.

Many of the artist's favorite nocturnal haunts and companions are described in a book, *Autour de Toulouse-Lautrec*, written by his friend Paul Leclercq, the subject of this portrait. It was painted four years before Lautrec's early death, prematurely brought on by a life of dissipation that ruined his health. A born portraitist, Lautrec shared with Degas the gift for expressing the essential character of a human face or a gesture through a broken line or flowing arabesque. Here, with the quick, light touch of his brush he has captured the ironic expression of his friend, a man of the world, chatting casually but with mordant wit.

PLATE 100

HENRI ROUSSEAU [1844–1910]

War

CALLED "LE DOUANIER" because of his employment at the customs house in Paris, Rousseau retired from this occupation at the age of forty to take up painting. He never had any formal training, and because his ingenuous paintings were so far removed from accepted conventions of the day, the general public derived only amusement from the works he exhibited at the Salle des Indépendants and in the Salon d'Automne. But more perceptive critics, such as the poet Guillaume Apollinaire and the artists Gauguin, Odilon Redon, and the young Picasso, realized that in Henri Rousseau they were encountering the unique phenomenon of a powerful creative imagination exploring painting afresh, completely uninhibited by preconceived notions of style, technique, or subject matter. This quest for an entirely new vision, new outlets for expression, was the problem that was preoccupying young artists at the turn of the century.

Although Rousseau's subjects were sometimes the familiar suburbs and the people of Paris, he did not hesitate to invent exotic scenes of tropical jungles or deserts he had never visited. In this allegory, *War*, discord, in hideous guise, sowing death by steel and fire, looks down from his apocalyptic horse (interestingly enough, also a psychoanalytical symbol of death) upon humanity lying mutilated and bleeding amid the devastation of nature. Daring color contrasts of blacks, blues, pinks, and pale yellows accentuate the monumental rhythms of a composition as highly stylized as a medieval tapestry. It is this power to infuse his naive visions with remarkable poetry that makes Rosseau by far the greatest of the primitive or "Sunday" painters who have fascinated our times since Apollinaire first focused attention on them.